Praise for *The Simpsons and Their Mathematical Secrets*

"Not content merely to point out the mathematical references, Mr. Singh uses them as a starting point for lively discussions of mathematical topics, anecdotes and history. Even someone with no mathematical background will enjoy his accounts of the nature of infinity and the meaning of the number e, the life of tragic genius Srinivasa Ramanujan and the obsessions of Bill James, the oracle of baseball statistics."—*The New York Times*

"Singh uses the show as a thread along which to string mini-essays on some of math's greatest hits." *The Washington Post*

"Loved the book and bought one for my mom."—Al Jean, executive producer and writer on *The Simpsons*

"It's Martin Gardner-esque. Singh uses *The Simpsons* as a springboard to so many wonderful topics."—Mike Reiss, senior writer on *The Simpsons*

"Singh uses the show's mathematical references as a way into discussing Fermat's Last Theorem, Pi and the possibility of a doughnut-shaped universe. The clarity of his explanations is impressive, and there are some illuminating interviews with *Simpsons* writers, highlighting the parallels between solving problems and concocting jokes . . . This is a valuable, entertaining book that, above all, celebrates a supremely funny, sophisticated show."—*Financial Times*

"A fun trip with the 'ultimate TV vehicle for pop culture mathematics.'"
—*Kirkus Reviews*

"Mathematical concepts both useful and obscure explained via the antics of America's favorite yellow family!"—*Mental Floss*

"Engaging (and educational)."—Wired.com

"The perfect Christmas present for both mathematical savants and *Simpsons* aficionados."—*Physics World*

"Singh shows a knack for gliding seamlessly between abstract mathematical concepts and everyday life, always seeking out the most engaging, human and topical examples."—*The Times*

Fermat's Enigma: The Epic Quest to Solve the World's Greatest Mathematical Problem (US edition)

Fermat's Last Theorem: The Story of a Riddle that Confounded the World's Greatest Minds for 358 Years (UK edition)

The Code Book: The Science of Secrecy from Ancient Egypt to Quantum Cryptography

Big Bang: The Origin of the Universe

Trick or Treatment: Alternative Medicine on Trial

SIMON SINGH

THE SIMPSONS
AND THEIR
MATHEMATICAL
SECRETS

BLOOMSBURY

NEW YORK · LONDON · NEW DELHI · SYDNEY

Published by Bloomsbury USA, New York
Bloomsbury is a trademark of Bloomsbury Publishing Plc

All papers used by Bloomsbury USA are natural, recyclable products made from wood grown in well-managed forests. The manufacturing processes conform to the environmental regulations of the country of origin.

LIBRARY OF CONGRESS CATALOGING-IN-PUBLICATION DATA
Singh, Simon.
The Simpsons and their mathematical secrets /
Simon Singh.—First U.S. Edition.
pages cm
Includes bibliographical references and index.
ISBN 978-1-62040-277-1 (hardback)
1. Mathematics—Miscellanea. 2. Simpsons (Television program)—Miscellanea. I. Title.
QA99.S48 2013 510—dc23 2013020884

First U.S. edition published 2013
This paperback edition published 2014

Paperback ISBN: 978-1-62040-278-8
3 5 7 9 10 8 6 4 2

Printed and bound in the U.S.A. by Thomson-Shore Inc., Dexter, Michigan

Bloomsbury books may be purchased for business or promotional use. For information on bulk purchases please contact Macmillan Corporate and Premium Sales Department at specialmarkets@macmillan.com.

Dedicated to

Anita and Hari

$$\eta + \psi = \varepsilon$$

CONTENTS

· · · · · · · · · · · · ·

THE SIMPSONS
AND THEIR
MATHEMATICAL
SECRETS

THE TRUTH ABOUT
THE SIMPSONS

• • • • • • • • • •

The *Simpsons* is arguably the most successful television show in
history. Inevitably, its global appeal and enduring popularity
have prompted academics (who tend to overanalyze everything) to
identify the subtext of the series and to ask some profound questions.
What are the hidden meanings of Homer's utterances about dough-
nuts and Duff beer? Do the spats between Bart and Lisa symbolize
something beyond mere sibling bickering? Are the writers of *The
Simpsons* using the residents of Springfield to explore political or so-
cial controversies?

One group of intellectuals authored a text arguing that *The Simp-
sons* essentially provides viewers with a weekly philosophy lecture. *The
Simpsons and Philosophy* claims to identify clear links between various
episodes and the issues raised by history's great thinkers, including
Aristotle, Sartre, and Kant. Chapters include "Marge's Moral Motiva-
tion," "The Moral World of the Simpson Family: A Kantian Perspec-
tive," and "Thus Spake Bart: On Nietzsche and the Virtues of Being
Bad."

Alternatively, *The Psychology of The Simpsons* argues that Spring-
field's most famous family can help us grasp a deeper understanding
of the human mind. This collection of essays uses examples from the
series to explore issues such as addiction, lobotomies, and evolution-
ary psychology.

By contrast, Mark I. Pinsky's *The Gospel According to The Simpsons*
ignores philosophy and psychology, and focuses on the spiritual sig-
nificance of *The Simpsons*. This is surprising, because many characters

appear to be unsympathetic toward the tenets of religion. Regular viewers will be aware that Homer consistently resists pressure to attend church each Sunday, as demonstrated in "Homer the Heretic" (1992): "What's the big deal about going to some building every Sunday? I mean, isn't God everywhere? . . . And what if we've picked the wrong religion? Every week we're just making God madder and madder?" Nevertheless, Pinsky argues that the adventures of the Simpsons frequently illustrate the importance of many of the most cherished Christian values. Many vicars and priests agree, and several have based sermons on the moral dilemmas that face the Simpson family.

Even President George H. W. Bush claimed to have exposed the real message behind *The Simpsons*. He believed that the series was designed to display the worst possible social values. This motivated the most memorable sound bite from his speech at the 1992 Republican National Convention, which was a major part of his reelection campaign: "We are going to keep on trying to strengthen the American family to make American families a lot more like the Waltons and a lot less like the Simpsons."

The writers of *The Simpsons* responded a few days later. The next episode to air was a rerun of "Stark Raving Dad" (1991), except the opening had been edited to include an additional scene showing the family watching President Bush as he delivers his speech about the Waltons and the Simpsons. Homer is too stunned to speak, but Bart takes on the president: "Hey, we're just like the Waltons. We're praying for an end to the Depression, too."

However, all these philosophers, psychologists, theologians, and politicians have missed the primary subtext of the world's favorite TV series. The truth is that many of the writers of *The Simpsons* are deeply in love with numbers, and their ultimate desire is to drip-feed morsels of mathematics into the subconscious minds of viewers. In other words, for more than two decades we have been tricked into watching an animated introduction to everything from calculus to geometry, from π to game theory, and from infinitesimals to infinity.

"Homer3," the third segment in the three-part episode "Treehouse

of Horror VI" (1995) demonstrates the level of mathematics that appears in *The Simpsons*. In one sequence alone, there is a tribute to history's most elegant equation, a joke that only works if you know about Fermat's last theorem, and a reference to a $1 million mathematics problem. All of this is embedded within a narrative that explores the complexities of higher-dimensional geometry.

"Homer³" was written by David S. Cohen, who has an undergraduate degree in physics and a master's degree in computer science. These are very impressive qualifications, particularly for someone working in the television industry, but many of Cohen's colleagues on the writing team of *The Simpsons* have equally remarkable backgrounds in mathematical subjects. In fact, some have PhDs and have even held senior research positions in academia and industry. We will meet Cohen and his colleagues during the course of the book. In the meantime, here is a list of degrees for five of the nerdiest writers:

J. STEWART BURNS BS Mathematics, Harvard University
 MS Mathematics, UC Berkeley

DAVID S. COHEN BS Physics, Harvard University
 MS Computer Science, UC Berkeley

AL JEAN BS Mathematics, Harvard University

KEN KEELER BS Applied Mathematics, Harvard University
 PhD Applied Mathematics, Harvard University

JEFF WESTBROOK BS Physics, Harvard University
 PhD Computer Science, Princeton University

In 1999, some of these writers helped create a sister series titled *Futurama*, which is set one thousand years in the future. Not surprisingly, this science fiction scenario allowed them to explore mathematical themes in even greater depth, so the latter chapters of this book

are dedicated to the mathematics of *Futurama*. This includes the first piece of genuinely innovative and bespoke mathematics to have been created solely for the purposes of a comedy storyline.

Before reaching those heady heights, I will endeavour to prove that nerds and geeks* paved the way for *Futurama* to become the ultimate TV vehicle for pop culture mathematics, with mentions of theorems, conjectures, and equations peppered throughout the episodes. However, I will not document every exhibit in the Simpsonian Museum of Mathematics, as this would mean including far more than one hundred separate examples. Instead, I will focus on a handful of ideas in each chapter, ranging from some of the greatest breakthroughs in history to some of today's thorniest unsolved problems. In each case, you will see how the writers have used the characters to explore the universe of numbers.

Homer will introduce us to the Scarecrow theorem while wearing Henry Kissinger's glasses, Lisa will show us how an analysis of statistics can help steer baseball teams to victory, Professor Frink will explain the mind-bending implications of his Frinkahedron, and the rest of Springfield's residents will cover everything from Mersenne primes to the googolplex.

Welcome to *The Simpsons and Their Mathematical Secrets*.

Be there or be a regular quadrilateral.

* In 1951, *Newsweek* reported that *nerd* was a derogatory term gaining popularity in Detroit. In the 1960s, students at Rensselaer Polytechnic Institute preferred the spelling *knurd*, which was *drunk* spelled backward—the implication being that knurds are the opposite of party animals. However, with the emergence of nerd pride over the past decade, the term is now embraced by mathematicians and others of their ilk. Similarly, *geek* is a label to be admired, as demonstrated by the popularity of geek chic and a headline in *Time* magazine in 2005: "The Geek Shall Inherit the Earth."

CHAPTER 1
BART THE GENIUS

. · . · . · . · . · . · . · . · .

I n 1985, the cult cartoonist Matt Groening was invited to a meeting with James L. Brooks, a legendary director, producer, and screen-writer who had been responsible for classic television shows such as *The Mary Tyler Moore Show*, *Lou Grant*, and *Taxi*. Just a couple of years earlier, Brooks had also won three Academy Awards as producer, director, and writer of *Terms of Endearment*.

Brooks wanted to talk to Groening about contributing to *The Tracey Ullman Show*, which would go on to become one of the first big hits on the newly formed Fox network. The show consisted of a series of comedy sketches starring the British entertainer Tracey Ullman, and the producers wanted some animated shorts to act as bridges between these sketches. Their first choice for these so-called bumpers was an animated version of Groening's *Life in Hell*, a comic strip featuring a depressed rabbit named Binky.

While sitting in reception, waiting to meet Brooks, Groening considered the offer he was about to receive. It would be his big break, but Groening's gut instinct was to decline the offer, because *Life in Hell* had launched his career and carried him through some tough times. Selling Binky to Fox seemed like a betrayal of the cartoon rabbit. On the other hand, how could he turn down such a huge opportunity? At that moment, outside Brooks's office, Groening realized that the only way to resolve his dilemma would be to create some characters to offer in place of Binky. According to the mythology, he invented the entire concept of *The Simpsons* in a matter of minutes.

Brooks liked the idea, so Groening created dozens of animated shorts starring the members of the Simpson family. These were sprinkled through three seasons of *The Tracey Ullman Show*, with each

animation lasting just one or two minutes. Those brief appearances might have marked the beginning and the end of *The Simpsons*, except that the production team began to notice something strange.

Ullman often relied on extraordinary makeup and prosthetics to create her characters. This was problematic, because her performances were filmed in front of a live audience. To keep the audience entertained while Ullman prepared, someone suggested patching together and playing out some of the animations featuring the Simpsons. These animations had already been broadcast, so it was merely an opportunistic recycling of old material. To everyone's surprise, the audiences seemed to enjoy the extended animation sequences as much as the live sketches.

Groening and Brooks began to wonder if the antics of Homer, Marge, and their offspring could possibly sustain a full-length animation, and soon they teamed up with writer Sam Simon to work on a Christmas special. Their hunch was right. "Simpsons Roasting on an Open Fire" was broadcast on December 17, 1989, and was a massive success, both in terms of audience figures and with the critics.

This special was followed one month later by "Bart the Genius." This was the first genuine episode of *The Simpsons*, inasmuch as it premiered the famous trademark opening sequence and included the debut of Bart's notorious catchphrase "Eat my shorts." Most noteworthy of all, "Bart the Genius" contains a serious dose of mathematics. In many ways, this episode set the tone for what was to follow over the next two decades, namely a relentless series of numerical references and nods to geometry that would earn *The Simpsons* a special place in the hearts of mathematicians.

· ● ·

In hindsight, the mathematical undercurrent in *The Simpsons* was obvious from the start. In the first scene of "Bart the Genius," viewers catch a glimpse of the most famous mathematical equation in the history of science.

The episode begins with a scene in which Maggie is building a tower out of her alphabet blocks. After placing a sixth block on top,

she stares at the stack of letters. The doomed-to-be-eternally-one-year-old scratches her head, sucks her pacifier, and admires her creation: EMCSQU. Unable to represent an equals sign and lacking any numbered blocks, this was the closest that Maggie could get to representing Einstein's famous scientific equation $E = mc^2$.

Some would argue that mathematics harnessed for the glory of science is somehow second-class mathematics, but for these purists there are other treats in store as the plot of "Bart the Genius" unfolds.

While Maggie is building $E = mc^2$ with her toy blocks, we also see Homer, Marge, and Lisa playing Scrabble with Bart. He triumphantly places the letters *KWYJIBO* on the board. This word, *kwyjibo*, is not found in any dictionary, so Homer challenges Bart, who gets revenge by defining *kwyjibo* as "a big, dumb, balding North American ape, with no chin . . ."

During this somewhat bad-tempered Scrabble game, Lisa reminds Bart that tomorrow he has an aptitude test at school. So, after the *kwyjibo* fiasco, the story shifts to Springfield Elementary School and Bart's test. The first question that faces him is a classic (and, frankly, rather tedious) mathematics problem. It concerns two trains leaving Sante Fe and Phoenix, each one traveling at different speeds and with different numbers of passengers, who seem to get on and off in odd and confusing groups. Bart is baffled and decides to cheat by stealing the answer sheet belonging to Martin Prince, the class dweeb.

Bart's plan not only works, it works so well that he is whisked into Principal Skinner's office for a meeting with Dr. Pryor, the school psychologist. Thanks to his skulduggery, Bart has a score that indicates an IQ of 216, and Dr. Pryor wonders if he has found a child prodigy. His suspicions are confirmed when he asks Bart if he finds lessons boring and frustrating. Bart gives the expected answer, but for all the wrong reasons.

Dr. Pryor persuades Homer and Marge to enroll Bart at the Enriched Learning Center for Gifted Children, which inevitably turns into a nightmarish experience. During the first lunch break, Bart's classmates show off their intellects by offering him all manner of deals couched in mathematical and scientific terms. One student makes the

following offer: "Tell you what, Bart, I'll trade you the weight of a bowling ball on the eighth moon of Jupiter from my lunch for the weight of a feather on the second moon of Neptune from your lunch."

Before Bart can decipher the implications of Neptunian moons and Jovian bowling balls, another student makes a fresh and equally confusing offer: "I'll trade you one thousand picoliters of my milk for four gills of yours." It is yet another pointless puzzle, merely designed to belittle the newbie.

The next day, Bart's mood deteriorates even further when he realizes that the first lesson is mathematics. The teacher gives her students a problem, and it is at this point that we encounter the first example of an overt mathematical joke in *The Simpsons*. While at the board, the teacher writes up an equation and says: "So y equals r cubed over three, and if you determine the rate of change in this curve correctly, I think you will be pleasantly surprised."

There is a short pause before all the students—except one—work out the answer and begin to laugh. The teacher tries to help Bart amid the guffaws of his classmates by writing a couple of hints on the board. Eventually, she writes down the solution to the problem. Bart is still perplexed, so the teacher turns to him and says: "Don't you get it, Bart? Derivative dy equals three r squared dr over three, or r squared dr, or r dr r."

The teacher's explanation is displayed in the sketch opposite. However, even with this visual aid, I suspect that you may be as bewildered as Bart, in which case it might help to focus on the final line on the board. This line (r dr r) is not only the answer to the problem, but also the supposed punch line. This prompts two questions; why is r dr r funny and why is it the answer to the mathematics problem?

The class laughs because r dr r sounds like *har-de-har-har*, an expression that has been used to indicate sarcastic laughter in reaction to a bad joke. The *har-de-har-har* phrase was popularized by Jackie Gleason, who played Ralph Kramden in the classic 1950s TV sitcom *The Honeymooners*. Then, in the 1960s, the phrase became even more popular when the Hanna-Barbera animation studio created a cartoon character named Hardy Har Har. This pessimistic hyena with a pork-

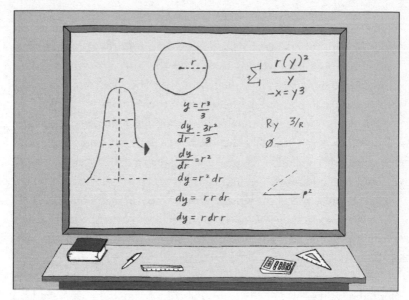

When the teacher poses a calculus problem in "Bart the Genius," she unhelpfully uses an unconventional layout and inconsistent notation, and she also makes an error. Nevertheless, she still obtains the correct answer. This sketch reproduces the content of the teacher's board, except that here the calculus problem is laid out more clearly. The important equations are the six lines below the circle.

pie hat starred alongside Lippy the Lion in dozens of animations

So, the punch line involves a pun based on $r\,dr\,r$, but why is this the answer to the mathematics question? The teacher has posed a problem that relates to a notoriously nasty area of mathematics known as calculus. This is a topic that strikes terror into the hearts of many teenagers and triggers nightmarish flashbacks in some older people. As the teacher explains when she sets out the problem, the goal of calculus is to "determine the rate of change" of one quantity, in this case y, with respect to another quantity, r.

If you have some recollection of the rules of calculus,[*] then you will be able to follow the logic of the joke fairly easily and arrive at the

[*] Readers with a rusty knowledge of calculus may need to be reminded of the following general rule: The derivative of $y = r^n$ is $dy/dr = n \times r^{n-1}$. Readers with no knowledge of calculus can be reassured that their blind spot will not hinder their understanding of the rest of the chapter.

correct answer of r dr r. If you are one of those who is terrified of cal-
culus or who suffers flashbacks, don't worry, for now is not the time
to embark on a long-winded lecture on the nitty-gritty of calculus.
Instead, the more pressing issue is why were the writers of *The Simp-
sons* putting complicated mathematics in their sitcom?

The core team behind the first season of *The Simpsons* consisted of
eight of Los Angeles's smartest comedy writers. They were keen to cre-
ate scripts that included references to sophisticated concepts from all
areas of human knowledge, and calculus was particularly high on the
agenda because two of the writers were devotees of mathematics. These
two nerds were responsible for the r dr r joke in particular and deserve
credit more generally for making *The Simpsons* a vehicle for mathemat-
ical tomfoolery.

The first nerd was Mike Reiss, whom I met when I spent a few days
with the writers of *The Simpsons*. Just like Maggie, he displayed his
mathematical talents while playing with building blocks as a toddler.
He distinctly recalls a moment when he observed that the blocks
obeyed a binary law, inasmuch as two of the smallest blocks were the
same size as one medium block, while two of the medium blocks were
the same size as one large block, and two of the large blocks equaled
one very large block.

As soon as he could read, Reiss's mathematical interest matured
into a love of puzzles. In particular, he was captivated by the books of
Martin Gardner, the twentieth century's greatest recreational mathe-
matician. Gardner's playful approach to puzzles appealed to both
young and old, or as one of his friends once put it: "Martin Gardner
has turned thousands of children into mathematicians, and thou-
sands of mathematicians into children."

Reiss began with *The Unexpected Hanging and Other Mathematical
Diversions* and then spent all his pocket money on other puzzle books
by Gardner. At the age of eight, he wrote to Gardner explaining that
he was a fan and pointing out a neat observation concerning *palin-
dromic square numbers*, namely that they tend to have an odd number
of digits. Palindromic square numbers are simply square numbers that
are the same when written back to front, such as 121 (11^2) or 5,221,225

$(2,285^2)$. The eight-year-old was absolutely correct, because there are thirty-five such numbers less than 100 billion, and only one of them—698,896 (836^2)—has an even number of digits.

Reiss reluctantly admitted to me that his letter to Gardner also contained a question. He asked if there was a finite or infinite supply of *prime numbers*. He now looks back on the question with some embarrassment: "I can visualize the letter so perfectly, and that's a real stupid, naïve question."

Most people would consider that Reiss is being rather harsh on his eight-year-old self, because the answer is not at all obvious. The question is based on the fact that each whole number has *divisors*, which are those numbers that will divide into it without any remainder. A prime number is notable because it has no divisors other than 1 and the number itself (so-called trivial divisors). Thus, 13 is a prime number because it has no non-trivial divisors, but 14 is not, because it can be divided by 2 and 7. All numbers are either prime (e.g., 101) or can be broken down into prime divisors (e.g., $102 = 2 \times 3 \times 17$). Between 0 and 100 there are 25 prime numbers, but between 100 and 200 there are only 21 primes, and between 200 and 300 there are only 16 primes, so they certainly seem to become rarer. However, do we eventually run out of primes, or is the list of primes endless?

Gardner was happy to point Reiss toward a proof by the ancient Greek scholar Euclid.* Working in Alexandria around 300 B.C., Euclid was the first mathematician to prove that there existed an infinity of primes. Perversely, he achieved this result by assuming the exact opposite and employing a technique known as *proof by contradiction* or *reductio ad absurdum*. One way to interpret Euclid's approach to the problem is to begin with the following bold assertion:

Assume that the number of primes is finite
and all these primes have been compiled into a list:

$$p_1, p_2, p_3, \ldots, p_n.$$

* Incidentally, and coincidentally, Gardner was living on Euclid Avenue when he replied that Euclid had the answer to Reiss's question.

We can explore the consequences of this statement by multiplying all the primes on the list and then adding 1, which creates a new number: $N = p_1 \times p_2 \times p_3 \times \cdots \times p_n + 1$. This new number N is either a prime number or not a prime number, but either way it contradicts Euclid's initial assertion:

(a) If N is a prime number, then it is missing from the original list. Therefore, the claim to have a complete list is clearly false.

(b) If N is not a prime number, then it must have prime divisors. These divisors must be new primes, because the primes on the original list will leave a remainder of 1 when divided into N. Therefore, again, the claim to have a complete list is clearly false.

In short, Euclid's original assertion is false—his finite list does not contain all the prime numbers. Moreover, any attempt to repair the claim by adding some new prime numbers to the list is doomed to failure, because the entire argument can be repeated to show that the enhanced list of primes is still incomplete. This argument proves that any list of prime numbers is incomplete, which implies that there must be an infinity of primes.

As the years passed, Reiss developed into a very accomplished young mathematician and earned a place on the state of Connecticut mathematics team. At the same time, he was developing a flair for comedy writing and was even receiving some recognition for his talent. For example, when his dentist boasted to him about how he always submitted witty, but unsuccessful, entries for *New York* magazine's weekly humor competition, young Michael trumped him by announcing that he had also entered and been rewarded for his efforts. "I would win it a lot as a kid," said Reiss. "I didn't realize I was competing against professional comedy writers. I found out later all the *Tonight Show* writers would be entering the contest and here I was, aged ten, and I would win it, too."

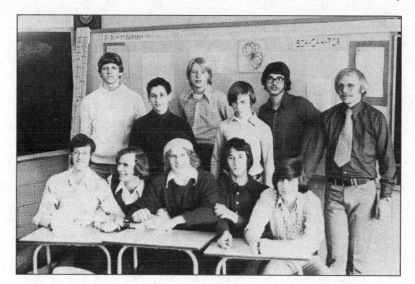

Mike Reiss (second in the back row) on the 1975 Bristol Eastern High School Mathematics Team. As well as Mr. Kozikowski, who coached the team and appears in the photograph, Reiss had many other mathematical mentors. For example, Reiss's geometry teacher was Mr. Bergstromm. In an episode titled "Lisa's Substitute" (1991), Reiss showed his gratitude by naming Lisa's inspirational substitute teacher Mr. Bergstromm.

When Reiss was offered a place at Harvard University, he had to decide between majoring in mathematics or English. In the end, his desire to be a writer eclipsed his passion for numbers. Nevertheless, his mathematical mind always remained active and he never forgot his first love.

The other gifted mathematician who helped give birth to *The Simpsons* went through a similar set of childhood experiences. Al Jean was born in Detroit in 1961, a year after Mike Reiss. He shared Reiss's love of Martin Gardner's puzzles and was also a mathlete. In 1977, in a Michigan mathematics competition, he tied for third place out of twenty thousand students from across the state. He even attended hothousing summer camps at Lawrence Technological University and the University of Chicago. These camps had been established during the cold war in an effort to create mathematical minds that could

rival those emerging from the Soviet network of elite mathematics training programs. As a result of this intense training, Jean was accepted to study mathematics at Harvard when he was only sixteen years old.

Once at Harvard, Jean was torn between his mathematical studies and a newly discovered interest in comedy writing. He was eventually accepted as a member of the *Harvard Lampoon*, the world's longest-running humor magazine, which meant he spent less time thinking about mathematical proofs and more time thinking up jokes.

Reiss was also a writer for the *Harvard Lampoon*, which had become famous across America after it published *Bored of the Rings* in 1969, a parody of Tolkien's classic. This was followed in the 1970s by a live theater show called *Lemmings*, and then a radio show titled *The National Lampoon Radio Hour*. Reiss and Jean forged a friendship and writing partnership at the *Harvard Lampoon*, and it was this college experience that gave them the confidence to start applying for jobs as TV comedy writers when they eventually graduated.

Their big break came when they were hired as writers on *The Tonight Show*, where their innate nerdiness was much appreciated. As well as being an amateur astronomer, host Johnny Carson was a part-time debunker of pseudoscience, who from time to time donated $100,000 to the James Randi Educational Foundation, an organization dedicated to rational thinking. Similarly, when Reiss and Jean left *The Tonight Show* and joined the writing team for *It's Garry Shandling's Show*, they discovered that Shandling himself had majored in electrical engineering at the University of Arizona before dropping out to pursue a career in comedy.

Then, when Reiss and Jean joined the writing team for the first season of *The Simpsons*, they felt that this was the ideal opportunity to express their love of mathematics. *The Simpsons* was not just an entirely new show, but also an entirely new format, namely a prime-time animated sitcom aimed at all ages. The usual rules did not apply,

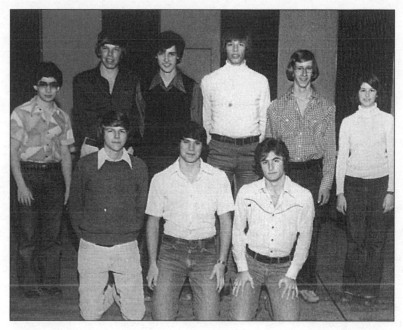

A photograph of the mathematics team from the 1977 Harrison High School yearbook. The caption identifies Al Jean as the third student in the back row and notes that he won gold and third place in the Michigan state competition. Jean's most influential teacher was the late Professor Arnold Ross, who ran the University of Chicago Summer program.

which perhaps explains why Reiss and Jean were allowed—and indeed encouraged—to nerdify episodes whenever possible.

In the first and second seasons of *The Simpsons*, Reiss and Jean were key members of the writing team, which enabled them to include several significant mathematical references. However, the mathematical heart of *The Simpsons* beat even stronger in the third season and beyond, because the two *Harvard Lampoon* graduates were promoted to the roles of executive producers.

This was a crucial turning point in the mathematical history of *The Simpsons*. From this point onward, not only could Jean and Reiss continue to parachute their own mathematical jokes into the episodes, but they could also begin to recruit other comedy writers with strong

mathematical credentials. Over the coming years, *The Simpsons* script-editing sessions would occasionally take on an atmosphere reminiscent of a geometry tutorial or a seminar on number theory, and the resulting shows would contain more mathematical references than any other series in the history of television.

ARE YOU π-CURIOUS?

· • · • · • · • · • ·

S ometimes the mathematical references inserted in *The Simpsons* are highly obscure, and indeed we will encounter some of them in the next chapter. On other occasions, the jokes inserted by Reiss, Jean, and their colleagues incorporate mathematical concepts that will be familiar to many viewers. A classic example is the number π, which has made several guest appearances in the series over the past two decades.

Just in case you have forgotten, π is simply the ratio of the circumference of a circle to its diameter. Anyone can obtain a rough sense of π's value by drawing a circle, and then cutting three pieces of string equal to the circle's diameter. The three stringlets fit almost perfectly around the circumference, with just a small gap remaining. To be more precise, roughly 3.14 diameters are equal to the circumference, which is the approximate value of π. This relationship between π and a circle's circumference and diameter is summarized in the following equation:

$$\text{circumference} = \pi \times \text{diameter}$$

$$C = \pi d$$

Since the diameter of a circle is double the length of the radius, the equation can also be expressed in the following way:

$$\text{circumference} = 2 \times \pi \times \text{radius}$$

$$C = 2\pi r$$

This is perhaps the first small step that we take as children from simple arithmetic to more complex ideas. I can still remember my

8 · SIMON SINGH

own first encounter with π, because it left me flabbergasted. Mathematics was no longer just about long multiplication and vulgar fractions, but was now also about something esoteric, elegant, and universal; every circle in the world obeyed the π equation, from Ferris wheels to Frisbees, from chapatis to the Earth's equator.

And, as well as predicting the circumference of a circle, π can also be used to calculate the area within the circumference:

$$\text{Area} = \pi \times \text{radius}^2$$

$$A = \pi r^2$$

There is a pun-based joke referring to this particular equation in the episode "Simple Simpson" (2004). In this episode, Homer disguises himself as a superhero named Simple Simon, Your Friendly Neighborhood Pie Man, and punishes evildoers by flinging pies in their faces. The Pie Man's first act of superheroism is to deliver retribution to someone who bullies Lisa. This is witnessed by a character named Drederick Tatum, Springfield's famous ex-boxer, who proclaims: "We all know 'πr^2', but today 'pie are justice'. I welcome it."

Although Al Jean introduced this joke into the script, he is reluctant to take all the credit (or perhaps all the blame): "Oh, that's an old joke. That was definitely a joke I'd heard years ago. The guy who should get credit is somebody from 1820."

Jean is exaggerating when he says 1820, but Tatum's words do indeed offer a fresh twist on a traditional joke that has been handed down from one generation of mathematicians to the next. The most famous version of the joke appeared in 1951 on the American comedy series *The George Burns and Gracie Allen Show*. During an episode titled "Teenage Girl Spends the Weekend," Gracie comes to the aid of young Emily, who is complaining about her homework:

EMILY: I wish geometry were as easy as Spanish.
GRACIE: Well maybe I can help you. Say something to me in geometry.

EMILY: Say something in geometry?
GRACIE: Yeah, go ahead.
EMILY: Well, alright. Errr . . . πr^2.
GRACIE: Is that what they teach you in school these days? πr^2?
EMILY: Yeah.
GRACIE: Emily. Pie are round. Cookies are round. Crackers are square.

These jokes rely on the fact that "pie" and "π" are homophones, which lends itself to punnery. Hence, comedians owe a debt of gratitude to William Jones, who was responsible for popularizing the symbol π. This eighteenth-century mathematician, along with many others, earned his living by offering tutorials in London's coffee houses in exchange for a penny. While he was plying his trade at these so-called Penny Universities, Jones was also working on a major treatise titled *A New Introduction to the Mathematics*, and this was the first book to employ the Greek letter π in the context of discussing the geometry of circles. Thus the potential for new mathematical punning was born. Jones chose π because it is the initial letter of the Greek word περιφέρεια (*periphereia*), meaning circumference.

• • •

Three years before the appearance of the π gag in "Simple Simpson," the writers of *The Simpsons* had included another reference to π in the episode "Bye, Bye, Nerdie" (2001). This time, instead of resurrecting an old joke, the writers created some genuinely new π humor, albeit based on a curious incident from π's history. To appreciate this joke, it is first necessary to remind ourselves of the value of π and how it has been measured over the centuries.

I stated earlier that π = 3.14 is only an approximation. This is because π is known as an *irrational number*, which means that it is impossible to specify its value with perfect accuracy because its decimal places continue to infinity without any pattern. Nevertheless, the challenge for early mathematicians was to go beyond the rough and

ready estimate of 3.14, and to pin down this elusive number by measuring it as accurately as possible.

The first serious attempt at a more precise measurement of π was made by Archimedes in the third century B.C. He could see that an accurate measurement of π depended on an accurate measurement of the circumference of a circle. This is inevitably tricky, because circles are built from sweeping curves, not straight lines. Archimedes's great breakthrough was to sidestep the problem of measuring curves by approximating the shape of a circle with straight lines.

Consider a circle with diameter (d) equal to 1 unit. We know that $C = \pi d$, which means it has a circumference (C) equal to π. Next draw two squares, one around the outside of the circle and one tucked inside the circle.

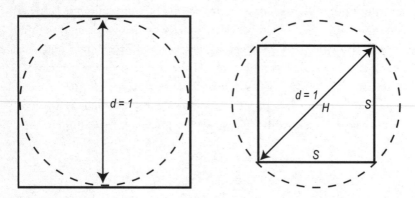

The actual circumference of the circle must, of course, be smaller than the perimeter of the large square and larger than the perimeter of the small square. So, if we measure the perimeters of the squares, we can obtain upper and lower bounds on the circumference.

The perimeter of the large square is easy to measure, because each side is the same length as the circle's diameter, which we know to be equal to 1 unit. Therefore the perimeter of the large square measures 4×1 units = 4 units.

The perimeter of the small square is a little trickier to fathom, but we can pin down the length of each side by using the Pythagorean theorem. Conveniently, the diagonal of the square and two of its sides

form a right-angled triangle. The hypotenuse (H) is not only equal in length to the diagonal of the square, but it is also as long as the circle's diameter, namely 1 unit. The Pythagorean theorem states that the square of the hypotenuse is equal to the sum of the squares of the other two sides. If we label the sides of the square S, then this means that $H^2 = S^2 + S^2$. If $H = 1$, then the other two sides must each have a length of $1/\sqrt{2}$ units. Therefore the perimeter of the small square measures $4 \times 1/\sqrt{2}$ units = 2.83 units.

As the circumference of the circle must be less than the perimeter of the large square, yet greater than the perimeter of the small square, we can now declare with confidence that the circumference must be between 2.83 and 4.00.

Remember, we stated earlier that a circle with a diameter of 1 unit has a circumference equal to π, therefore the value of π must lie between 2.83 and 4.00.

This was Archimedes's great discovery.

You might not be impressed, because we already know that π is roughly 3.14, so a lower bound of 2.83 and an upper bound of 4.00 are not very useful. However, the power of Archimedes's breakthrough was that it could be refined. For, instead of trapping the circle between a small and a large square, he then trapped the circle between a small and a large hexagon. If you have ten minutes to spare and some confidence with numbers, then you can prove for yourself that measuring the perimeters of the two hexagons implies that π must be more than 3.00 and less than 3.464.

A hexagon has more sides than a square, which makes it a better approximation to a circle. This explains why it delivers tighter limits for the value of π. Nonetheless, there is still a large margin of error here. So, Archimedes persisted, repeating his method with increasingly multisided polygons, using shapes that approximated ever closer to a circle.

Indeed, Archimedes persevered to the extent that he eventually trapped a circle between two 96-sided polygons, and he calculated the perimeters of both shapes. This was an impressive feat, particularly bearing in mind that Archimedes did not have modern algebraic notation, he had no knowledge of decimals, and he had to do all his lengthy calculations by hand. But it was worth the effort, because he was able to trap the true value of π between 3.141 and 3.143.

Fast-forwarding eight centuries to the 5th century A.D., the Chinese mathematician Zu Chongzhi took the Archimedean approach another step—or another 12,192 steps to be exact—and used two 12,288-sided polygons to prove that the value of π lay between 3.1415926 and 3.1415927.

The polygonal approach reached its zenith in the seventeenth century with mathematicians such as the Dutchman Ludolph van Ceulen, who employed polygons with more than 4 billion billion sides to measure π to 35 decimal places. After he died in 1610, the engraving on his tombstone explained that π was more than 3.14159265358979 323846264338327950288 and less than 3.141592653589793238462 64338327950289.

As you may have deduced by this point, measuring π is a tough job, and one that would carry on for eternity. This is because π is an irrational number. So, is there any point in calculating π to any greater accuracy? We will return to this question later, but for the time being we have covered enough essential π information to provide the context for the mathematical joke in the episode "Bye, Bye, Nerdie."

The plot of the episode centers on the bullying of nerds, which continues to be a global problem despite the wise words of the Amer-

ican educationalist Charles J. Sykes, who wrote in 1995: "Be nice to nerds. Chances are you'll end up working for one." When Lisa endeavors to explain why bullies cannot resist picking on nerds, she suspects that nerds are emitting a scent that marks them out as victims. She persuades some of her nerdiest school friends to work up a sweat, which she collects and analyzes. After a great deal of research, she finally isolates a pheromone emitted by every "geek, dork, and four-eyes" that could be responsible for attracting bullies. She names this pheromone *poindextrose*, in honor of Poindexter, the boy genius character created for the 1959 cartoon series *Felix the Cat*.

In order to test her hypothesis, she rubs some poindextrose on the jacket of the formidable ex-boxer Drederick Tatum, who is visiting her school. Sure enough, the pheromone attracts Nelson Muntz, the school bully. Even though Nelson knows it is preposterous and inappropriate for a schoolyard bully to attack an ex-boxer, he cannot resist the allure of poindextrose and even gives Tatum a wedgie. Lisa has the proof she needs.

Excited by her discovery, Lisa decides to deliver a paper ("Airborne Pheromones and Aggression in Bullies") at the 12th Annual Big Science Thing. The conference is hosted by John Nerdelbaum Frink Jr., Springfield's favorite absentminded professor. It is Frink's responsibility to introduce Lisa, but the atmosphere is so intense and the audience so excitable that he struggles to bring the conference to order. Frustrated and desperate, Frink eventually calls out: "Scientists . . . Scientists, please! I'm looking for some order. Some order, please, with the eyes forward . . . and the hands neatly folded . . . and the paying of attention . . . *Pi is exactly three!*"

Suddenly, the noise stops. Professor Frink's idea worked, because he correctly realized that declaring an exact value for π would stun an audience of geeks into silence. After thousands of years of struggling to measure π to incredible accuracy, how dare anybody replace 3.1415 9265358979323846264338327950288419716939937510582097494 4592307816406286208998628034825342117067982148086513… with 3!

The scene echoes a limerick written by Professor Harvey L. Carter (1904–94), a historian at Colorado College:

> *'Tis a favorite project of mine,*
> *A new value of pi to assign.*
> *I would fix it at 3*
> *For it's simpler, you see,*
> *Than 3 point 1 4 1 5 9.*

However, Frink's outrageous statement was not based on Carter's whimsical limerick. Instead, Al Jean explained that he had suggested the "*Pi is exactly three!*" line because he had recently read about an incident that took place in Indiana in 1897, when politicians attempted to legislate an official (and wildly incorrect) value for π.

The Indiana Pi Bill, officially known as House Bill No. 246, of the 1897 sitting of the Indiana General Assembly was the brainchild of Edwin J. Goodwin, a physician from the town of Solitude in the southwest corner of the state. He had approached the assembly and proposed a bill that focused on his solution to a problem known as "squaring the circle," an ancient problem that had already been proven impossible in 1882. Goodwin's complicated and contradictory explanation contained the following line relating to the diameter of a circle:

". . . the fourth important fact, that the ratio of the diameter and circumference is as five-fourths to four."

The ratio of the diameter to the circumference is equal to π, so Goodwin was effectively dictating a value for π according to the following recipe:

$$\pi = \frac{\text{circumference}}{\text{diameter}} = \frac{4}{5/4} = 3.2$$

Goodwin said that Indiana schools could use his discovery without charge, but that the state and he would share the profits from royalties

charged to other schools who wished to adopt a value of 3.2 for π. Initially, the technical nature of the bill meant that it baffled the politicians, who bounced it from the House of Representatives to the Finance Committee to the Committee on Swamplands and finally to the Committee on Education, where an atmosphere of confusion led to it being passed without any objection.

It was then up to the state senate to ratify the bill. Fortunately, a certain Professor C. A. Waldo, who was then head of the Mathematics Department at Purdue University in West Lafayette, Indiana, happened to be visiting the statehouse during this period to discuss funding for the Indiana Academy of Science. By chance, someone on the funding committee showed him the bill and offered to introduce him to Dr. Goodwin, but Waldo replied that this would not be necessary, as he already knew enough crazy people.

Instead, Professor Waldo worked hard to raise concerns with the senators, who began to ridicule Goodwin and his bill. The *Indianapolis Journal* quoted Senator Orrin Hubbell: "The Senate might as well try to legislate water to run up hill as to establish mathematical truth by law." Consequently, when the bill was debated a second time, there was a successful motion to postpone it indefinitely.

Professor Frink's absurd declaration that π equals 3 is a neat reminder that Goodwin's postponed bill still exists in a filing cabinet in the basement of the Indiana statehouse, waiting for a gullible politician to resuscitate it.

HOMER'S LAST THEOREM

· • · • · • · • · •·

Every so often, Homer Simpson explores his inventing talents. In "Pokey Mom" (2001), for instance, he creates Dr. Homer's Miracle Spine-O-Cylinder, which is essentially a battered trash can with random dents that "perfectly match the contours of the human vertibrains." He promotes his invention as a treatment for back pain, even though there is not a jot of evidence to support his claim. Springfield's chiropractors, who are outraged that Homer might steal their patients, threaten to destroy Homer's invention. This would allow them once again to corner the market in back problems and happily promote their own bogus treatments.

Homer's inventing exploits reach a peak in "The Wizard of Evergreen Terrace" (1998). The title is a play on the Wizard of Menlo Park, the nickname given to Thomas Edison by a newspaper reporter after he established his main laboratory in Menlo Park, New Jersey. By the time he died in 1931, Edison had 1,093 U.S. patents in his name and had become an inventing legend.

The episode focuses on Homer's determination to follow in Edison's footsteps. He constructs various gadgets, ranging from an alarm that beeps every three seconds just to let you know that everything is all right to a shotgun that applies makeup by shooting it directly onto the face. It is during this intense research and development phase that we glimpse Homer standing at a blackboard and scribbling down several mathematical equations. This should not be a surprise, because many amateur inventors have been keen mathematicians, and vice versa.

Consider Sir Isaac Newton, who incidentally made a cameo appearance on *The Simpsons* in an episode titled "The Last Temptation

of Homer" (1993). Newton is one of the fathers of modern mathematics, but he was also a part-time inventor. Some have credited him with installing the first rudimentary flapless cat flap—a hole in the base of his door to allow his cat to wander in and out at will. Bizarrely, there was a second smaller hole made for kittens! Could Newton really have been so eccentric and absentminded? There is debate about the veracity of this story, but according to an account by J. M. F. Wright in 1827: "Whether this account be true or false, indisputably true is it that there are in the door to this day two plugged holes of the proper dimensions for the respective egresses of cat and kitten."

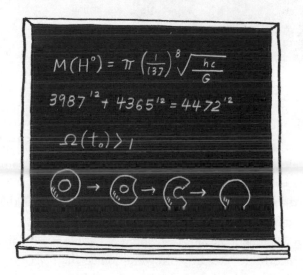

The bits of mathematical scribbling on Homer's blackboard in "The Wizard of Evergreen Terrace" were introduced into the script by David S. Cohen, who was part of a new generation of mathematically minded writers who joined *The Simpsons* in the mid-1990s. Like Al Jean and Mike Reiss, Cohen had exhibited a genuine talent for mathematics at a young age. At home, he regularly read his father's copy of *Scientific American* and toyed with the mathematical puzzles in Martin Gardner's monthly column. Moreover, at Dwight Morrow High School in Englewood, New Jersey, he was co-captain of the mathematics team that became state champions in 1984.

David S. Cohen pictured in the Dwight Morrow High School yearbook of 1984. The running joke was that everyone on the Math Team was co-captain, so that they all could put it on their college applications.

Along with high school friends David Schiminovich and David Borden, he formed a teenage gang of computer programmers called the Glitchmasters, and together they created FLEET, their very own computer language, designed for high speed graphics and gaming on the Apple II Plus. At the same time, Cohen maintained an interest in comedy writing and comic books. He pinpoints the start of his professional career to cartoons he drew while in high school that he sold to his sister for a penny.

Even when he went on to study physics at Harvard University, he maintained his interest in writing and joined the *Harvard Lampoon*, eventually becoming president. Over time, like Al Jean, Cohen's passion for comedy and writing overtook his love of mathematics and physics, and he rejected a career in academia in favor of becoming a writer for *The Simpsons*. Every so often, however, Cohen returns to his roots by smuggling mathematics into the TV series. The symbols and diagrams on Homer's blackboard provide a good example of this.

Cohen was keen in this instance to include scientific equations alongside the mathematics, so he contacted one of his high school friends, David Schiminovich, who had stayed on the academic path to become an astronomer at Columbia University.

The first equation on the board is largely Schiminovich's work, and

it predicts the mass of the Higgs boson, $M(H^0)$, an elementary parti-cle that that was first proposed in 1964. The equation is a playful combination of various fundamental parameters, namely the Planck constant, the gravitational constant, and the speed of light. If you look up these numbers and plug them into the equation,* it predicts a mass of 775 giga-electron-volts (GeV), which is substantially higher than the 125 GeV estimate that emerged when the Higgs boson was discovered in 2012. Nevertheless, 775 GeV was not a bad guess, par-ticularly bearing in mind that Homer is an amateur inventor and he performed this calculation fourteen years before the physicists at CERN, the European Organization for Nuclear Research, tracked down the elusive particle.

The second equation is . . . going to be set aside for a moment. It is the most mathematically intriguing line on the board and worth the wait.

The third equation concerns the density of the universe, which has implications for the fate of the universe. If $\Omega(t_0)$ is bigger than 1, as initially written by Homer, then this implies that the universe will eventually implode under its own weight. In an effort to reflect this cosmic consequence at a local level, there appears to be a minor im-plosion in Homer's basement soon after viewers see this equation.

Homer then alters the inequality sign, so the equation changes from $\Omega(t_0) > 1$ to $\Omega(t_0) < 1$. Cosmologically, the new equation sug-gests a universe that expands forever, resulting in something akin to an eternal cosmic explosion. The storyline mirrors this new equation, because there is a major explosion in the basement as soon as Homer reverses the inequality sign.

The fourth line on the blackboard is a series of four mathematical diagrams that show a doughnut transforming into a sphere. This line relates to an area of mathematics called *topology*. In order to under-stand these diagrams, it is necessary to know that a square and a circle are identical to each other according to the rules of topology. They are

* Hints for those brave enough to do the calculation: Do not forget that $E = mc^2$ and remember to convert the result to GeV energy units.

considered to be *homeomorphic*, or topological twins, because a square drawn on a rubber sheet can be transformed into a circle by careful stretching. Indeed, topology is sometimes referred to as "rubber sheet geometry."

Topologists are not concerned with angles and lengths, which are clearly altered by stretching the rubber sheet, but they do care about more fundamental properties. For example, the fundamental property of a letter **A** is that it is essentially a loop with two legs. The letter **R** is also just a loop with two legs. Hence, the letters **A** and **R** are homeomorphic, because an **A** drawn on a rubber sheet can be transformed into an **R** by careful stretching.

However, no amount of stretching can transform a letter **A** into a letter **H**, because these letters are fundamentally different from each other by virtue of **A** consisting of one loop and two legs and **H** consisting of zero loops. The only way to turn an **A** into an **H** is to cut the rubber sheet at the peak of the **A**, which destroys the loop. However, cutting is forbidden in topology.

The principles of rubber sheet geometry can be extended into three dimensions, which explains the quip that a topologist is someone who cannot tell the difference between a doughnut and a coffee cup. In other words, a coffee cup has just one hole, created by the handle, and a doughnut has just one hole, in its middle. Hence, a coffee cup made of a rubbery clay could be stretched and twisted into the shape of a doughnut. This makes them homeomorphic.

By contrast, a doughnut cannot be transformed into a sphere, because a sphere lacks any holes, and no amount of stretching, squeezing, and twisting can remove the hole that is integral to a doughnut. Indeed, it is a proven mathematical theorem that a doughnut is topologically distinct from a sphere. Nevertheless, Homer's blackboard scribbling seems to achieve the impossible, because the diagrams show the successful transformation of a doughnut into a sphere. How?

Although cutting is forbidden in topology, Homer has decided that nibbling and biting are acceptable. After all, the initial object is a doughnut, so who could resist nibbling? Taking enough nibbles out of the doughnut turns it into a banana shape, which can then be re-

shaped into a sphere by standard stretching, squeezing, and twisting. Mainstream topologists might not be thrilled to see one of their cherished theorems going up in smoke, but a doughnut and a sphere are identical according to Homer's personal rules of topology. Perhaps the correct term is not *homeomorphic*, but rather *Homermorphic*.

• • •

The second line on Homer's blackboard is perhaps the most interesting, as it contains the following equation:

$$3{,}987^{12} + 4{,}365^{12} = 4{,}472^{12}$$

The equation appears to be innocuous at first sight, unless you know something about the history of mathematics, in which case you are about to smash up your slide rule in disgust. For Homer seems to have achieved the impossible and found a solution to the notorious mystery of Fermat's last theorem!

Pierre de Fermat first proposed this theorem in about 1637. Despite being an amateur who only solved problems in his spare time, Fermat was one of the greatest mathematicians in history. Working in isolation at his home in southern France, his only mathematical companion was a book called *Arithmetica*, written by Diophantus of Alexandria in the third century A.D. While reading this ancient Greek text, Fermat spotted a section on the following equation:

$$x^2 + y^2 = z^2$$

This equation is closely related to the Pythagorean theorem, but Diophantus was not interested in triangles and the lengths of their sides. Instead, he challenged his readers to find whole number solutions to the equation. Fermat was already familiar with the techniques required to find such solutions, and he also knew that the equation has an infinite number of solutions. These so-called Pythagorean triple solutions include

$$3^2 + 4^2 = 5^2$$

$$5^2 + 12^2 = 13^2$$

$$133^2 + 156^2 = 205^2$$

So, bored with Diophantus' puzzle, Fermat decided to look at a variant. He wanted to find whole number solutions to this equation:

$$x^3 + y^3 = z^3$$

Despite his best efforts, Fermat could only find trivial solutions involving a zero, such as $0^3 + 7^3 = 7^3$. When he tried to find more meaningful solutions, the best he could offer was an equation that was out of kilter by just one, such as $6^3 + 8^3 = 9^3 - 1$.

Moreover, when Fermat further increased the power to which x, y, and z are raised, his efforts to find a set of solutions were thwarted again and again. He began to think that it was impossible to find whole number solutions to any of the following equations:

$$x^3 + y^3 = z^3$$

$$x^4 + y^4 = z^4$$

$$x^5 + y^5 = z^5$$

$$x^6 + y^6 = z^6$$

$$\vdots$$

$$x^n + y^n = z^n, \quad \text{where } n > 2$$

Eventually, however, he made a breakthrough. He did not find a set of numbers that fitted one of these equations, but rather he developed an argument that proved that no such solutions existed. He scribbled a pair of tantalizing sentences in Latin in the margin of his copy of Diophantus's *Arithmetica*. He began by stating that there are no whole number solutions for any of the infinite number of equations above,

and then he confidently added this second sentence: *"Cuius rei demonstrationem mirabilem sane detexi, hanc marginis exiguitas non caperet."* (I have discovered a truly marvelous proof of this, which this margin is too narrow to contain.)

Pierre de Fermat had found a proof, but he did not bother to write it down. This is perhaps the most frustrating note in the history of mathematics, particularly as Fermat took his secret to the grave.

Fermat's son Clément-Samuel later found his father's copy of *Arithmetica* and noticed this intriguing marginal note. He also spotted many similar marginal jottings, because Fermat had a habit of stating that he could prove something remarkable, but rarely wrote down the proof. Clément-Samuel decided to preserve these notes by publishing a new edition of *Arithmetica* in 1670, which included all his father's marginal notes next to the original text. This galvanized the mathematical community into finding the missing proofs associated with each claim, and one by one they were able to confirm that Fermat's claims were correct. Except, nobody could prove that there were no solutions to the equation $x^n + y^n = z^n$ ($n > 2$). Hence, this equation became known as Fermat's last theorem, because it was the only one of Fermat's claims that remained unproven.

As each decade passed without a proof, Fermat's last theorem became even more infamous, and the desire for a proof increased. Indeed, by the end of the nineteenth century, the problem had caught the imaginations of many people outside of the mathematical community. For example, when the German industrialist Paul Wolfskehl died in 1908, he bequeathed 100,000 marks (equivalent to $1 million today) as a reward for anyone who could prove Fermat's last theorem. According to some accounts, Wolfskehl despised his wife and the rest of his family, so his will was designed to snub them and reward mathematics, a subject that he had always loved. Others argue that the Wolfskehl Prize was his way of thanking Fermat, because it is said his fascination with the problem had given him a reason to live when he was on the verge of suicide.

Whatever the motives, the Wolfskehl Prize catapulted Fermat's last theorem into public notoriety, and in time it even became part of

popular culture. In "The Devil and Simon Flagg," a short story written by Arthur Porges in 1954, the titular hero makes a Faustian pact with the Devil. Flagg's only hope of saving his soul is to pose a question that the Devil cannot answer, so he asks for a proof of Fermat's last theorem. After accepting defeat, the Devil said: "Do you know, not even the best mathematicians on other planets—all far ahead of yours—have solved it? Why, there's a chap on Saturn—he looks something like a mushroom on stilts—who solves partial differential equations mentally; and even he's given up."

Fermat's last theorem has also appeared in novels (*The Girl Who Played with Fire* by Stieg Larsson), in films (*Bedazzled* with Brendan Fraser and Elizabeth Hurley), and plays (*Arcadia* by Tom Stoppard). Perhaps the theorem's most famous cameo is in a 1989 episode of *Star Trek: The Next Generation* titled "The Royale," in which Captain Jean-Luc Picard describes Fermat's last theorem as "a puzzle we may never solve." However, Captain Picard was wrong and out of date, because the episode was set in the twenty-fourth century and the theorem was actually proven in 1995 by Andrew Wiles at Princeton University.*

Wiles had dreamed about tackling Fermat's challenge ever since he was ten years old. The problem then obsessed him for three decades, which culminated in seven years of working in complete secrecy. Eventually, he delivered a proof that the equation $x^n + y^n = z^n$ $(n > 2)$ has no solutions. When his proof was published, it ran to 130 dense pages of mathematics. This is interesting partly because it indicates the mammoth scale of Wiles's achievement, and partly because his chain of logic is far too sophisticated to have been discovered in the seventeenth century. Indeed, Wiles had used so many modern tools and techniques that his proof of Fermat's last theorem cannot be the approach that Fermat had in mind.

This point was alluded to in a 2010 episode of the BBC TV series *Doctor Who*. In "The Eleventh Hour," the actor Matt Smith debuts as

* I should point out that this is a story that is close to my heart, as I have written a book and directed a BBC documentary about Fermat's last theorem and Andrew Wiles's proof. Coincidentally, during a brief stint at Harvard University, Wiles lectured Al Jean, who went on to write for *The Simpsons*.

the regenerated Eleventh Doctor, who must prove his credentials to a group of geniuses in order to persuade them to take his advice and save the world. Just as they are about to reject him, the Doctor says: "But before you do, watch this. Fermat's theorem. The proof. And I mean the real one. Never been seen before." In other words, the Doctor is tacitly acknowledging that Wiles's proof exists, but he rightly does not accept that it is Fermat's proof, which he considers to be the "real one." Perhaps the Doctor went back to the seventeenth century and obtained the proof directly from Fermat.

So, to summarize, in the seventeenth century, Pierre de Fermat states that he can prove that the equation $x^n + y^n = z^n$ ($n > 2$) has no whole number solutions. In 1995, Andrew Wiles discovers a new proof that verifies Fermat's statement. In 2010, the Doctor reveals Fermat's original proof. Everyone agrees that the equation has no solutions.

Thus, in "The Wizard of Evergreen Terrace," Homer appears to have defied the greatest minds across almost four centuries. Fermat, Wiles, and even the Doctor state that Fermat's equation has no solutions, yet Homer's blackboard jottings present us with a solution:

$$3{,}987^{12} + 4{,}365^{12} = 4{,}472^{12}$$

You can check it yourself with a calculator. Raise 3,987 to the twelfth power. Add it to 4,365 to the twelfth power. Take the twelfth root of the result and you get 4,472.

Or at least that is what you get on any calculator that can squeeze only ten digits onto its display. However, if you have a more accurate calculator, something capable of displaying a dozen or more digits, then you will find a different answer. The actual value for the third term in the equation is closer to

$$3{,}987^{12} + 4{,}365^{12} = 4{,}472.000000007057617187 5^{12}$$

So what is going on? Homer's equation is a so-called near-miss solution to Fermat's equation, which means that the numbers 3,987, 4,365, and 4,472 very nearly make the equation balance—so much so

that the discrepancy is hardly discernible. However, in mathematics you either have a solution or you do not. A near-miss solution is ultimately no solution at all, which means that Fermat's last theorem remains intact.

David S. Cohen had merely played a mathematical prank on those viewers who were quick enough to spot the equation and clued-up enough to recognize its link with Fermat's last theorem. By the time this episode aired in 1998, Wiles's proof had been published for three years, so Cohen was well aware that Fermat's last theorem had been conquered. He even had a personal link to the proof, because he had attended some lectures by Ken Ribet while he was a graduate student at the University of California, Berkeley, and Ribet had provided Wiles with a pivotal stepping-stone in his proof of Fermat's last theorem.

Cohen obviously knew that Fermat's equation had no solutions, but he wanted to pay homage to Pierre de Fermat and Andrew Wiles by creating a solution that was so close to being correct that it would apparently pass the test if checked with only a simple calculator. In order to find his pseudosolution, he wrote a computer program that would scan through values of x, y, z, and n until it found numbers that almost balanced. Cohen finally settled on $3,987^{12} + 4,365^{12} = 4,472^{12}$ because the resulting margin of error is minuscule—the left side of the equation is only 0.000000002 percent larger than the right side.

As soon as the episode aired, Cohen patrolled the online message boards to see if anybody had noticed his prank. He eventually spotted a posting that read: "I know this would seem to disprove Fermat's last theorem, but I typed it in my calculator and it worked. What in the world is going on here?"

He was delighted that budding mathematicians around the world might be intrigued by his mathematical paradox: "I was so happy, because my goal was to get enough accuracy so that people's calculators would tell them the equation worked."

Cohen is very proud of his blackboard in "The Wizard of Evergreen Terrace." In fact, he derives immense satisfaction from all the mathematical tidbits he has introduced into *The Simpsons* over the

years: "I feel great about it. It's very easy working in television to not feel good about what you do on the grounds that you're causing the collapse of society. So, when we get the opportunity to raise the level of discussion—particularly to glorify mathematics—it cancels out those days when I've been writing those bodily function jokes."

CHAPTER 4

THE PUZZLE OF
MATHEMATICAL HUMOR

. • . • . • . • . • . • .

A s might be expected, many of the mathematical writers of *The Simpsons* have a passion for puzzles. Naturally, this love of puzzles has found its way into various episodes.

For example, the world's most famous puzzle, the Rubik's Cube, crops up in "Homer Defined" (1991). The episode features a flashback to 1980, the year the cube was first exported from Hungary, when a younger Homer attends a nuclear safety training session. Instead of paying attention to the instructor's advice on what to do in the event of a meltdown, he is focused on his brand-new cube and cycling through some of the 43,252,003,274,489,856,000 permutations in order to find the solution.

Rubik's Cubes have also appeared in the episodes "Hurricane Neddy" (1996) and "НОМЯ" (2001), and the Rubik's Cube was invoked as a threat by Moe Szyslak in "Donnie Fatso" (2010). As proprietor and bartender of Moe's Tavern, Moe regularly receives prank calls from Bart asking to speak with particular people with fictitious and embarrassing names. This prompts Moe to call out to everyone in the bar with lines such as "Has anyone seen Maya Normousbutt?" and "Amanda Hugginkiss? Hey, I'm looking for Amanda Hugginkiss." The "Donnie Fatso" episode is notable because Moe receives a phone call that is not a prank and not from Bart. Instead, Marion Anthony D'Amico, head of Springfield's notorious D'Amico crime family, is calling. Fat Tony, as he is known to his friends (and enemies), simply wants Moe to find out if his Russian friend Yuri Nator is in the bar. Assuming that this is another prank by Bart, Moe makes

the mistake of threatening the caller: "I'm gonna chop you into little pieces and make you into a Rubik's Cube which I will never solve!"

A more ancient puzzle appears in "Gone Maggie Gone" (2009), an episode that is partly a parody of Dan Brown's novel *The Da Vinci Code*. The storyline begins with a total solar eclipse, ends with the discovery of the jewel of St. Teresa of Avila, and revolves around the false belief that Maggie is the new messiah. From a puzzle lover's point of view, the episode's most interesting scene concerns Homer, who finds himself trapped on one side of a river with his baby (Maggie), his dog (Santa's Little Helper), and a large bottle of poison capsules.

Homer is desperate to cross the river. There is a boat, but it is flimsy and can only carry Homer and one other item at a time. Of course, he cannot leave Maggie with the poison because the baby might swallow a capsule, and he cannot leave Santa's Little Helper with Maggie in case the dog bites the baby. Hence, Homer's challenge is to work out a sequence of crossings that will allow him to ferry everybody and everything safely to the other side.

As Homer begins to think about this predicament, the animation style changes and the problem is summarized in the style of a medieval illuminated manuscript, accompanied by the words: "How does the fool cross the river with his burdens three?" This is a reference to a medieval Latin manuscript titled *Propositiones ad Acuendos Juvenes* (Problems to Sharpen the Young), which contains the earliest reference to this sort of river-crossing problem. The manuscript is a marvelous compilation of more than fifty mathematical puzzles written by Alcuin of York, regarded by many as the most learned man in eighth-century Europe.

Alcuin poses an identical problem to Homer's dilemma, except that he frames it in terms of a man transporting a wolf, a goat, and a cabbage, and he has to avoid the wolf eating the goat, and the goat eating the cabbage. The wolf is essentially equivalent to Santa's Little Helper, the goat has the same role as Maggie, and the cabbage is in place of the poison.

The solution to Homer's problem, which he works out for himself,

is to start by taking Maggie across the river from the original bank to the destination bank. Then he would return to the original bank to collect the poison, and row back to the destination bank and deposit the poison. He cannot leave the poison with Maggie, so he would bring Maggie back to the original bank and leave her there, while he takes Santa's Little Helper across to the destination bank to join the poison. He would then row back to the original bank to collect Maggie. Finally, he would row to the destination bank to complete the challenge with everyone and everything having safely crossed the river.

Unfortunately, he is unable to fully implement his plan. For when Homer leaves Maggie on the destination bank, at the end of the first stage, she is promptly kidnapped by nuns. This is something that Alcuin failed to factor into his original framework for the problem.

In an earlier episode, "Lisa the Simpson" (1998), a puzzle plays an even more important role by triggering the entire plotline. The story starts in the school cafeteria, where Lisa sits opposite Martin Prince, who is perhaps Springfield's most gifted young mathematician. Indeed, Martin experiences life from an entirely mathematical perspective, as demonstrated in "Bart Gets an F" (1990), in which Bart temporarily befriends Martin and offers him some advice: "From now on, you sit in the back row. And that's not just on the bus. It goes for school and church, too . . . So no one can see what you're doing." Martin then reframes Bart's advice in terms of mathematics: "The potential for mischief varies inversely to one's proximity to the authority figure!" He even jots down the equation that encapsulates Bart's wisdom, in which M represents the potential for mischief and P_A is proximity to an authority figure:

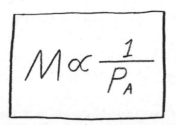

$$M \propto \frac{1}{P_A}$$

In the cafeteria, Martin becomes interested in Lisa's lunch, which is not the usual cafeteria food, but rather a vacuum-packed space-themed meal. When Lisa holds up the lunch and explains that it is "what John Glenn eats when he's not in space," Martin spots a puzzle on the back of the packet. The challenge is to find the next symbol in this sequence:

$$M \heartsuit 8 \bowtie \mathbb{I}$$

Martin solves the puzzle in the blink of an eye, but Lisa remains perplexed. She gradually becomes more and more frustrated as students sitting nearby, including Bart, say that they can identify the next symbol in the sequence. It seems that everyone can work out the answer . . . except Lisa. Consequently, she spends the rest of the episode questioning her intellectual ability and academic destiny. Fortunately, you will not have to suffer such emotional turmoil. I suggest you spend a minute thinking about the puzzle, and then take a look at the answer provided in the caption on the next page.

The lunch puzzle is noteworthy because it helped to shore up the mathematical foundations of *The Simpsons* by playing a part in attracting a new mathematician to the writing team. J. Stewart Burns had studied mathematics at Harvard before embarking on a PhD at the University of California, Berkeley. His doctoral thesis would have involved algebraic number theory or topology, but he abandoned his research before making much progress, and he received a master's degree instead of a PhD. The reason for his premature departure from Berkeley was a job offer from the producers of the sitcom *Unhappily Ever After*. Burns had always harbored ambitions to become a television comedy writer, and this was his big break. Soon he became friends with David S. Cohen, who invited Burns to the offices of *The Simpsons* in order to attend a table reading of an episode, which happened to be "Lisa the Simpson." As the storyline unfolded, including the number-based puzzle, Burns gradually felt that this was where he belonged, working alongside Cohen and the other mathematical writers. While working on *Unhappily Ever After*, Burns was labeled as the

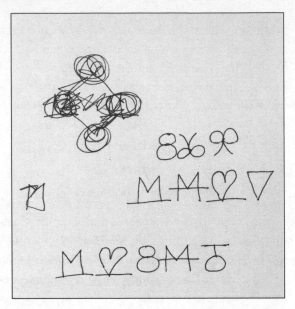

Although David S. Cohen cannot remember if he suggested the puzzle that appears in "Lisa the Simpson," he certainly drew the initial sketches. The puzzle, almost as it appeared in the episode, is in the lower line of this page of doodles. Solving the problem relies on noticing that the left and right halves of each symbol are mirror images of each other. The right half of the first symbol is 1, and the left half is its reflection. The right half of the second symbol is 2, and the left half is its reflection. The pattern continues with 3, 4, and 5, so the sixth symbol would be 6 joined to its own reflection.

The upper line suggests Cohen was thinking of using the sequence (3, 6, 9), but this idea was abandoned, probably because the fourth element, 12, would have required two digits. The middle line, which shows the sequence (1, 4, 2, 7), was also abandoned. It is unclear what the fifth element of the sequence would have been, and Cohen can no longer remember what he had in mind.

geeky mathematician with a master's degree. By contrast, when he joined *The Simpsons*, a master's degree in mathematics was no longer exceptional. Instead of being labeled a geek, he became known as the go-to guy for toilet humor.

After telling me the story about how he was recruited to join *The Simpsons*, Burns drew some parallels between puzzles and jokes, and suggested that they have a great deal in common. Both have carefully constructed setups, both rely on a surprise twist, and both effectively

have punch lines. Indeed, the best puzzles and jokes make you think and smile at the moment of realization. And perhaps that is part of the reason why mathematicians have proved to be such valuable additions to the writing team of *The Simpsons*.

As well as bringing their love of puzzles to the series, the mathematicians have also brought a new way of working. Burns has observed that his nonmathematical colleagues will generally offer fully formed gags created in a moment of inspiration, whereas the mathematicians on the writing team have a tendency to offer raw ideas for jokes. These incomplete jokes are then bounced around the writers' room until they have been resolved.

As well as using this group approach in order to invent jokes, the mathematicians also rely on it to develop storylines. According to Jeff Westbrook, Burns's writing colleague on *The Simpsons* and another ex-mathematician, this enthusiasm for collaboration harks back to their previous careers: "I was a theoretician in computer science, which meant I was sitting around with other guys proving lots of mathematical theorems. When I came here, I was surprised to discover that it is the same kind of thing in the writers' room, because we're also just sitting around throwing out ideas. There's this common creative thread, which is that you're trying to solve problems. In one case, it's a mathematical theorem that's a problem. In the other case, it's a story issue. We want to break the story down and analyze it. What is this story all about?"

With this in mind, I began to ask other writers why they thought so many mathematically inclined writers had found a home at *The Simpsons*. As far as Cohen is concerned, mathematically trained comedy writers are more confident and comfortable exploring the unknown armed only with their intuition: "The process of proving something has some similarity with the process of comedy writing, inasmuch as there's no guarantee you're going to get to your ending. When you're trying to think of a joke out of thin air (that also is on a certain subject or tells a certain story), there's no guarantee that there exists a joke that accomplishes all the things you're trying to do . . . and is funny. Similarly, if you're trying to prove something

mathematically, it's possible that no proof exists. And it's certainly very possible that no proof exists that a person can wrap their mind around. In both cases—finding a joke or proving a theorem—intuition tells you if your time is being invested in a profitable area."

Cohen added that training in mathematics helps give you the intellectual stamina required to write an episode of *The Simpsons*: "It sounds fun and easy, but there's a lot of pounding your brain against the wall. We're trying to tell a complicated story in a short amount of time and there are a lot of logical problems that need to be overcome. It's a big puzzle. It's hard to convince somebody of the pain and suffering that goes into making these shows, because the final product is fast moving and lighthearted. Any given moment in the writing process can be fun, but it's also draining."

For a contrasting perspective, I then spoke to Matt Selman, who had studied English and history before joining the writing team. He identifies himself as the "guy who knows least about mathematics." When asked why *The Simpsons* has become a magnet for people with a penchant for polynomials, Selman agreed with Cohen that the scripts are essentially a puzzle and that complicated episodes are "a real brain burner." Also, according to Selman, the mathematical writers do have a particular trait: "Comedy writers all like to think that we're great observers of the human condition and that we understand pathos, bathos, and all the -athoses. If you wanted to disparage the mathematicians, then you could say that they are cold and heartless, and that they don't have great jokes about what it's like to love or to lose, but I disagree. However, there is a difference. I think the mathematical mind lends itself best to writing very silly jokes, because logic is at the heart of mathematics. The more you think about logic, the more you have fun twisting it and morphing it. I think the logical mind finds great humor in illogic."

Mike Reiss, who worked on the very first episode of *The Simpsons*, agrees: "There are so many wrong theories about humor. Have you ever heard Freud on humor? He's just wrong, wrong, wrong. However, I realized an awful lot of jokes work on false logic. I'll give you

an example. A duck walks into a drugstore and says, 'I'd like some ChapStick, please,' and the druggist says, 'Will you be paying cash for that?' and the duck says, 'No, put the ChapStick on my bill.' Now if incongruity was what made comedy, then it would be funny that a duck walks into a drugstore. It's not incongruity, but it's the fact that there's a false logic to it, which brings all the disparate elements of this story together."

Although the writers have offered various explanations of why mathematical minds lend themselves to writing comedy, one important question remains: Why have all these mathematicians ended up working on *The Simpsons* rather than *30 Rock* or *Modern Family*?

Al Jean has one possible explanation, which emerged as he recalled his teenage years and his relationship with laboratories: "I hated experimental science because I was terrible in the lab and I could never get the results correct. Doing mathematics was very different." In other words, scientists have to cope with reality and all its imperfections and demands, whereas mathematicians practice their craft in an ideal abstract world. To a large extent, mathematicians, like Jean, have a deep desire to be in control, whereas scientists enjoy battling against reality.

According to Jean, the difference between mathematics and science is paralleled by the difference between writing for a live-action sitcom versus writing for an animated series: "I think live-action TV is like experimental science, because actors do it the way they want to do it and you have to stick within those takes. By contrast, animation is more like pure mathematics, because you have real control over exactly the nuance of the line, how the lines are delivered, and so on. We can really control everything. Animation is a mathematician's universe."

· · ·

Some of Mike Reiss's favorite jokes rely on mathematics: "I like these jokes. I savor them. I'm just thinking of this other great joke I heard when I was a kid. It's about these guys who buy a truckload of

watermelons at a dollar apiece and then they go across town and sell them for a dollar apiece. At the end of the day, they have no money and the one guy says, 'We should have bought a bigger truck.'"*

Reiss's vignette is part of a long tradition of mathematical jokes, ranging from trivial one-liners to intricate narratives. Such jokes might seem bizarre to most people, and indeed they are not the sort of material that you might typically hear in a stand-up comedian's usual repertoire, but they are very much part of the culture of mathematics.

The first time I encountered a sophisticated mathematical joke was as a teenager, while reading *Concepts of Modern Mathematics* by Ian Stewart:

An astronomer, a physicist, and a mathematician (it is said) were holidaying in Scotland. Glancing from a train window, they observed a black sheep in the middle of a field. "How interesting," observed the astronomer, "all Scottish sheep are black!" To which the physicist responded, "No, no! *Some* Scottish sheep are black!" The mathematician gazed heavenward in supplication, and then intoned, "In Scotland there exists at least one field, containing at least one sheep, *at least one side of which is black*."

I stored that joke in the back of my head for the next seventeen years and then included it in my first book, which discussed the history and proof of Fermat's last theorem. The joke was a perfect illustration of the rigorous nature of mathematics. Indeed, I was so fond of the joke, I would often recount the tale of the black sheep while lecturing, and afterward members of the audience would sometimes approach me and tell me their own jokes about π, infinity, abelian groups, and Zorn's lemma.

Curious about what else was making my fellow geeks chortle, I

* We can recast this joke in a more mathematical framework by defining P_r as the retail price, P_w as the wholesale price, and N as the number of watermelons that the truck can carry. The profit (\$) formula is $\$ = N \times (P_r - P_w)$. Hence, if $P_w = P_r$, then buying a bigger truck and increasing N clearly makes no difference to the profit.

asked people to e-mail me their favorite mathematical jokes, and for the past decade I have received a steady flow of comedic offerings of a nerdy nature, ranging from dismal puns to rich anecdotes. One of my favorites is a story that was originally told by the historian of mathematics Howard Eves (1911–2004). The tale concerns the mathematician Norbert Wiener, who pioneered cybernetics:

> When [Wiener] and his family moved to a new house a few blocks away, his wife gave him written directions on how to reach it, since she knew he was absentminded. But when he was leaving his office at the end of the day, he couldn't remember where he put her note, and he couldn't remember where the new house was. So he drove to his old neighborhood instead. He saw a young child and asked her, "Little girl, can you tell me where the Wieners moved?" "Yes, Daddy," came the reply, "Mommy said you'd probably be here, so she sent me to show you the way home."

However, anecdotes about famous mathematicians and jokes that rely on the stereotypical characteristics of mathematicians offer only limited insights into the nature of mathematics. They can also become repetitive, as highlighted by this well-known parody:

> An engineer, a physicist, and a mathematician find themselves in an anecdote, indeed an anecdote quite similar to many that you have no doubt already heard. After some observations and rough calculations the engineer realizes the situation and starts laughing. A few minutes later the physicist understands too and chuckles to himself happily as he now has enough experimental evidence to publish a paper. This leaves the mathematician somewhat perplexed, as he had observed right away that he was the subject of an anecdote, and deduced quite rapidly the presence of humor from similar anecdotes, but considers this anecdote to be too trivial a corollary to be significant, let alone funny.

By contrast, there are many jokes in which the humor relies on the actual language and tools of mathematics. For example, there is one well-known joke that was apparently created during an exam by a mischievous student named Peter White from Norwich, England. The question asked students for an expansion of the bracket $(a + b)^n$. If you have not come across this type of question previously, then all you need to know is that it concerns the binomial theorem and the correct answer ought to have explained that the rth term of the expansion has the coefficient $n!/[(r - 1)!(n - r + 1)!]$. This is quite a technical answer, but Peter had a radically different interpretation of the question and an inspired solution:

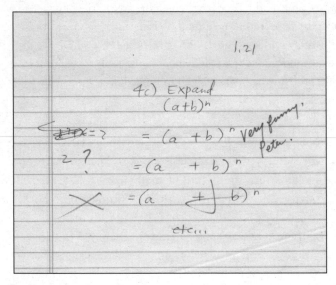

Peter's imaginative answer got me thinking. Creating a mathematical joke requires an understanding of mathematics, and appreciating the joke requires a similar level of understanding. Hence, mathematical jokes test your mathematical knowledge.

With this in mind, I have gathered the world's best mathematical jokes, classified them according to their degree of difficulty, and divided them into five examination papers distributed through the course of this book. As you continue exploring the mathematical hu-

mor that appears in *The Simpsons*, you will encounter these increasingly difficult test papers. Your task is to read through the jokes and see how many make you laugh (or groan), which will help you assess how your mathematical knowledge and sense of humor are developing.

You may turn over your first exam paper . . . now!

Good luck.

ARITHMETICKLE AND GEOMETEEHEEHEE EXAMAMINATION

A FIVE-PART TEST OF HUMOR AND MATHEMATICS

The examination is divided into five separate sections.

The first section is an elementary examination,
consisting of eight simple jokes.*

Subsequent sections are increasingly difficult.

Score yourself according to the number
of laughs/groans you experience

If you laugh/groan enough to score more than
50 percent, then you will have passed that particular
section of the exam.

* These puns, gags, and shaggy-dog stories have been handed down from one
generation of geeks to the next, which means that the names of the writers have sadly
been lost in the mists of time (or the writers have understandably sought anonymity).

EXAMINATION I

ELEMENTARY PAPER

Joke 1 Q: What did the number 0 say to the number 8? 2 points
A: Nice belt!

Joke 2 Q: Why did 5 eat 6? 2 points
A: Because 7 8 9.

Joke 3 Knock, knock. 3 points
Who's there?
Convex.
Convex who?
Convex go to prison!

Joke 4 Knock, knock. 3 points
Who's there?
Prism.
Prism who?
Prism is where convex go!

Joke 5 Teacher: "What is seven Q plus three Q?" 2 points
Student: "Ten Q."
Teacher: "You're welcome."

Joke 6 A Cherokee chief had three wives, each of whom 4 points
was pregnant. The first squaw gave birth to a
boy, and the chief was so elated that he built her
a teepee made of buffalo hide. A few days later,
the second squaw gave birth, and also had a boy.
The chief was extremely happy; he built her a
teepee made of antelope hide. The third squaw
gave birth a few days later, but the chief kept the
birth details a secret.

He built the third wife a teepee out of hippo-
potamus hide and challenged the people in the
tribe to guess the details of the birth. Whoever in
the tribe could guess correctly would receive a
fine prize. Several people tried, but they were
unsuccessful in their guesses. Finally, a young
brave came forth and declared that the third wife
had delivered twin boys. "Correct!" cried the
chief. "But how did you know?"

"It's simple," replied the warrior. "The value of
the squaw of the hippopotamus is equal to the
sons of the squaws of the other two hides."

*Other versions of joke 6 have different punch
lines. There are bonus points if either of these
punch lines make you smile:*

Joke 7 "The share of the hypertense muse equals the 2 points
sum of the shares of the other two brides."

Joke 8 "The squire of the high pot and noose is equal to 2 points
the sum of the squires of the other two sides."

TOTAL – 20 POINTS

Six Degrees of Separation

· ◦ ▪ ◦ · ● · ● · ● · ● · ● ·

While visiting Los Angeles in October 2012, I was lucky enough to attend a table-read of an upcoming episode of *The Simpsons* titled "Four Regrettings and a Funeral." This involved the cast reading through the entire episode in order to iron out any problems before the script was finalized in preparation for animation. It was bizarre to see and hear a fully grown Yeardley Smith delivering lines with little Lisa's voice. Similarly, I experienced extreme cognitive dissonance when I heard the voices of Homer, Marge, and Moe Szyslak, whose tones and diction are so familiar from years of watching *The Simpsons*, emerge from the all-too-human forms of Dan Castellaneta, Julie Kavner, and Hank Azaria.

Although there is much else to appreciate in "Four Regrettings and a Funeral," it is sadly lacking in mathematical references. However, that same day I was given a preliminary script for another upcoming episode, "The Saga of Carl," which contained an entire scene dedicated to the mathematics of probability.

"The Saga of Carl" opens with Marge dragging her family away from the television and taking them on an educational trip to the Hall of Probability at Springfield's Science Museum. There, they watch a video introduced by an actor playing the role of Blaise Pascal (1623–62), the father of probability theory, and they also see an experimental demonstration of probability theory known as the *Galton board*. This involves marbles rolling down a slope and ricocheting off a series of pins. At each pin, the marbles bounce randomly to the left or right, only to hit the next row of pins and be met by the same random opportunity. The marbles are finally collected in a series of slots and form a humped distribution.

The Galton board was named after its English inventor, the polymath Francis Galton (1822–1911). The balls enter at the top, bounce off the pins, and fall to the bottom, where they form a so-called binomial distribution. A version of this classic probability experiment appears in "The Saga of Carl."

Having only read the script, it was impossible for me to know how the Galton board would appear on screen. The only thing I could be sure of was that the humped distribution would be mathematically accurate, because one of the writers explained that the exact nature of the marble distribution had dominated one of the script redrafting sessions. According to Jeff Westbrook, he and a couple of other mathematicians on the writing team argued about which probability equation correctly describes the marble distribution, while the other writers stared in silence. "We were arguing about whether it should be Gaussian or Poisson," recalled Westbrook. "In the end, I decided it all depends on how you model it, but essentially it's the binomial distribution. Everyone else was kind of looking bored and rolling their eyes."

Westbrook majored in physics at Harvard, and then completed a highly mathematical PhD in computer science at Princeton University. His supervisor was Robert Tarjan, a world-famous computer scientist,

who in 1986 won the Turing Award, known as the Nobel Prize of computing. After finishing his PhD, Westbrook spent five years as an associate professor at Yale University and then joined AT&T Bell Laboratories. However, Westbrook loved slapstick and punnery as much as statistics and geometry, so he eventually left research and headed west to Los Angeles.

His mother, who had always supported his ambition to become a researcher, initially labeled his move into comedy writing an "absolute crime." Westbrook thinks his father, a mathematician, had similar reservations, but was too polite to voice them. His research colleagues were equally unsupportive. Westbrook still remembers his boss's final words to him when he left AT&T Bell Labs: "Well, I understand why you're doing it. I hope you fail because I would like you to come back here and work."

After hearing about his academic background, I wondered if Westbrook was the most mathematically qualified of all the writers on *The Simpsons*. He had certainly climbed highest up the academic ladder, but perhaps others had written more research papers or collaborated with a wider range of mathematicians. In search of a metric for mathematical magnificence, it struck me that one way to obtain a rating would be to apply a technique based on the notion of *six degrees of separation*.

This is the idea that everyone in the world is connected to everyone else by a maximum of just six relationships. For example, I probably know someone, who knows someone, who knows someone, who knows someone, who knows someone, who knows you. This is the most general and best-known version of six degrees of separation, but the technique can be adapted to specific communities, such as mathematicians. Hence, six degrees of separation can be used to identify who is well connected in the world of mathematics, and who, therefore, might have the best mathematical credentials. It is not a perfect measurement, but it can offer some interesting insights.

The mathematical version of six degrees of separation is called *six degrees of Paul Erdős*, named after the mathematician Paul Erdős (1913–96). The goal is to find a connection between any given math-

ematician and Erdős, and mathematicians with closer connections are then ranked higher than those with more tenuous connections. But why is Erdős considered to be at the center of the mathematical universe?

Erdős holds this position because he was the most prolific mathematician of the twentieth century. He published 1,525 research papers, which he wrote with 511 co-authors. This incredible achievement was made possible by Erdős's eccentric lifestyle, which involved traveling from one campus to another, setting up shop with a different mathematician every few weeks, and writing research papers with each of them. Throughout his life, he was able to fit all his belongings into a single suitcase, which was very convenient for a nomadic mathematician constantly on the road in search of the most interesting problems and the most fruitful collaborations. He fueled his brain with coffee and amphetamines in order to maximize his mathematical output, and he often repeated a notion first posited by his colleague Alfréd Rényi: "A mathematician is a machine for turning coffee into theorems."

In six degrees of Paul Erdős, connections are made via co-authored articles, typically mathematical research papers. Anybody who has co-authored a paper directly with Erdős is said to have an *Erdős number* of 1. Similarly, mathematicians who have co-authored a paper with someone who has co-authored a paper with Erdős are said to have an Erdős number of 2, and so on. Via one chain or another, Erdős can be connected to almost any mathematician in the world, regardless of their field of research.

Take Grace Hopper (1906–92) for example. She built the first compiler for a computer programming language, inspired the development of the programming language COBOL, and popularized the term *bug* to describe a defect in a computer after finding a moth trapped in the Mark II computer at Harvard University. Hopper did much of her mathematics in industry or as a member of the United States Navy. Indeed, "Amazing" Grace Hopper was eventually promoted to rear admiral, and there is now a destroyer named the USS *Hopper*. In short, Hopper's hardheaded, applied, technology-driven,

industrial, military mode of mathematics was utterly different from Erdős's purist devotion to numbers, yet Hopper has an Erdős number of just 4. This is because she published papers with her doctoral supervisor Øystein Ore, whose other students included the eminent group theorist Marshall Hall, who co-authored a paper with the distinguished British mathematician Harold R. Davenport, who had published with Erdős.

So, how does Jeff Westbrook rank in terms of his Erdős number? He started publishing research papers while working on his PhD in computer science at Princeton University. As well as writing his 1989 thesis, titled "Algorithms and Data Structures for Dynamic Graph Algorithms," he co-authored papers with his supervisor Robert Tarjan. In turn, Tarjan has published with Maria Klawe, who collaborated with Paul Erdős. This gives Westbrook a very respectable Erdős number of just 3.

However, this does not make him a clear winner among the writers on *The Simpsons*. David S. Cohen has published a paper with Manuel Blum, another Turing Award winner, who in turn has published a paper with Noga Alon at Tel Aviv University, who in turn published several papers with Erdős. Hence, Cohen can also claim an Erdős number of 3.

In order to break the tie between Cohen and Westbrook, I decided to explore another facet of being a successful writer on *The Simpsons*, namely being well connected to the heart of the Hollywood entertainment industry. One approach to measuring where a person sits in the Hollywood hierarchy is to employ another version of six degrees of separation, which is known as *six degrees of Kevin Bacon*. The challenge is to find an individual's so-called *Bacon number* by linking him or her to Kevin Bacon through films. For example, Sylvester Stallone has a Bacon number of 2, because he appeared in *Your Studio and You* (1995) with Demi Moore, and she was in *A Few Good Men* (1992) with Kevin Bacon.

So, which member of *The Simpsons* writing team has the lowest Bacon number, and therefore the best Hollywood credentials? That

Colombia Un~ ?
In Colombia ??

honor belongs to the remarkable Jeff Westbrook. He got his break as
an actor in the naval adventure *Master and Commander: The Far Side
of the World* (2003). While the film was in production, the director
advertised for experienced seamen of Anglo-Irish extraction to man
the ships, and Westbrook volunteered because he was a keen sailor
who fit the ethnic bill. As a result, he was given a minor role in the
film alongside leading actor Russell Crowe. Crowe is important, be-
cause he was in *The Quick and the Dead* (1995) with Gary Sinise, who
co-starred with Bacon in *Apollo 13* (1995). Hence, Westbrook has a
Bacon number of 3, which puts him just behind Stallone. In short, he
has impressive Hollywood credentials.

Thus, Westbrook has both a Bacon number of 3 and an Erdős
number of 3. It is possible to combine these numbers into a so-called
Erdős-Bacon number of 6, which gives an indication of Westbrook's
overall connectivity in the worlds of both Hollywood and mathemat-
ics. Although we have not yet discussed the Erdős-Bacon numbers for
the rest of the writing team behind *The Simpsons*, I can confirm that
none of them can beat Westbrook's score. In other words, out of the
entire gang of Tinseltown nerds, Westbrook is overall the tinseliest
and the nerdiest.*

• • •

I first became aware of Erdős-Bacon numbers thanks to Dave Bayer,
a mathematician at Colombia University. He was a consultant on the
film *A Beautiful Mind*, based on Sylvia Nasar's acclaimed biography
of the mathematician John Nash, who had won the Nobel Prize in
Economic Sciences in 1994. Bayer's responsibilities included checking

* I have, of course, looked at my own credentials. My Erdős number is 4 and my
Bacon number is 2, which puts me on a par with Jeff Westbrook. Moreover, I also
appear to have a Sabbath number, which is generated as a result of musical
collaborations linking me to a member of the rock band Black Sabbath. Indeed,
according to the Erdős Bacon Sabbath Project (http://ebs.rosschurchley.com), I have
an Erdős-Bacon-Sabbath number of 10, giving me the world's eighth-lowest Erdős-
Bacon-Sabbath number, on a par with Richard Feynman, among others!

the equations that appeared on screen and acting as Russell Crowe's hand double in the blackboard scenes. Bayer was also given a minor role toward the end of the film, when the Princeton mathematics professors offer their pens to Nash to acknowledge his great discoveries. Bayer proudly explained: "In my scene, known as the Pen Ceremony, I say, 'A privilege, professor.' I'm the third professor to lay down a pen before Russell Crowe." So, Bayer was in a *Beautiful Mind*, acting alongside Rance Howard. In turn, Rance Howard was in *Apollo 13* with Kevin Bacon, which means that Bayer has a Bacon number of 2.

As a highly respected mathematician, it is no surprise that Bayer has an Erdős number of 2, which gives him a combined Erdős-Bacon number of just 4. When *A Beautiful Mind* was released in 2001, Bayer claimed to have the world's lowest Erdős-Bacon number.

More recently, Bruce Reznick, a mathematician at the University of Illinois, has claimed an even lower Erdős-Bacon number. He co-authored a paper with Erdős, titled "The Asymptotic Behavior of a Family of Sequences," which gives him an Erdős number of 1. Equally impressive is the fact that he had a very minor role in *Pretty Maids All in a Row*, a 1971 film written and produced by Gene Roddenberry, legendary creator of *Star Trek*. This teen slasher movie, which tells the story of a serial killer who hunts down his victims at Oceanfront High School, has a cast that includes Roddy McDowall, who was in *The Big Picture* (1989) with Kevin Bacon. This gives Reznick a Bacon number of 2, which means that he has an incredibly low Erdős-Bacon number of 3.

So far, the record low Erdős-Bacon numbers have been posted by mathematicians venturing into acting, but some actors have dabbled in research and have thereby achieved respectable Erdős-Bacon numbers. One of the most famous examples is Colin Firth, whose path to Erdős began when he was guest editor for BBC Radio 4's *Today* program. For an item on the program, Firth asked neuroscientists Geraint Rees and Ryota Kanai to conduct an experiment to look at correlations between brain structure and political views. This led to

further research, and in due course the neuroscientists invited Firth to join them as co-author on a paper titled "Political Orientations Are Correlated with Brain Structure in Young Adults." Although Rees is a neuroscientist, he has an Erdős number of 5, because of convoluted collaborations that ultimately link him to the world of mathematics. Having published with Rees, Firth can claim an Erdős number of 6. He also has a Bacon number of just 1, because he worked with Bacon on *Where the Truth Lies* (2005). This gives Firth an Erdős-Bacon number of 7—impressive, but a long way from Reznick's record.

Similarly, Natalie Portman is notable for having an Erdős-Bacon number. She conducted research while she was a student at Harvard University, which led to her becoming a co-author on a paper titled "Frontal Lobe Activation During Object Permanence: Data from Near-Infrared Spectroscopy." However, she is not identified as Natalie Portman on any research databases, as she published under her birth name, Natalie Hershlag. One of the other co-authors was Abigail A. Baird, who has a link into mathematical research, which results in her having an Erdős number of 4. This means Portman has an Erdős number of 5. Her Bacon number relies on a directorial credit for one of the segments in the anthology film *New York, I Love You* (2009). Some versions of the film contain a segment starring Kevin Bacon, so technically Portman has a Bacon number of 1. This gives Portman an Erdős-Bacon number of 6, which is low enough to beat Firth, but too high to offer any hope of a serious challenge to Reznick's record.

What about Paul Erdős? Surprisingly, he has a Bacon number of 4, because he appeared in *N Is a Number* (1993), a documentary about his life, which also featured Tomasz Luczak, who was in *The Mill and the Cross* (2011) with Rutger Hauer, who was in *Wedlock* (1991) with Preston Maybank, who was in *Novocaine* (2001) with Kevin Bacon. His Erdős number, for obvious reasons, is 0, so Erdős has a combined Erdős-Bacon number of 4—not quite enough to match Reznick.

And, finally, what about Kevin Bacon's Erdős-Bacon number? Bacon, being Bacon, has a Bacon number of 0. As yet, he does not have an Erdős number. In theory, he might develop a passion for number theory and collaborate on a research paper with someone who already has an Erdős number of 1. This would give him an unbeatably low Erdős-Bacon number of 2.

CHAPTER 6

LISA SIMPSON, QUEEN
OF STATS AND BATS

• • • • • • • • • • •

When the Simpsons made their television debut as part of
The Tracey Ullman Show, their individual personalities
were not quite as developed as they are today. Indeed, when Nancy
Cartwright, the voice of Bart Simpson, wrote a memoir titled *My Life
as a Ten-Year-Old Boy*, she highlighted a major character flaw in Lisa:
"She was just an animated eight-year-old kid who had no personality."

The description is harsh but fair. If Lisa had any personality in
those early appearances, then it was merely as a watered-down female
version of Bart; slightly less mischievous and just as bored with books.
Nerdvana was the last thing on Lisa's mind.

However, as the launch of *The Simpsons* stand-alone series ap
proached, Matt Groening and his team of writers made a concerted
effort to give Lisa a distinct identity. Her brain was reconfigured and
she was reincarnated as an intellectual powerhouse, blessed with ad-
ditional reserves of compassion and social responsibility. Cartwright
neatly summarized the personality of her revamped fictional sister:
"Lisa Simpson is the kind of child we not only want our children to
be, but also the kind of child we want *all* children to be."

Although Lisa is a multitalented renaissance student, Principal
Skinner acknowledges her special talent for mathematics in "Tree-
house of Horror X" (1999). After a large of stack of bench seats falls
on Lisa, he cries out: "She's been crushed! . . . And so have the hopes
of our mathletics team."

We see this gift for mathematics in action in "Dead Putting Society"
(1990), an episode that revolves around Homer and Bart challenging

Ned and Todd Flanders, their holier-than-thou neighbors, to a minia-ture golf tournament. In the buildup to the big match, Bart is strug-gling to develop his putting technique, so he turns to Lisa for advice. She should have suggested that Bart change his grip, because he is natu-rally left-handed, and throughout this episode he adopts a right-hand-er's putting stance. Instead, Lisa focuses on geometry as the key to putting, because she can use this area of mathematics to calculate the ball's ideal trajectory and guarantee Bart a hole in one every time. In a practice session, she successfully teaches Bart how to bounce the golf ball off five walls and into the hole, prompting Bart to say: "I can't be-lieve it. You've actually found a practical use for geometry!"

It is a neat stunt, but the writers use Lisa's character to explore deeper mathematical ideas in "MoneyBART" (2010). In the opening scene of this episode, the glamorous Dahlia Brinkley is welcomed back to Springfield Elementary as the only student to have gone on to attend an Ivy League college. Not surprisingly, Principal Skinner and Superintendent Chalmers try to ingratiate themselves with Ms. Brin-kley, as do some of the students. This includes the usually philistine Nelson Muntz, who tries to impress Springfield's most successful alumna by pretending to be Lisa's friend. Feigning interest in Lisa's mathematical aptitude, he encourages her to demonstrate her ability to Ms. Brinkley:

NELSON: She can do the kind of math that has letters. Watch! What's *x*, Lisa?
LISA: Well, that depends.
NELSON: Sorry. She did it yesterday.

During this encounter, Dahlia explains to Lisa that exam results will not be enough to get into the best universities, and that her own success was partly built on a wide range of extracurricular activities while at Springfield Elementary. Lisa mentions that she is treasurer of the jazz club and started the school's recycling society, but Dahlia is not impressed: "Two clubs. Well, that's a bridge bid, not an Ivy League application."

Meanwhile, Bart's Little League baseball team, the Isotots, has lost its coach, so Lisa seizes the opportunity to improve her Ivy League credentials by taking charge. Although she has gained a new extracurricular activity, she realizes that she does not know the first thing about baseball, so she heads to Moe's Tavern to ask Homer for advice. Rather than pass on his own expertise, Homer's response is to point his daughter toward an unlikely quartet of geeks sitting in the corner. To Lisa's surprise, Benjamin, Doug, and Gary from Springfield University are having an intense discussion about the finer points of baseball with Professor Frink. When Lisa asks why they are discussing sport, Frink explains that "baseball is a game played by the dexterous, but only understood by the Poindexterous."[*]

In other words, Frink is stating that the only way to understand baseball is through deep mathematical analysis. He hands Lisa a stack of books to take away and study. As Lisa departs, Moe approaches the geeks and bemoans the fact that they are not drinking any beer: "Oh, why did I advertise my drink specials in *Scientific American*?"

Lisa follows Frink's advice. Indeed, a reporter spots her poring over piles of technical books immediately prior to her first game in charge of the Isotots. This extraordinary sight prompts him to remark: "I haven't seen this many books in a dugout since Albert Einstein went canoeing."

Lisa's books have titles such as $e^{i\pi} + 1 = 0$, $F = MA$, and *Schrödinger's Bat*. Although these titles are fictional, the book tucked below Lisa's laptop is *The Bill James Historical Baseball Abstract*, which is a real catalog of the most important statistics in baseball, compiled by one of baseball's deepest thinkers.

Bill James has come to be revered in the worlds of both baseball and statistics, but his research in these areas did not begin within the sports establishment or in the ivory towers of academia. Instead, his initial and greatest insights came to him during long and lonely nights

[*] Remember, Poindexter was the boy genius from *Felix the Cat* who inspired the name poindextrose, given to the pheromone discovered by Lisa in the episode "Bye, Bye, Nerdie" (2010).

Lisa surrounded by books, including *The Bill James Historical Baseball Abstract*.

as a night watchman at a pork and beans factory owned by Stokely–
Van Camp, one of America's venerable canning companies.

While protecting the nation's supply of pork and beans, James
sought out truths that had eluded previous generations of baseball
aficionados. Gradually, he came to the conclusion that the statistics
being used to assess the strength of individual baseball players were
sometimes inappropriate, occasionally poorly understood, and, worst
of all, often misleading. For example, the headline statistic for assess-
ing the performance of a fielder was the number of errors made: the
fewer the errors, the better the fielder. This seems obviously sensible,
but James had doubts about the validity of the error statistic.

To appreciate James's concerns, imagine that a batter has hit a ball into
the air far from any fielders. A speedy fielder dashes fifty yards, gets to the
ball just in time, but fumbles the catch. This is marked down as an error.
Later in the game, a sluggish fielder is faced with the same scenario, but he
is unable to reach halfway to where the ball lands and has no hope of even
attempting a catch. Crucially, this is *not* marked down as an error, because
the fielder did not fumble or drop the ball.

Based on this information alone, which player would you prefer to have on your team? The obvious answer is the faster player, because next time he might make the catch, whereas the slower player will always be too slow to have any chance of doing something useful in this scenario.

However, according to the error statistics, the faster player made an error, while the slower player did not. So, if we were to pick a player based on the error statistics alone, then we would pick the wrong player. This was the sort of statistic that kept James awake at night. It had the potential to give a false impression of a player's performance.

Of course, James was not the first person to be concerned about the abuse and misuse of statistics. Mark Twain famously popularized the statement: "There are three kinds of lies: lies, damned lies, and statistics." In a similar vein, the chemist Fred Menger wrote: "If you torture data sufficiently, it will confess to almost anything." However, James was convinced that statistics could be a great force for good. If only he could identify the right set of statistics and interpret them correctly, he believed he would gain a profound insight into the true nature of baseball.

Each night he would stare at the data, jot down some equations, and test various hypotheses. Eventually, he began to develop a useful statistical framework and he organized his theories into a slim pamphlet titled *1977 Baseball Abstract: Featuring 18 Categories of Statistical Information That You Just Can't Find Anywhere Else*. He advertised it in the *Sporting News* and was able to sell seventy-five copies.

The sequel, *1978 Baseball Abstract*, contained forty thousand statistics and was more successful, selling 250 copies. In his *1979 Baseball Abstract*, James explained his motivation for publishing all these statistics: "I am a mechanic with numbers, tinkering with the records of baseball games to see how the machinery of baseball offense works. I do not start with the numbers any more than a mechanic starts with a monkey wrench. I start with the game, with the things that I see there and the things that people say there. And I ask: Is it true? Can you validate it? Can you measure it?"

Year after year, James witnessed a growing readership for his

FURTHER OBSERVATIONS ABOUT THE MURKY WORLD OF STATISTICS

"He uses statistics as a drunken man uses a lamppost—for support rather than illumination." —ANDREW LANG

"42.7 percent of all statistics are made up on the spot." —STEVEN WRIGHT

"Giving a school man only a little, or very superficial, knowledge of statistics is like putting a razor in the hands of a baby." —CARTER ALEXANDER

"Then there is the man who drowned crossing a stream with an average depth of six inches." —W. I. E. GATES

"I always find that statistics are hard to swallow and impossible to digest. The only one I can ever remember is that if all the people who go to sleep in church were laid end to end they would be a lot more comfortable."

—MRS. MARTHA TAFT

"The average human has one breast and one testicle." —DES MACHALE

While heading to a conference on board a train, three statisticians meet three biologists. The biologists complain about the cost of the train fare, but the statisticians reveal a cost-saving trick. As soon as they hear the inspector's voice, the statisticians squeeze into the toilet. The inspector knocks on the toilet door and shouts: "Tickets, please!" The statisticians pass a single ticket under the door, and the inspector stamps it and returns it. The biologists are impressed. Two days later, on the return train, the biologists showed the statisticians that they have bought only one ticket, but the statisticians reply: "Well, we have no ticket at all." Before they can ask any questions, the inspector's voice is heard in the distance. This time the biologists bundle into the toilet. One of the statisticians secretly follows them, knocks on the toilet door and asks: "Tickets please!" The biologists slip the ticket under the door. The statistician takes the ticket, dashes into another toilet with his colleagues, and waits for the real inspector. The moral of the story is simple: "Don't use a statistical technique that you don't understand." —ANONYMOUS

Baseball Abstract, as like-minded number crunchers realized that they had discovered a guru. The novelist and journalist Norman Mailer became a fan, as did the baseball fanatic and actor David Lander, who played Squiggy on the TV show *Laverne and Shirley*. One of James's youngest fans was Tim Long, who would go on to join the writing team of *The Simpsons*, write the script for "MoneyBART," and feature a copy of one of James's books alongside Lisa Simpson.

According to Long, James was his hero as a teenager: "I loved calculus in high school and I was a baseball fan. My dad and I bonded over baseball. However, baseball was nothing but folk wisdom in terms of how it was managed, so I liked the idea of a guy who came along with numbers to disprove a lot of folk wisdom. I was a huge fan of Bill James when I was fourteen."

Among James's most avid followers were mathematicians and computer programmers, who were not only absorbing his discoveries but also developing their own insights. Pete Palmer, for example, was a computer programmer and systems engineer at a radar base in the Aleutian Islands, keeping an eye on the Russians. This was the high-tech equivalent of being the night watchman at a pork and beans factory, and just like James, he would think about baseball stats while he was working late into the night. In fact, he had been fascinated by the subject since childhood, when he had obsessively compiled baseball records on his mother's typewriter. One of his most important contributions was to develop a new statistic known as the *on-base plus slugging percentage* (OPS), which encapsulated two of the most desirable qualities in a batter, namely the ability to smash a ball out of the park and the less glamorous knack of being able to get on base.

To give you a sense of how Palmer used mathematics to assess batters, the full-blooded formula for OPS is shown on the next page. The first component of OPS is *slugging percentage* (SLG), which is simply a player's total number of bases divided by the number of at-bats. The second component is *on-base percentage* (OBP), which we will discuss later when we return to "MoneyBART," because Lisa Simpson refers to OBP when picking her team.

The formula for OPS, which was first popularized in the book *The Hidden Game of Baseball*, which Palmer co-wrote with baseball historian John Thorn. Please do not feel guilty if you want to skip over this minefield of mathematics and baseball jargon.

$$OPS = SLG + OBP$$

$$SLG = \frac{TB}{AB} \qquad OBP = \frac{H + BB + HBP}{AB + BB + SF + HBP}$$

Therefore,

$$OPS = \frac{AB \times (H + BB + HBP) + TB \times (AB + BB + SF + HBP)}{AB \times (AB + BB + SF + HBP)}$$

or SF → sacrifice bunts

OPS = on-base plus slugging	H = hits	AB = at-bats
OBP = on-base percentage	BB = base on balls	SF = sacrifice flies
SLG = slugging percentage	HBP = times hit by pitch	TB = total bases

Like Palmer and James, Richard Cramer was another part-time amateur statistician who would use mathematics to explore baseball. As a researcher with the pharmaceutical company SmithKline, Cramer had access to considerable computing power, which was supposed to be used to help develop new drugs. Instead, Cramer left the computers running overnight in order to tackle questions in baseball, such as whether or not clutch hitters are a real phenomenon. A clutch hitter is a player who has the special ability of excelling when his team is under the most pressure. Typically, the clutch hitter delivers a big hit when his team is on the verge of losing, particularly in a big game situation. Commentators and pundits have sworn for decades that such players exist, but Cramer decided to check: Do clutch hitters really exist, or are they merely the result of selective recall?

Cramer's approach was simple, elegant, and entirely mathematical. He would measure players' performances in ordinary games and in high-pressure situations during a particular season—Cramer chose

the 1969 season. A few players did seem to excel at key moments, but was that due to some innate superpower that kicked in when they were under pressure, or was it simply a fluke? The next stage of Cramer's analysis was to perform the same calculations for the 1970 season; if clutch hitting was a genuine skill possessed by special players, then the clutch hitters in 1969 would surely also be clutch hitters in 1970. On the other hand, if clutch hitting was a fluke, then the supposed clutch hitters of 1969 would be replaced by a new bunch of lucky clutch hitters in 1970. Cramer's calculations demonstrated that there was no significant relationship between the two sets of clutch hitters across the two seasons. In other words, supposed clutch hitters in one season could not maintain their performance. They were not particularly clutchy, just lucky.

In his 1984 *Baseball Abstract*, James explained that he was not surprised: "How is it that a player who possesses the reflexes and the batting stroke and the knowledge and the experience to be a .262 hitter in other circumstances magically becomes a .300 hitter when the game is on the line? How does that happen? What is the process? What are the effects? Until we can answer those questions, I see little point in talking about clutch ability."

Derek Jeter, who is nicknamed "Captain Clutch" thanks to his batting performances with the New York Yankees, vehemently disagreed with the statisticians. In an interview with *Sports Illustrated*, he said: "You can take those stats guys and throw them out the window." Unfortunately, Jeter's own figures supported James's conclusion. Averaged across thirteen seasons, Jeter's batting average/on-base percentage/slugging percentage stats were .317/.388/.462 in regular season games, and .309/.377/.469 (marginally worse) in crucial playoff games.

Of course, all new mathematical disciplines need names, and in due course this empirical, objective, and analytical approach to understanding baseball became known as *sabermetrics*. The term, coined by James, has its root in SABR, the acronym for the Society for American Baseball Research, an organization set up to foster research into all areas of baseball, such as the history of the game, baseball in relation

to the arts, and women in baseball. For two decades, the baseball establishment largely ignored and sometimes even mocked James and his growing band of sabermetric colleagues. However, sabermetrics was eventually vindicated, when one team was brave enough to apply it in the most ruthless manner possible and prove that it held the secret to baseball success.

In 1995, the Oakland Athletics baseball team was purchased by Steve Schott and Ken Hofmann, two property developers who made it clear from the outset that the team's budget had to be slashed. When Billy Beane became general manager in 1997, the Athletics were notorious for having the lowest payroll in Major League Baseball. Without money, it dawned on Beane that his only hope of winning a decent number of games was to rely on statistics. In other words, he would use mathematics to outsmart his wealthier rivals.

A devotee of Bill James, Beane showed his faith in statistics by hiring a stats-obsessed Harvard economics graduate, Paul DePodesta, as his assistant. In turn, DePodesta hired more statistical obsessives, such as Ken Mauriello and Jack Armbruster, a pair of financial analysts who left Wall Street and set up a baseball stats company called Advanced Value Matrix Systems. They analyzed the data from each individual play across hundreds of past games in order to judge the exact contribution of each pitcher, fielder, and hitter. Their algorithms minimized the haphazard influence of luck and effectively placed a dollar figure on every player on every team. This gave Beane the information he needed to acquire undervalued players.

He soon realized that the best bargains appeared on the market at midseason, when teams that were no longer capable of winning their league would cut their losses by selling off players. The law of supply and demand dictated a drop in prices, and Beane was able to use statistics to pinpoint excellent players who had gone unnoticed within struggling teams. Sometimes DePodesta recommended trades or acquisitions that seemed crazy to the traditionalists, but Beane rarely doubted his advice. Indeed, the crazier the deal, the bigger the opportunity to acquire an undervalued player. The power of DePodesta's mathematics and the resulting midseason deals was already

clear by 2001. The Oakland A's won only 50 percent of their 81 games in the first half of that season; that increased to 77 percent in the second half of the season, and they finished second in the American League West.

This dramatic stats-based improvement was later documented in *Moneyball,* a book by the journalist Michael Lewis, who followed Beane's adventures with sabermetrics over the course of several seasons. Of course, the title of the episode of *The Simpsons* in which Lisa becomes a baseball coach, "MoneyBART," is based on the title of Lewis's book. Moreover, in the picture on page 66, the third book below Lisa's computer is *Moneyball.* Hence, we can be sure that Lisa is fully aware of Billy Beane and his commitment to implementing sabermetrics in its purest form.

Unfortunately, Beane lost three of his key players to the New York Yankees at the end of the 2001 season. The Yankees could simply afford to sabotage their rivals by buying up the talent; the Yankees' payroll was $125 million, whereas bargain basement teams like the Oakland A's were forced to survive on $40 million. Lewis described the situation thus: "Goliath, dissatisfied with his size advantage, has bought David's sling."

Hence, the 2002 season got off to a bad start for the Athletics, yet again. However, DePodesta's computer highlighted some cheap mid-season deals that more than compensated for those players lost to the Yankees. In fact, sabermetrics resulted in the Oakland A's finishing on top of the American League West after completing a remarkable late-season winning streak of twenty games in a row, which broke the American League record. This was the ultimate victory of logic over dogma. Sabermetrics had resulted in arguably the greatest achievement in baseball in modern times.

When Lewis published *Moneyball* the following year, he admitted that he had occasionally doubted Beane's reliance on mathematics: "My problem can be simply put: every player is different. Every player must be viewed as a special case. The sample size is always one. [Beane's] answer is equally simple: baseball players follow similar patterns, and these patterns are etched in the record books. Of course,

every so often some player may fail to embrace his statistical destiny, but on a team of twenty-five players the statistical aberrations will tend to cancel each other out."

Moneyball brought Beane to public attention as the maverick hero who had enough confidence in sabermetrics to challenge baseball's orthodoxy. He also gained admirers in other sports, such as soccer, as discussed in appendix 1. Even those who were not sports fans became aware of Beane's success when Hollywood released *Moneyball*, an Oscar-nominated film based on Lewis's book, starring Brad Pitt as Billy Beane.

Naturally, Beane's success persuaded rival teams to adopt Oakland's approach and hire sabermetricians. The Boston Red Sox hired Bill James prior to the 2003 season, and a year later the father of sabermetrics helped the team win the World Series for the first time in eighty-six years, breaking the so-called Curse of the Bambino. Eventually, full-time sabermetricians were also hired by the Los Angeles Dodgers, New York Yankees, New York Mets, San Diego Padres, St. Louis Cardinals, Washington Nationals, Arizona Diamondbacks, and Cleveland Indians. However, one baseball team has surpassed all these in terms of proving the power of mathematics, namely the Springfield Isotots led by Lisa Simpson.

In "MoneyBART," when Lisa leaves Moe's Tavern* armed with books about mathematics, she is determined to employ statistics to help the Isotots win. Sure enough, she successfully uses spreadsheets, computer simulations, and detailed analysis to transform the Isotots from "cellar dwellers" into the second-best team in the league behind Capital City. However, when Lisa tells Bart not to swing at anything in a game against Shelbyville, he disobeys her instructions . . . and wins the game. According to Lisa, however, Bart's home run was just a fluke. Indeed, she feels that such insubordination could potentially undermine her statistical strategy and destroy the team's future hopes.

* Incidentally, when Lisa is in Moe's Tavern talking to Professor Frink, he uses his laptop to show her an online video of Bill James, voiced by the real Bill James.

Hence, she throws Bart off the team, because "he thought he was better than the laws of probability."

Having noted that Nelson Muntz has the highest on-base percentage, Lisa follows the tenets of sabermetrics and makes him the new lead-off hitter, whose most important task is to get on base. Lisa clearly agrees with her fellow sabermetrician Eric Walker, who views the significance of on-base percentage as follows: "Simply yet exactly put, it is the probability that the batter will not make an out. When we state it that way, it becomes, or should become, crystal clear that the most important isolated (one-dimensional) offensive statistic is the on-base percentage. It measures the probability that the batter will not be another step toward the end of the inning."

Sure enough, thanks to Lisa's knowledge of on-base percentage, the Isotots continue their winning streak. One commentator declares her success as "a triumph of number crunching over the human spirit."

The Isotots duly make it to the Little League State Championship, where they play Capital City. Unfortunately, one of her players, Ralph Wiggum, is incapacitated by a juice overdose, so Lisa is forced to ask Bart to return to the team. He accepts the invitation with reluctance, because he knows that he will be faced with a dilemma: Does he follow his instinct or follow Lisa's mathematically based tactics? With Capital City leading the Isotots 11–10 in the ninth and final inning, Bart again decides to disobey Lisa. This time he makes the final out and the Isotots lose, all because of Bart's failure to follow the sabermetric gospel.

Although the episode ends with Lisa and Bart reconciled, the siblings clearly have two entirely different philosophies. According to Lisa, baseball demands to be analyzed and understood, whereas Bart believes the sport is all about instinct and emotion. These views mirror a bigger argument about the role of mathematics and science. Does analysis destroy the intrinsic beauty of the world around us, one might ask, or does it make the world even more beautiful? In many ways, Bart's attitude encapsulates the views expressed by the English Romantic poet John Keats:

> *Do not all charms fly*
> *At the mere touch of cold philosophy?*
> *There was an awful rainbow once in heaven:*
> *We know her woof, her texture; she is given*
> *In the dull catalogue of common things.*
> *Philosophy will clip an Angel's wings,*
> *Conquer all mysteries by rule and line,*
> *Empty the haunted air, and gnomed mine—*
> *Unweave a rainbow, as it erewhile made*
> *The tender-person'd Lamia melt into a shade.*

These lines are from a poem titled "Lamia," the name of a child-eating demon from Greek mythology. In the context of the nineteenth century, Keats's use of the word *philosophy* included the concepts of mathematics and science. He is arguing that mathematics and science dissect and unpick the elegance of the natural world. Keats believes that rational analysis will "unweave a rainbow," thereby destroying its inherent beauty.

By contrast, Lisa Simpson would argue that such analysis turns the sight of a rainbow into an even more exhilarating experience. Perhaps Lisa's worldview was best articulated by the physicist and Nobel laureate Richard Feynman:

I have a friend who's an artist and he's sometimes taken a view which I don't agree with very well. He'll hold up a flower and say, "Look how beautiful it is," and I'll agree, I think. And he says— "you see, I as an artist can see how beautiful this is, but you as a scientist, oh, take this all apart and it becomes a dull thing." And I think that he's kind of nutty. First of all, the beauty that he sees is available to other people and to me, too, I believe, although I may not be quite as refined aesthetically as he is . . . I can appreciate the beauty of a flower. At the same time I see much more about the flower than he sees. I could imagine the cells in there, the complicated actions inside which also have a beauty. I mean it's not just beauty at this dimension of one centimeter;

there is also beauty at a smaller dimension, the inner structure. Also the processes, the fact that the colors in the flower evolved in order to attract insects to pollinate it is interesting—it means that insects can see the color. It adds a question: Does this aesthetic sense also exist in the lower forms? Why is it aesthetic? All kinds of interesting questions, which shows that a science knowledge only adds to the excitement and mystery and the awe of a flower. It only adds; I don't understand how it subtracts.

CHAPTER 7

GALGEBRA AND GALGORITHMS

• • • • • • • • • • •

I n "They Saved Lisa's Brain" (1999), Lisa's mathematical talents and general brilliance earn her an invitation to join the local chapter of Mensa, the society for people with high IQ. Her membership coincides with Mensa members taking control of Springfield after Mayor Quimby flees to avoid accusations of corruption. It seems like a great opportunity for Springfield to grow and prosper under the guidance of the community's smartest men, women, and child.

Unfortunately, a high IQ does not automatically equate to wise leadership. For example, one of the more absurd decisions of Springfield's new leaders is to adopt a metric time system, something akin to the French model that was tried in 1793. The French thought it was mathematically appealing to have a day with ten hours, each hour containing one hundred minutes, and each minute containing one hundred seconds. Although the French abandoned the system in 1805, Principal Skinner proudly boasts in this episode: "Not only are the trains now running on time, they're running on metric time. Remember this moment, people: 80 past 2 on April 47th."

Comic Book Guy, a fan of *Star Trek,* makes the proposal to limit sex to only once every seven years. It is an attempt to mimic *Pon farr,* a phenomenon whereby Vulcans go into heat every seven years. Subsequent decrees, such as a broccoli juice program and a plan to build a shadow-puppet theater (both Balinese and Thai), eventually cause the decent citizens of Springfield to rebel against the intellectual elite. Indeed, as the episode reaches its finale, the revolting masses focus their anger on Lisa, who is only saved when none other than Professor Stephen Hawking arrives in the nick of time to rescue her. Although we associate Hawking with cosmology, he spent thirty years as the

Lucasian Professor of Mathematics at the University of Cambridge, which makes him the most famous mathematician to have appeared on *The Simpsons*. However, not everyone recognizes Hawking when he arrives in his wheelchair. When Hawking points out that the Mensa members have been corrupted by power, Homer says: "Larry Flynt is right! You guys stink!"*

The writers had been anxious to persuade Professor Hawking to make a guest appearance in this particular episode, because the plot required a character who was even smarter than all Springfield's Mensa members put together. The professor, who had been a fan of the series for many years, was already planning to visit America, so immediately his schedule was rejigged to allow him to visit the studios and attend a voice-recording session. Everything seemed in place for Hawking to make his guest appearance on *The Simpsons*, until his wheelchair had a bout of stage fright and suffered a major breakdown forty-eight hours before he was supposed to fly from Monterey to Los Angeles. Hawking's graduate assistant, Chris Burgoyne, fixed the glitch, but only after working for 36 hours through the night and into the next day.

Once Hawking arrived at the recording studio, the writers waited patiently as every script line was keyed into his computer. The only remaining problem occurred when the voice synthesizer struggled to deliver the line that describes Hawking's disappointment at the way Springfield was being governed: "I wanted to see your utopia, but now I see it is more of a Fruitopia." The computer's dictionary did not contain this American fruit-flavored drink, so Hawking and the team had to figure out how to construct *Fruitopia* phonetically. Commenting later on the episode, writer Matt Selman recalled: "It's good to know that we were taking the most brilliant man in the world and using his time to record *Fruitopia* in individual syllables."

The most memorable aspect of Hawking's appearance in "They Saved Lisa's Brain" concerns the manner in which he rescues Lisa

* Larry Flynt is an American publisher of pornography. An assassination attempt in 1978 left him paralyzed from the waist down and wheelchair-bound.

from the mob. His wheelchair deploys a helicopter rotor, and he whisks Lisa off to safety. Presumably he realizes that Lisa is capable of achieving great things in the future and he wants her to fulfill her academic potential. Indeed, we can be sure that Lisa will be successful at university, because we catch a glimpse of Lisa's destiny in "Future-Drama" (2005). The storyline relies on a gadget invented by Professor Frink, which allows people to look into the future. Lisa sees that she will graduate two years early and win a scholarship to Yale. Frink's gadget also reveals that women will dominate science and mathematics in the decades ahead, so much so that some subjects are given more appropriate names. We see Lisa deciding whether to study galgebra or femistry.

The overt support for women in mathematics and science in "Future-Drama" was largely prompted by a news story that had broken while the script was being written. In January 2005, Lawrence Summers, president of Harvard University, made some controversial comments at a conference titled Diversifying the Science & Engineering Workforce. In particular, Summers theorized about why women were underrepresented in academia, stating that "in the special case of science and engineering, there are issues of intrinsic aptitude, and particularly of the variability of aptitude, and that those considerations are reinforced by what are in fact lesser factors involving socialization and continuing discrimination."

Summers was speculating that the spread of ability was broader among men compared to women, which would result in more men and fewer women being spectacularly high achievers in science and engineering. Not surprisingly, his theory provoked an enormous backlash, partly because many felt that such comments from a high-profile figure in academia would discourage young women from pursuing careers in mathematics and science. The controversy contributed to Summers's resignation the following year.

The writers of *The Simpsons* were pleased that they could make a passing topical reference to the Summers incident in "Future-Drama," but they were keen to more fully explore the question of women in mathematics and science, so they returned to the subject the following

year and tackled it in an episode titled "Girls Just Want to Have Sums" (2006).

The episode starts with a performance of *Stab-A-Lot: The Itchy & Scratchy Musical**. After a series of inevitably macabre songs, there is a standing ovation and the director, Juliana Krellner, appears on stage to take a bow. Next to her is Principal Skinner, who proudly reveals that Krellner used to be a student of Springfield Elementary School:

> SKINNER: You know, Juliana, it's no surprise you became such a success. You always got straight As in school.
> JULIANA: Well, I remember getting a B or two in math.
> SKINNER: Well, of course you did. You are a girl.
> [Audience gasps.]
> SKINNER: All I meant was, from what I've seen, boys are better at math, science, the real subjects.
> JULIANA: [To audience] Calm down, calm down. I'm sure Principal Skinner didn't mean girls are inherently inferior.
> SKINNER: No, of course not. I don't know why girls are worse.

Principal Skinner then becomes the subject of a hate campaign and, despite his best efforts to make amends, he only stirs up further controversy. Eventually, Skinner is replaced by a radically progressive educationalist, Melanie Upfoot, who decides to protect Springfield's girls against prejudice by placing them in a separate school. At first, Lisa relishes the idea of an educational system that will allow girls to flourish, but the reality is that Ms. Upfoot wants to indoctrinate her girls with a form of mathematics that is supposedly both feminine and feminist.

According to Ms. Upfoot, girls should be taught mathematics in a

* The musical is a spin-off from *The Itchy and Scratchy Show*, a cartoon watched by Bart and Lisa. The origins of Itchy and Scratchy can be traced back to a young Matt Groening watching Disney's *101 Dalmatians*, in which there is a scene showing the puppies watching television. Decades later, Groening wanted to recreate the idea of a cartoon within a cartoon.

much more emotional manner: "How do numbers make you feel? What does a plus sign smell like? Is the number 7 odd, or just different?" After becoming frustrated by her new teacher's approach to numeracy, Lisa asks if the girls' class is ever going to tackle any real mathematical problems. Ms. Upfoot replies: *"Problems?* That's how men see math, something to be attacked—something to be *figured out."*

This division between feminine and masculine mathematics is only fictional, but it echoes a real trend in recent decades toward touchy-feely mathematics for both boys and girls. Many members of the older generation are concerned that today's students are not being stretched in terms of tackling traditional problems, but instead are being spoon-fed a more trivial curriculum. This concern has given rise to a spoof history of mathematics education known as "The Evolution of a Mathematical Problem":

1960:

A lumberjack sells a truckload of lumber for $100. His cost of production is 4/5 of this price. What is his profit?

1970:

A lumberjack sells a truckload of lumber for $100. His cost of production is 4/5 of this price, or in other words $80. What is his profit?

1980:

A lumberjack sells a truckload of wood for $100. His cost of production is $80, and his profit is $20. Your assignment: Underline the number 20.

1990:

By cutting down beautiful forest trees, a lumberperson makes $20. What do you think of his or her way of making a living? In your group, discuss how the forest birds and squirrels feel, and write an essay about it.

Desperate for some real mathematics, Lisa sneaks out of her class and peers in through the window of the boys' school, where she glimpses a traditional geometry problem on the blackboard. It is not long before she is caught spying and escorted back to the girls' school, and once again she is fed a diet of diluted arithmetic gruel.

It is the final straw. When she returns home that afternoon, Lisa asks her mother to help her disguise herself as a boy so that she can attend the boys' school and participate in their lessons under the identity of Jake Boyman. The storyline mirrors the plot of *Yentl*, in which a young orthodox Jewish girl cuts her hair and dresses as a man in order to study the Talmud.

Unfortunately, dressing as a boy is not enough. Lisa soon finds out that, in order to be accepted by her new classmates, she has to start behaving like a stereotypical boy. This flies in the face of everything she values. Ultimately, she is even willing to bully Ralph Wiggum, one of the most innocent pupils in her class, just to earn the approval of the notorious bully Nelson Muntz.

Lisa resents having to behave like a boy to get a decent education, but continues with her plan in order to study mathematics and prove that girls are just as good as boys. Her determination pays off: Lisa not only excels academically, she also receives the award for Outstanding Achievement in the Field of Mathematics. The award is presented to her at a joint assembly for boys and girls, and Lisa uses this opportunity to reveal her true identity, and proclaims: "That's right, everyone! The best math student in the whole school is a girl!"

Dolph Starbeam, who usually hangs out with fellow school bullies Kearney Zzyzwicz, Jimbo Jones, and Nelson Muntz, shouts: "We've been Yentled!"

Bart also stands up and declares: "The only reason Lisa won is because she learned to think like a boy; I turned her into a burping, farting, bullying math machine."

As the episode reaches its climax, Lisa continues with her speech: "And I did get better at math, but it was only by abandoning everything I believed in. I guess the real reason we don't see many women in math and science is . . ."

And at that very moment, the school's music teacher cuts her off midsentence in order to introduce Martin Prince playing the flute. In this way, the writers sneakily sidestepped having to confront this controversial issue.

When I met writers Matt Selman and Jeff Westbrook, they both recalled that it was almost impossible to find a satisfactory ending to the episode, because there is no easy way to explain why women continue to be underrepresented in many areas of mathematics and science. They did not want to deliver a simplistic or glib conclusion. Neither did they want to find themselves in, as Selman described it, "Skinner-like trouble."

· · ·

The storyline of "Girls Just Want to Have Sums" mirrors not only the plot of *Yentl*, but also the life of the famous French mathematician Sophie Germain. Incredibly, the facts of Germain's battle against sexism are even stranger than the fictional narratives of Lisa and Yentl.

Born in Paris in 1776, Germain's obsession with mathematics began when she chanced upon Jean-Étienne Montucla's *Histoire des Mathématiques* (History of Mathematics). In particular, she was struck by his essay on the extraordinary life and tragic death of Archimedes. Legend has it that Archimedes was busy drawing geometric figures in the sand when the Roman army invaded Syracuse in 212 B.C. Indeed, he was so obsessed with analyzing the mathematical properties of his shapes in the sand that he ignored an approaching Roman soldier who was demanding his attention. Offended by the apparent rudeness, the soldier raised his spear and stabbed Archimedes to death. Germain found the story inspiring; mathematics had to be the most fascinating subject if it could spellbind someone to such an extent that he might ignore threats to his own life.

As a result, Germain began to study mathematics all day and even through the night. According to a family friend, her father confiscated her candles to discourage her from studying when she should have been sleeping. In due course, Sophie's parents relented. Indeed, when they accepted that she would not marry, but instead would de-

vote her life to mathematics and science, they introduced her to tutors and supported her financially.

At the age of twenty-eight, Germain decided that she wanted to attend the newly opened École Polytechnique in Paris. The stumbling block was that this prestigious institution would only admit male students. However, Germain found a way around this problem when she learned that the college made its lecture notes publicly available and even encouraged outsiders to submit observations on these notes. This generous gesture was intended for gentlemen, so Germain simply adopted a male pseudonym, Monsieur LeBlanc. In this way, she obtained the notes and began submitting insightful observations to one of the tutors.

Just like Lisa Simpson, Germain had adopted a male identity in order to study mathematics. So when Dolph Starbeam shouts out, "We've been Yentled!" it would have been more germane had he exclaimed, "We've been Germained!"

Germain was sending her observations to Joseph-Louis Lagrange, not only a member of the École Polytechnique but also one of the world's most respected mathematicians. He was so astonished by the brilliance of Monsieur LeBlanc that he demanded to meet this extraordinary new student, which forced Germain to own up to her deception. Although she feared he would be angry with her, Lagrange was actually pleasantly surprised to discover that Monsieur LeBlanc was a mademoiselle, and he gave Germain his blessing to continue with her studies.

She could now build a reputation in Paris as a female mathematician. Nonetheless, she occasionally relied on her male alter ego when writing to mathematicians whom she had not met and who might not otherwise take her seriously. Most notably, she became Monsieur LeBlanc in her correspondence with the brilliant German mathematician Carl Friedrich Gauss, author of *Disquisitiones Arithmeticae* (Arithmetical Investigations), arguably the most important and wideranging treatise on mathematics for more than one thousand years. Gauss acknowledged the talents of his new pen friend—"I am delighted that arithmetic has found in you so able a friend"—but he had

no idea that Monsieur LeBlanc was actually a woman.

Her true identity only became clear to Gauss when Napoleon's French army invaded Prussia in 1806. Germain was anxious that Gauss, like Archimedes, might become the victim of a military invasion, so she sent a message to General Joseph-Marie Pernety, a family friend who was commanding the advancing forces. He duly guaranteed Gauss's safety, and explained to the mathematician that he owed his life to Mademoiselle Germain. When Gauss realized that Germain and LeBlanc were the same person, he wrote:

> But how to describe to you my admiration and astonishment at seeing my esteemed correspondent Monsieur LeBlanc metamorphose himself into this illustrious personage who gives such a brilliant example of what I would find it difficult to believe. A taste for the abstract sciences in general and above all the mysteries of numbers is excessively rare: one is not astonished at it: the enchanting charms of this sublime science reveal themselves only to those who have the courage to go deeply into it. But when a person of the sex which, according to our customs and prejudices, must encounter infinitely more difficulties than men to familiarize herself with these thorny researches, succeeds nevertheless in surmounting these obstacles and penetrating the most obscure parts of them, then without doubt she must have the noblest courage, quite extraordinary talents, and superior genius.

In terms of pure mathematics, Germain's most famous contribution was in relation to Fermat's last theorem. Although she could not formulate a complete proof, Germain made more progress than anyone else of her generation, which prompted the Institut de France to award her a medal for her achievements.

She also had an interest in prime numbers, those numbers that cannot be divided by any other number except 1 and the number itself. Prime numbers can be put into different categories, and one particular set is named in honor of Germain. A prime number p is labeled a *Germain prime* if $2p + 1$ is also prime. So, 7 is not a Germain prime,

because $2 \times 7 + 1 = 15$, and 15 is not prime. By contrast, 11 is a Germain prime, because $2 \times 11 + 1 = 23$, and 23 is a prime.

Research into prime numbers is nearly always considered important, because these numbers are essentially the building blocks of mathematics. In the same way that all molecules are composed of atoms, all the counting numbers are either primes or the products of primes multiplied together. Given that they are central to all things numerical, it will not come as a surprise that a prime number makes a guest appearance in a 2006 episode of *The Simpsons*, as we will discover in the next chapter.

EXAMINATION II

HIGH SCHOOL PAPER

Joke 1 Q: What are the 10 kinds of people in the world? 1 point
A: Those who understand binary, and those who don't.

Joke 2 Q: Which trigonometric functions do farmers like? 1 point
A: Swine and cowswine.

Joke 3 Q: Prove that every horse has an infinite number of legs. 2 points
A: Proof by intimidation: Horses have an even number of legs. Behind they have two legs and in front they have forelegs. This makes a total of six legs, but this is an odd number of legs for a horse. The only number that is both odd and even is infinity. Therefore horses have an infinite number of legs.

Joke 4 Q: How did the mathematician reply when he was asked how his pet parrot died? 2 points
A: Polynomial. Polygon.

Joke 5 Q: What do you get when you cross an 3 points
 elephant and a banana?
 A: | elephant | × | banana | × sin θ

Joke 6 Q: What do you get if you cross a mosquito 3 points
 with a mountain climber?
 A: You can't cross a vector with a scalar.

Joke 7 One day, Jesus said to his disciples: "The 2 points
 Kingdom of Heaven is like $2x^2 + 5x - 6$."
 Thomas looked confused and asked Peter:
 "What does the teacher mean?"
 Peter replied: "Don't worry— it's just
 another one of his parabolas."

Joke 8 Q: What is the volume of a pizza of thick- 3 points
 ness a and radius z?
 A: pi.z.z.a

Joke 9 During a security briefing at the White 3 points
 House, Defense Secretary Donald Rumsfeld
 breaks some tragic news: "Mr President,
 three Brazilian soldiers were killed yesterday
 while supporting U.S. troops."
 "My God!" shrieks President George W.
 Bush, and he buries his head in his hands.
 He remains stunned and silent for a full
 minute. Eventually, he looks up, takes a deep
 breath, and asks Rumsfeld: "How many is a
 brazillion?"

TOTAL – 20 POINTS

CHAPTER 8

A PRIME-TIME SHOW

· • · • · • · • · • ·

T he storyline of "Marge and Homer Turn a Couple Play" (2006)
centers around a baseball star named Buck "Home Run King"
Mitchell, who plays for the Springfield Isotopes. When he and his
wife, Tabitha Vixx, experience marital problems, Mitchell's perfor-
mance on the field begins to suffer, so they turn to Homer and Marge
for relationship advice. After various twists and turns, the episode
culminates at Springfield Stadium, where Tabitha hijacks the Jumbo-
Vision screen and publicly declares her love for Buck to the entire
crowd.

The episode features the voice of singer and actress Mandy Moore,
a reference to J. D. Salinger, and a nod to Michelangelo's *Pietà*, but
mathematical viewers would have been most excited by an appear-
ance by a very special prime number. Before revealing the details of
the prime number and how it is incorporated into the episode, let us
step back and meet the two mathematicians who provided the inspi-
ration for this prime number reference, namely Professor Sarah Gre-
enwald of Appalachian State University and Professor Andrew Nestler
of Santa Monica College.

Greenwald and Nestler's interest in *The Simpsons* dates back to
1991, when they first met and became friends at the Mathematics
Department at the University of Pennsylvania. They were both start-
ing work on their PhDs, and once a week they would gather with
other graduate students to watch *The Simpsons* and share a meal. Nes-
tler remains clear about why the series appealed to them: "The writers
created two recurring nerds: Professor Frink, a scientist, and Martin
Prince, a gifted elementary school student. And they were alongside a

main character, Lisa Simpson, who was also highly intelligent and inquisitive. The inclusion of these characters made the show something that intellectuals would want to watch in order to, in a sense, laugh at themselves."

It was not long before Greenwald and Nestler began to pick up on the various mathematical references in *The Simpsons*. As well as enjoying the jokes about higher mathematics, they were tickled by those scenes involving mathematics in the context of education. Nestler recalls that he was particularly fond of a line by Edna Krabappel, in "This Little Wiggy" (1998), when Springfield's bitterest teacher turns to her class and asks: "Now, *whose calculator* can tell me what seven times eight is?"

After a while, they encountered so many mathematical jokes that Nestler decided to create a database of scenes that might interest mathematicians. According to Nestler, it was the obvious thing to do: "I am by nature a collector, and enjoy cataloging things. When I was young I collected business cards. My main hobby is collecting Madonna records; I have over 2,300 physical records in my Madonna collection."

A few years later, after they had received their doctorates and started teaching, both Greenwald and Nestler began incorporating scenes from *The Simpsons* into their lectures. Nestler, whose doctoral thesis was on algebraic number theory, used material from the animated sitcom in his courses covering calculus, precalculus, linear algebra, and finite mathematics.

By contrast, Greenwald's research interest has always been *orbifolds*, a specialty within geometry, so she tended to include geometrical jokes from *The Simpsons* in her course titled Math 1010 (Liberal Arts Math). For example, she has discussed the opening couch gag from "Homer the Great" (1995). The opening sequence of each episode ends with the Simpson family converging on their couch in order to watch television, which always leads to a piece of visual humor. In this case, the couch gag involves Homer and his family exploring a paradoxical network of staircases under the influence of three gravitational forces, each one acting perpendicular to the others. This scene

is a tribute to *Relativity*, a famous lithograph print by the twentieth-century Dutch artist M. C. Escher, who was obsessed with mathematics in general and geometry in particular.

After a few years of incorporating *The Simpsons* into their mathematics courses, Greenwald and Nestler's quirky approach to teaching attracted some local media attention, which then led to an interview on National Public Radio's *Science Friday*. When some of the *Simpsons* writers heard the show, they were astonished to learn that their nerdy inside jokes were now the basis of college mathematics courses. They were keen to meet the professors and thank them for their dedication to both mathematics and *The Simpsons*, so the writers invited Greenwald and Nestler to attend a table-read of an upcoming episode, which turned out to be "Marge and Homer Turn a Couple Play."

On August 25, 2005, Greenwald and Nestler listened to the table-read that described the topsy-turvy relationship between Buck Mitchell and Tabitha Vixx. While the professors sat back and enjoyed the story, the writers paid close attention to every line, listening for good gags that could be made better and bad gags that ought to be dropped. Later that day, after the professors had returned home, the writers compared notes and began to offer tweaks to the script. Everyone around the table agreed that this was a strong episode, but there was one glaring omission—the entire episode was devoid of mathematics!

It seemed rude to have invited Greenwald and Nestler to a table-read because of their interest in the mathematics of *The Simpsons*, yet show the professors an episode that would not provide them with any new material for their classes. The writers started re-examining the script, scene by scene, looking for an appropriate place to insert some mathematics. Eventually, one of them spotted that the climax of the episode provided the perfect opportunity to bring in some interesting numbers.

Just before Tabitha makes her declaration of love on the Jumbo-Vision screen, a question is displayed on the same screen that asks the

crowd to guess the attendance at the game. It is presented as a multiple-choice question. In the table-read script, the numbers on offer on the screen were just plucked out of the air, but now the writers set about replacing them with numbers that possessed particularly interesting properties. Once the writers had completed their mission, Jeff Westbrook e-mailed Sarah Greenwald: "It's great you guys came by, because it really did light a little fire under us to some degree and today we put in some slightly more interesting mathematical numbers in honor of your visit."

The layout of the Jumbo-Vision screen from "Marge and Homer Turn a Couple Play."

The three interesting numbers, as they appeared on the Jumbo-Vision screen, would have seemed arbitrary and innocuous to casual viewers, but those with mathematical minds would immediately have seen that each one is remarkable in its own way.

The first number, 8,191, is a prime number. Indeed, it belongs to a special class of prime numbers known as *Mersenne primes*. These are

named after Marin Mersenne, who joined the Minim friars in Paris in 1611, thereafter dividing his time between praying to God and worshipping mathematics. He became particularly interested in a set of numbers of the form $2^p - 1$, where p is any prime number. The table below shows what happens if you plug all the prime numbers less than 20 into the formula $2^p - 1$.

Prime (p)	$2^p - 1$		Prime?
2	$2^2 - 1 =$	3	✓
3	$2^3 - 1 =$	7	✓
5	$2^5 - 1 =$	31	✓
7	$2^7 - 1 =$	127	✓
11	$2^{11} - 1 =$	2,047	✗
13	$2^{13} - 1 =$	8,191	✓
17	$2^{17} - 1 =$	131,071	✓
19	$2^{19} - 1 =$	524,287	✓

The striking feature in the table is that $2^p - 1$ seems to generate prime suspects, by which I mean numbers that might be prime. Indeed, all the numbers in the right-hand column are primes, except 2,047, because $2,047 = 23 \times 89$. In other words, $2^p - 1$ is a recipe that uses prime numbers as its ingredients in an attempt to make new prime numbers; these resulting primes are dubbed Mersenne primes. For example, when $p = 13$, then $2^{13} - 1 = 8,191$, which is the Mersenne prime that appears in "Marge and Homer Turn a Couple Play."

Mersenne primes are considered celebrities within the world of numbers, because they can be very large. Some are *titanic primes* (more than one thousand digits), some are *gigantic primes* (more than ten thousand digits), and the very largest are labeled *megaprimes* (more than one million digits). The ten largest known Mersenne primes are the biggest primes ever identified. The largest Mersenne prime

$(2^{57,885,161} - 1)$, which was discovered in January 2013, is more than seventeen million digits long.*

The second number on the stadium screen is 8,128, which is known as a *perfect number*. Perfection in the context of a number depends on its divisors, namely those numbers that will divide into it without any remainder. For example, the divisors of 10 are 1, 2, 5, and 10. A number is considered perfect if its divisors (except the number itself) add up to the number in question. The smallest perfect number is 6, because 1, 2, and 3 are divisors of 6, and $1 + 2 + 3 = 6$. The second perfect number is 28, because 1, 2, 4, 7, and 14 are divisors of 28, and $1 + 2 + 4 + 7 + 14 = 28$. The third perfect number is 496, and the fourth perfect number is 8,128, which is the one that crops up in "Marge and Homer Turn a Couple Play."

These four perfect numbers were all known to the ancient Greeks, but mathematicians would have to wait more than a millennium before the next three perfect numbers were discovered. 33,550,336 was discovered in roughly 1460, then 8,589,869,056 and 137,438,691,328 were both announced in 1588. As René Descartes, the seventeenth-century French mathematician, pointed out, "Perfect numbers, like perfect men, are very rare."

Because they are few and far between, it is easy to jump to the conclusion that there are only a finite number of perfect numbers. However, as yet, mathematicians cannot prove that the supply of perfect numbers is limited. Also, all the perfect numbers discovered so far are even, so perhaps all future perfect numbers will be even. Again, as yet, nobody has proved that this is indeed the case.

Despite these holes in our knowledge, we do know a few things about perfect numbers. For example, it has been proved that perfect

* There is a mass public participation project to find even larger Mersenne primes. The Great Internet Mersenne Prime Search (GIMPS) allows participants to download free software and then run it on their home computers while idling. Each machine then sifts through its batch of allotted numbers searching for a record-breaking prime. If you take part, then you might be lucky enough to discover the next record-breaking Mersenne prime.

numbers that are even (which might be all of them) are also *triangular numbers*:

$$6 = 1 + 2 + 3 \qquad 28 = 1 + 2 + 3 + 4 + 5 + 6 + 7$$

Moreover, we know that even perfect numbers (except 6) are always the sum of a series of consecutive odd cubes:

$$28 = 1^3 + 3^3$$

$$496 = 1^3 + 3^3 + 5^3 + 7^3$$

$$8{,}128 = 1^3 + 3^3 + 5^3 + 7^3 + 9^3 + 11^3 + 13^3 + 15^3$$

Last, but certainly not least, we know that there is a close relationship between even perfect numbers and Mersenne primes. In fact, mathematicians have proved that there is the same number of each, and it has been shown that every Mersenne prime can be used to generate a perfect number. Hence, we know of only forty-eight perfect numbers, because we know of only forty-eight Mersenne primes.

The third number that appears on the stadium screen, 8,208, is special because it is a so-called *narcissistic number*. This means that the number is equal to the sum of each of its digits raised to the power of the number of digits:

$$8{,}208 = 8^4 + 2^4 + 0^4 + 8^4 = 4{,}096 + 16 + 0 + 4{,}096$$

The reason why this number is labeled narcissistic is that the digits within it are being used to generate the number itself. The number appears to be self-obsessed, almost in love with itself.

There are many other examples of narcissistic numbers, such as

153, which equals $1^3 + 5^3 + 3^3$, but it has been shown that there is only a finite supply of narcissistic numbers. In fact, mathematicians know that there are only eighty-eight narcissistic numbers, and the largest one is 115,132,219,018,763,992,565,095,597,973,971,522,401.

However, if we relax the constraints, then it is possible to generate so-called *pretty wild narcissistic numbers*; these numbers can be generated using their own digits in any way that works. Here are some examples of pretty wild narcissistic numbers:

$$6,859 = (6 + 8 + 5)^{\sqrt{9}}$$

$$24,739 = 2^4 + 7! + 3^9$$

$$23,328 = 2 \times 3^{3!} \times 2 \times 8$$

So, thanks to the visit of Greenwald and Nestler, "Marge and Homer Turn a Couple Play" featured guest appearances by a Mersenne prime, a perfect number, and a narcissistic number. For years, *The Simpsons* had influenced the way that the professors had given their classes, and now the situation had been reversed, with the professors influencing *The Simpsons*.

But why had the writers chosen these particular types of number for the Jumbo-Vision screen? After all, there are hundreds of types of interesting numbers, and any of them could have played a cameo role. There are, for example, *vampire numbers*: These numbers have digits that can be divided and rearranged into two new numbers, known as *fangs*, which in turn can be multiplied together to re-create the original number. 136,948 is a vampire number, because 136,948 = 146 × 938. An even better example is 16,758,243,290,880, which is particularly batty and vampiric, because its fangs can be formed in four different ways:

$$16,758,243,290,880 = 1,982,736 \times 8,452,080$$

$$= 2,123,856 \times 7,890,480$$

$$= 2,751,840 \times 6,089,832$$

$$= 2,817,360 \times 5,948,208$$

Alternatively, if the writers wanted an incredibly special number, they could have chosen a *sublime number*. There are only two sublime numbers, because they have to satisfy two severe constraints that both relate to perfection. First, the total number of divisors must be a perfect number and, second, the divisors must add up to a perfect number. The first sublime number is 12, because its divisors are 1, 2, 3, 4, 6, and 12. The number of divisors is 6 and they add up to 28, and both 6 and 28 are perfect numbers. The only other sublime number is 6,086,555,670,238,378,989,670,371,734,243,169,622,657,830,773, 351,885,970,528,324,860,512,791,691,264.

According to the writers, the Mersenne, perfect, and narcissistic numbers were chosen to appear in "Marge and Homer Turn a Couple Play" merely because they all offered quantities that were close to a realistic crowd size. Also, they were the first types of number that came to mind. They were introduced as a last-minute change to the script, so there was not much time to put a great deal of thought into the numbers chosen.

However, in hindsight, I would argue that the writers picked just the right numbers, because the digits are still visible on the Jumbo-Vision screen when Tabitha Vixx appears, and each number seems to offer an apt description of Ms. Vixx. As one of the most glamorous characters to have appeared on *The Simpsons*, Tabitha considers herself to be perfect and in her prime, and not surprisingly, she is also a narcissist. Indeed, at the start of the episode, she is skimpily dressed and dancing provocatively in front of her husband's adoring baseball fans, so including a pretty wild narcissistic number on the stadium screen would have been even more appropriate.

• • •

Although Greenwald and Nestler might seem exceptional, they are not the only professors who discuss *The Simpsons* in their mathematics lectures. Joel Sokol at the Georgia Institute of Technology gives a lecture titled "Making Decisions Against an Opponent: An Application of Mathematical Optimization," which includes slides describing games of rock-paper-scissors played by characters in *The Simpsons*.

The lecture focuses on game theory, an area of mathematics concerned with modeling how participants behave in situations of conflict and cooperation. Game theory can offer insights into everything from dominoes to warfare, from animal altruism to trade union negotiations. Similarly, Dirk Mateer, an economist at Pennsylvania State University with a strong interest in mathematics, also makes use of *The Simpsons* and scenes involving rock-paper-scissors when he teaches game theory to his students.

Rock-paper-scissors (RPS) seems like a trivial game, so you might be surprised that it is of any mathematical interest. However, in the hands of a game theorist, RPS becomes a complex battle between two competitors trying to outwit each other. Indeed, RPS has many hidden layers of mathematical subtlety.

Before revealing these mathematical layers, let me begin with a brief review of the rules. The game is played between two players, and the rules are simple. Both players count "1 . . . 2 . . . 3 . . . Go!" and then offer up their hand in one of three ways: rock (clenched fist), paper (open, flat hand), or scissors (forefinger and middle finger form a V). The winner is decided according to the "circular hierarchy" that rock blunts scissors (rock wins), scissors cut paper (scissors win), and paper covers rock (paper wins). If the weapons are the same, then that round is a tie.

Over the centuries, different cultures have developed their own variations of RPS, ranging from the Indonesians, who play elephant-human-earwig, to sci-fi fans, who play UFO-microbe-cow. The latter version involves a UFO dissecting a cow, a cow eating microbes, and microbes contaminating a UFO.

Although each culture has its own weapons, the rules of the game remain essentially the same. Within these rules, it is possible to use the logic of mathematical game theory to identify which playing strategies are superior. This was demonstrated in "The Front" (1993), when Bart and Lisa play RPS to decide whose name should go first on their co-authored script for *The Itchy and Scratchy Show*. Looking at the RPS game from Lisa's point of view, her best strategy depends on a range of factors. For example, does Lisa know if her opponent is a

rookie or a pro, what does Lisa's opponent know about her, and is the goal to win or to avoid losing?

If Lisa was playing a world champion, then she might adopt a strategy of making a random throw, because not even a world champion would be able to predict whether she was going to throw rock, paper, or scissors. This would give Lisa an equal chance of winning, losing, or drawing. However, Lisa is playing her brother, who is not a world champion. Hence, she adopts a different strategy based on her own experience, which is that Bart is a particularly big fan of throwing rock. So, she decides to throw paper to beat his potential rock. Sure enough, her plan works and she wins. Bart's bad habit is consistent with research carried out by the World RPS Society, which suggests that rock is the most popular throw in general and is a particular favorite with boys.

This sort of game theoretic approach was important when the Japanese-based electronics corporation Maspro Denkoh was auctioning its art collection in 2005. In order to decide whether the multimillion-dollar contract should go to Sotheby's or Christie's, Maspro Denkoh ordered an RPS battle between the two auction houses. Nicholas Maclean, international director of Christie's Impressionist and Modern Art Department, took the matter so seriously that he asked his twin eleven-year-old daughters for advice. Their experience backed up the World RPS Society survey, inasmuch as the twins also felt that rock was the most common throw. Moreover, they pointed out that sophisticated players would be aware of this and would therefore throw paper. Maclean's hunch was that Sotheby's would adopt this sophisticated strategy, so he advised his bosses at Christie's to adopt a super-sophisticated strategy by throwing scissors. Sotheby's did indeed throw paper and Christie's won.

Another layer of mathematics emerges when we turbocharge the game of RPS by adding more options. First, it is important to stress that any new version of RPS must have an odd number of options (N). This is the only way of balancing the game, such that each option wins against and loses to an equal number ($N - 1$)/2 of other options. Hence, there is no four-option version of RPS, but there is a

five-option version called rock-paper-scissors-lizard-Spock (RPSLSp). Invented by computer programmer Sam Kass, this version became famous after it was featured in "The Lizard-Spock Expansion" (2008), an episode of the nerd-friendly sitcom *The Big Bang Theory*. Here are the circular hierarchy and hand gestures for rock-paper-scissors-lizard-Spock.

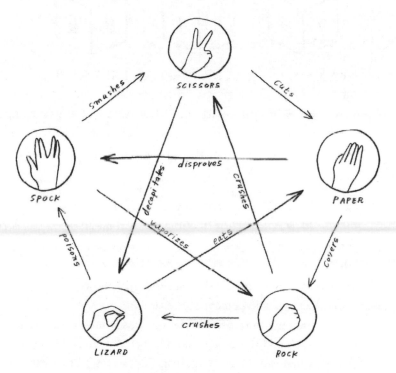

As the number of options increases, the chance of a tie decreases as $1/N$. Therefore, the chance of a tie is $1/3$ in RPS and $1/5$ in RPSLSp. If one wants to minimize the risk of a tie, then the biggest and best available version of RPS is RPS-101. Created by the animator David Lovelace, it has 101 defined hand gestures and 5,050 outcomes that result in a clear win. For example, quicksand swallows vulture, vulture eats princess, princess subdues dragon, dragon torches robot, and so on. The chance of a tie is $1/101$, which is less than 1 percent.

The most intriguing piece of mathematics that has emerged from

studying RPS is the invention of so-called *nontransitive dice*. These dice immediately arouse curiosity, because each one has a different combination of numbers on its faces:

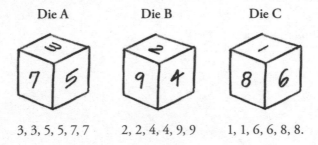

Die A	Die B	Die C
3, 3, 5, 5, 7, 7	2, 2, 4, 4, 9, 9	1, 1, 6, 6, 8, 8.

You and I can play a game with these dice that involves us picking one die each and then pitting them against each other. The winning player is the one whose die shows the higher number. So, which is the best die?

The grids on the page opposite show what happens with the three possible die pairings: (A v. B), (B v. C), (C v. A). The first grid tells us that die A is better than die B, because die A wins in 20 of the 36 possible outcomes. In other words, die A wins on average 56 percent of the time.

What about die B v. die C? The second grid shows that die B is better, because it wins 56 percent of the time.

In life, we are used to transitive relationships, which means that if A is better than B, and B is better than C, then A *must* be better than C. However, when we roll die A against die C, we find that die C is better, because it wins 56 percent of the time, as shown in the third grid. That is why these die are labeled nontransitive—they defy the normal convention of transitivity, just like the weapons in RPS. As mentioned earlier, the rules of RPS dictate an unconventional circular hierarchy, not a simple top-down hierarchy.

Nontransitive relationships are absurd and defy common sense, which is probably why they fascinate mathematicians, whether they are the writers of *The Simpsons*, university professors . . . or even the world's most successful investor, namely Warren Buffett, who has a

DIE A

DIE B	3	3	5	5	7	7
2	A	A	A	A	A	A
2	A	A	A	A	A	A
4	B	B	A	A	A	A
4	B	B	A	A	A	A
9	B	B	B	B	B	B
9	B	B	B	B	B	B

DIE B

DIE C	2	2	4	4	9	9
1	B	B	B	B	B	B
1	B	B	B	B	B	B
6	C	C	C	C	B	B
6	C	C	C	C	B	B
8	C	C	C	C	B	B
8	C	C	C	C	B	B

DIE C

DIE A	1	1	6	6	8	8
3	A	A	C	C	C	C
3	A	A	C	C	C	C
5	A	A	C	C	C	C
5	A	A	C	C	C	C
7	A	A	A	A	C	C
7	A	A	A	A	C	C

Each grid shows all the possible outcomes when two dice are rolled against each other. In the first grid, die A v. die B, you can see that the top left square is marked A and shaded light grey, because die A wins if it rolls a 3 and die B rolls a 2. However, the bottom right square is marked B and shaded dark grey, because die B wins if it rolls a 9 and die A rolls a 7. Taking all the combinations into account, die A wins 56 percent of time on average against die B.

net worth of approximately $50 billion. Buffett's picture in the 1947 Woodrow Wilson High School senior yearbook has the astute caption "Likes math; future stockbroker."

Buffett is known to be a fan of nontransitive phenomena and sometimes challenges people to a game of dice. Without giving any explanation, he hands his opponent three nontransitive dice and asks him or her to choose first. The opponent feels that this confers an advantage, because this appears to be an opportunity to select the "best" die. Of course, there is no best die, and Buffett deliberately chooses second to allow himself the privilege of selecting the particular die that is stronger than whichever one was chosen by his opponent. Buffett is not guaranteed to win, but the odds are heavily stacked in his favor.

When Buffett tried this trick on Bill Gates, the founder of Microsoft was immediately suspicious. He spent a while examining the dice and then politely suggested that Buffet should choose his die first.

CHAPTER 9

TO INFINITY AND BEYOND

· • · • · • · • · • ·

"Dead Putting Society" (1990) tells the story of a miniature golf match, in which Bart Simpson is playing Todd Flanders, the son of neighbor Ned Flanders. It is a very high-stakes confrontation, because the father of the loser faces a terrible fate. He will have to mow the winner's lawn in his wife's dress.

During a tense exchange between the two fathers, Homer and Ned invoke infinity to reinforce their positions:

HOMER: This time tomorrow, you'll be wearing high heels!
NED: Nope, you will.
HOMER: 'Fraid not.
NED: 'Fraid so!
HOMER: 'Fraid not.
NED: 'Fraid so!
HOMER: 'Fraid not infinity!
NED: 'Fraid so infinity plus one!
HOMER: D'oh!

I asked which of the writers had suggested this piece of dialogue, but nobody was able to remember. This is not surprising, as the script was written more than two decades ago. However, there was general agreement that Homer and Ned's petty argument would have derailed the scriptwriting process, as it would have triggered a debate over the nature of infinity. So, is infinity plus one more than infinity? Is it a meaningful statement or just gobbledygook? Can it be proved?

In their efforts to answer these questions, the mathematicians around the scripting table would doubtless have mentioned the name of Georg

Cantor, who was born in St. Petersburg, Russia, in 1845. Cantor was the first mathematician to really grapple with the meaning of infinity. However, his explanations were always deeply technical, so it was left to the eminent German mathematician David Hilbert (1862–1943) to convey Cantor's research. He had a knack for finding analogies that made Cantor's ideas about infinity more palatable and digestible.

One of Hilbert's most celebrated explanations of infinity involved an imaginary building known as Hilbert's Hotel—a rather grand hotel with an infinite number of rooms and each door marked 1, 2, 3, and so on. One particularly busy evening, when all the rooms are occupied, a new guest turns up without a reservation. Fortunately, Dr. Hilbert, who owns the hotel, has a solution. He asks all his guests to move from their current rooms to the next one in the hotel. So the guest in room 1 moves to room 2, the guest in room 2 moves to room 3, and so on. Everyone still has a room, but room 1 is now empty and available for the new guest. This scenario suggests (and it can be proven more rigorously) that infinity plus one is equal to infinity; a paradoxical conclusion, perhaps, but one that is undeniable.

This means that Ned Flanders is wrong when he thinks he can trump Homer's infinity with infinity plus one. In fact, Flanders would have been wrong even if he tried to win the argument with "infinity plus infinity," as proved by another vignette about Hilbert's Hotel.

The hotel is full again when an infinitely large coach arrives. The coach driver asks Dr. Hilbert if the hotel can accommodate his infinite number of passengers. Hilbert is unfazed. He asks all his current guests to move to a room number that is double their current room number, so the guest in room 1 moves to room 2, the guest in room 2 moves to room 4, and so on. The existing infinity of guests now occupy only the even-numbered rooms, and an equally infinite number of odd-numbered rooms are now vacant. In this way, the hotel is able to provide rooms for the infinite number of coach passengers.

Once more, this appears to be paradoxical. You might even suspect that it is nonsense, perhaps nothing more than the result of ivory tower philosophizing. Nevertheless, these conclusions about infinity are more than mere sophistry. Mathematicians reach these

conclusions about infinity, or any other concept, by building rigorously, step-by-step, upon solid foundations.

This point is well made by an anecdote in which a university vice chancellor complains to the head of his physics department: "Why do physicists always need so much money for laboratories and equipment? Why can't you be like the mathematics department? Mathematicians only need money for pencils, paper, and wastepaper baskets. Or even better, why can't you be like the philosophy department? All they need is pencils and paper."

The anecdote is a dig at philosophers, who lack the rigor of mathematicians. Mathematics is a meticulous search for the truth, because each new proposal can be ruthlessly tested and then either accepted into the framework of knowledge or discarded into the wastepaper basket. Although mathematical concepts might sometimes be abstract and arcane, they must still pass a process of intense scrutiny.

Thus, Hilbert's Hotel has clearly demonstrated that

$$infinity = infinity + 1$$

$$infinity = infinity + infinity$$

Although Hilbert's explanation avoids technical mathematics, Cantor was forced to delve deep into the mathematical architecture of numbers in order to reach his paradoxical conclusions about infinity, and his intellectual struggles took their toll on him. He suffered severe bouts of depression, spent extended periods in a sanatorium, and grew to believe that he was in direct communication with God. Indeed, he credited God for helping him to develop his ideas and believed that infinity was synonymous with God: "It is realized in the most complete form, in a fully independent otherworldly being, *in Deo*, where I call it the Absolute Infinite or simply Absolute." Cantor's mental state was partly the result of being criticized and mocked by more conservative mathematicians who could not come to terms with his radical conclusions about infinity. Tragically, Cantor died malnourished and impoverished in 1918.

After Cantor's death, Hilbert commended his colleague's attempt to address the mathematics of infinity, stating: "The infinite! No other question has ever moved so profoundly the spirit of man; no other idea has so fruitfully stimulated his intellect; yet no other concept stands in greater need of clarification than that of the infinite."

He made it very clear that he sat in Cantor's corner in the battle to comprehend infinity: "No one shall drive us from the paradise Cantor has created for us."

• • •

In addition to the ex-mathematicians working on *The Simpsons*, the writing team has also included scientists with an interest in mathematics, such as Joel H. Cohen (no relation to David S. Cohen), who studied science at the University of Alberta in Canada. Similarly, Eric Kaplan's studies at Columbia and Berkeley included an emphasis on the philosophy of science. Meanwhile, David Mirkin, who had planned to become an electrical engineer, spent time at Philadelphia's Drexel University and the National Aviation Facilities Experimental Center before joining *The Simpsons*. George Meyer had graduated with a degree in biochemistry, and then focused his attention on mathematics in a failed attempt to invent a foolproof betting system for the dog track. This was a blessing for the world of comedy, pushing Meyer away from the dog track and toward a career as one of the most respected comedy writers in Los Angeles.

Therefore, there have always been plenty of people willing to discuss mathematics during script meetings. Yet, despite their fondness for arcane diversions, the writers of *The Simpsons* realized that a seminar about infinity, Cantor, and Hilbert's Hotel could be a distraction when it took place in the middle of a scriptwriting session. Fortunately, a solution was found, something that would encourage more mathematical discussion without disrupting the scripting process: Math Club.

The idea for the club was the result of a conversation in a Los Angeles bar between Matt Warburton and Roni Brunn. Warburton, who had studied cognitive neuroscience at Harvard University, had become a writer for *The Simpsons* soon after the series began and stayed on the

team for more than a decade. Brunn had been part of the comedy scene while at Harvard and had been a *Harvard Lampoon* editor, but her career had focused on fashion and music after graduation.

"Math Club started with my sad realization that I was getting less sharp after graduating college," recalls Brunn. "I was envious of book clubs. I don't really like reading novels, but wanted a social setting for intellectual discussions. One night at a bar, I was telling Matt Warburton that it's not fair there are only book clubs, and that there should be a math club. He gave a noncommittal 'yeah' and went on with his beer. We talked about the numerous *Simpsons* writers who have backgrounds in mathematics, and it was enough encouragement for me to get started."

Contrary to what Brad Pitt might have advised, the first rule of Math Club was that you do talk about Math Club. In fact, evangelizing was encouraged. The core members were those who wrote for *The Simpsons*, but Math Club was open to teachers, researchers, and anyone else in Los Angeles who was interested in mathematics.

The first Math Club meeting took place at Brunn's apartment in September 2002. The inaugural lecture was titled "Surreal Numbers" and was delivered by J. Stewart Burns, who had started work on a PhD in mathematics before joining *The Simpsons*. One by one, Burns's colleagues gave their own Math Club lectures, with titles such as "An Introduction to Graph Theory" and "A Random Selection of Problems in Probability."

Although Math Club was an informal gathering of friends and colleagues with a common interest, the lecturers often had impeccable academic credentials. Ken Keeler, whose lecture was titled "Subdivision of a Square," is one of the most mathematically gifted writers on *The Simpsons*. He graduated summa cum laude from Harvard University, recognition that he was one of the most brilliant applied mathematicians to complete a bachelor's degree in the class of 1983. He then moved to Stanford University and studied for a master's degree in electrical engineering before returning to Harvard, where he received a PhD in applied mathematics with the snappily titled doctoral thesis "Map Representations and Optimal Encoding for Image Segmentation." Keeler then joined AT&T Bell Laboratories in New Jersey, whose researchers have

won seven Nobel Prizes. During this period, Keeler crossed paths with Jeff Westbrook. They were both active in the same area of research and co-authored a paper titled "Short Encodings of Planar Graphs and Maps." * They also co-authored a script for the sci-fi TV series *Star Trek: Deep Space Nine*, which involved two stand-up comedians starting a war after insulting every alien in the audience during their routines.

Math Club gradually grew in size. Sometimes, in order to accommodate all the members, it was necessary to hold sessions outside and use a suspended bedsheet as a makeshift projector screen. The biggest audiences, roughly one hundred people, turned up to hear the big-name mathematicians, such as Dr. Ronald Graham, the chief scientist at the California Institute for Telecommunications and Information Technology (Cal(IT)²). Incidentally, Graham was well known as having co-authored more than two dozen papers with Paul Erdős, and he was the foremost figure in popularizing the notion of Erdős numbers. One of Graham's other claims to fame is *Graham's number*, which set a record in 1977 for the largest number ever used in a mathematical paper. To get a sense of its size, consider the *Planck volume*, which is the smallest unit of volume in physics. It is possible to squeeze $10^{/5}$ such volumes inside a single hydrogen atom. If the digits of Graham's number were to be inscribed into the fabric of the cosmos so that each digit occupied just one Planck volume, then the entire visible universe would still not be large enough to contain it. It might be comforting to know that its last ten digits are ...2464195387.

One of the most memorable Math Club lectures was given by David S. Cohen, creator of Homer's last theorem. Cohen's talk was special because it was dedicated to explaining the research he had conducted prior to becoming a comedy writer. Having graduated with a degree from Harvard University, Cohen then spent a year at the Harvard Robotics Laboratory, later going on to complete a master's degree in computer science at the University of California, Berkeley. While at Berkeley, Cohen conducted research into the so-called *pancake sorting problem*, and this topic formed the basis of his Math Club lecture.

* *Discrete Applied Mathematics* 58, no. 3 (1995): 239–52.

The pancake sorting problem had first been posed in 1975 by Jacob E. Goodman, a geometer at the City College of New York, who used the pseudonym Harry Dweighter (harried waiter). He wrote:

The chef in our place is sloppy, and when he prepares a stack of pancakes they come out all different sizes. Therefore, when I deliver them to a customer, on the way to the table I rearrange them (so that the smallest winds up on top, and so on, down to the largest at the bottom) by grabbing several from the top and flipping them over, repeating this (varying the number I flip) as many times as necessary. If there are n pancakes, what is the maximum number of flips (as a function of n) that I will ever have to use to rearrange them?

In other words, if Homer visits Springfield's Municipal House of Pancakes, as featured in "The Twisted World of Marge Simpson" (1997), and the waiter delivers him n pancakes in a random size order, how many flips will be required to put them into the correct size order in the worst-case scenario? This number of flips is known as the pancake number, P_n. The challenge is to find a formula that predicts P_n.

The pancake sorting problem immediately captured the interest of mathematicians for two reasons. First, it seemed to offer potential insights into solving computer science problems, because rearranging pancakes has parallels with rearranging data. Second, it was a deceptively difficult puzzle, and mathematicians adore problems that are borderline impossible.

Some simple cases illuminate the problem. First, what is the pancake number for just one pancake? The answer is zero, because the pancake cannot arrive in the wrong order. So, $P_1 = 0$.

Next, what is the pancake number for two pancakes? Either the pancakes arrive in the correct order, or the reverse order. The worst case is easy to identify, and it requires only one flip to overturn both pancakes at once to transform them into the correct arrangement of pancakes. So, $P_2 = 1$.

Next, what is the pancake number for three pancakes? This is

trickier, because there are six possible starting arrangements. Depending on the starting arrangement, the number of flips required to reach the correct arrangement varies from zero to a worst-case scenario of three, so $P_3 = 3$.

In most cases, you can work out for yourself how to obtain the correct order in the appropriate number of flips. However, for the worst-case scenario, the reordering process is not obvious, so this series of three flips is shown below. Each row indicates the action of one flip, namely where the spatula is inserted and the pancake order after the flip.

As the pile of pancakes grows, the problem becomes increasingly difficult as there are more and more possible starting arrangements,

and an increasing number of possible flipping procedures. Worse still, there seems to be no pattern in the series of pancake numbers (P_n). Here are the first nineteen pancake numbers:

n	1	2	3	4	5	6	7	8	9	10
P	0	1	3	4	5	7	8	9	10	11

n	11	12	13	14	15	16	17	18	19	20
P	13	14	15	16	17	18	19	20	22	?

The sheer difficulty in running through all the pancake permutations and possible flipping strategies means that even very powerful computers have not yet been able to calculate the twentieth pancake number. And, after more than three decades, nobody has been able to sidestep the brute force computational approach by finding a clever equation that predicts pancake numbers. So far, the only breakthroughs have been in finding equations that set limits on the pancake number. In 1979, the upper limit for the pancake number was shown to be less than $(5n + 5)/3$ flips. This means that we can take a foolishly large number of pancakes, such as a thousand, and know for a fact that the pancake number (i.e., the number of flips required to rearrange the pancakes into size order in the worst-case scenario) will be less than

$$\frac{(5 \times 1,000 + 5)}{3} = 1,668\tfrac{1}{3}$$

Thus, given that you cannot perform a third of a flip, $P_{1,000}$ is less than or equal to 1,668. This result is famous, because it was published in a paper that was co-authored by William H. Gates and Christos H. Papadimitriou. William H. Gates is better known as Bill Gates, cofounder of Microsoft, and this is thought to be the only research paper that he has ever published.

The Gates paper, based on work he did as an undergraduate at Harvard, also mentions a devious variation of the problem. The *burnt*

pancake problem involves pancakes that are burnt on one side, so the challenge is to flip them into the right orientation (burnt side down), as well as flipping them into the correct size order. This is the problem that was addressed by David S. Cohen while at Berkeley.

Cohen authored a paper* on the burnt pancake problem in 1995, which set the lower and upper bounds for burnt pancake flipping between $3n/2$ and $2n - 2$. If we again use the example of 1,000 pancakes, but this time burnt, then we know that the number of flips required to orient and order them in the worst-case scenario is between 1,500 and 1,998.

This is what makes the writers of *The Simpsons* unique. They not only attend Math Club, but they also deliver rigorous lectures and even author serious mathematical research papers.

David S. Cohen recounted an anecdote that shows how the writers sometimes even astonish themselves when they realize the sheer level of mathematical prowess within the team: "I had written this paper on pancake numbers with help from my adviser, Manuel Blum, who's a well-known computer scientist, and we submitted it to a journal called *Discrete Applied Mathematics*. I subsequently left graduate school to come and write for *The Simpsons*. After the paper was accepted, there was an extremely long lag between it being submitted, revised, and published. So, by the time the paper was published, I had been working at *The Simpsons* for a while, and Ken Keeler had also been hired at that point. So, finally the research article appeared, and I came in with the reprints of this article and I said, 'Hey, I've got an article in *Discrete Applied Mathematics*.' Everyone was quite impressed, except Ken Keeler, who said, 'Oh yeah, I had a paper in that journal a couple of months ago.'"

With a wry smile on his face, Cohen bemoaned: "What does it mean that I come to write for *The Simpsons* and I cannot even be the only writer on this show with a paper in *Discrete Applied Mathematics*?"

* "On the Problem of Sorting Burnt Pancakes," *Discrete Applied Mathematics* 61, no. 2 (1995): 105–20.

THE SCARECROW THEOREM

· ● · ● · ● · ● · ● · ● · ●

Homer Simpson is not usually considered an intellectual power-house, instead enjoying a reputation as one of Springfield's more down-to-earth citizens. In "Homer vs. the Eighteenth Amendment" (1997), he offers a toast that explains his simple philosophy of life: "To alcohol! The cause of, and solution to, all of life's problems."

Nevertheless, the writers do occasionally allow Homer off the leash in order to explore the nerdier side of his character. We have already seen this in the 1998 episode "The Wizard of Evergreen Terrace," and there are several other episodes in which Homer shows that he can be a poster boy for geek pride. For example, the world's most prestigious scientific journal, *Nature*, praised him for a comment he makes in the episode "The PTA Disbands" (1995). After catching his daughter trying to build a perpetual motion machine, he puts her firmly in her place: "Lisa, in this house we *obey* the laws of thermodynamics!"

As well as parroting some of science's most fundamental laws, Homer also occasionally sets the scientific agenda. In "E-I-E-I-D'oh" (1999), he turns his hand to farming and sprinkles plutonium on his fields to boost his yield. Not surprisingly, the resulting plants are mutants. Homer calls his new crop *tomacco*, because the plants have the outward appearance of tomatoes and yet contain tobacco inside.

Rob Bauer, a *Simpsons* fan from Oregon, saw the episode and was inspired to replicate Homer's achievement. Instead of using radioactive material, he grafted tobacco roots onto a tomato plant and waited to see what would happen. It was not a completely crazy idea, because tomatoes and tobacco both belong to the nightshade family of plants, so grafting such plant relatives might enable the properties of one plant to transfer to the other. Indeed, the leaves of Bauer's tomato

plant did contain nicotine, proving that science fact can be almost as strange as science fiction.

The writers also encouraged Homer's intellectual side to flourish in "They Saved Lisa's Brain," an episode that has already been discussed in Chapter 7. After Stephen Hawking saves Lisa from a baying mob, the story ends with Professor Hawking chatting to Lisa's father in Moe's Tavern, where he is impressed with Homer's ideas about cosmology: "Your theory of a doughnut-shaped universe is intriguing . . . I may have to steal it."

This sounds ridiculous, but mathematically minded cosmologists claim that the universe might actually be structured like a doughnut. In order to explain how this geometry is possible, let us simplify the universe by imagining that the entire cosmos is flattened from three dimensions into two dimensions, so that everything exists on a sheet. Common sense might suggest that this universal sheet would be flat and extend to infinity in all directions. But cosmology is rarely a matter of common sense. Einstein taught us that space can bend, which leads to all sorts of other potential scenarios. For example, imagine that the universal sheet is not infinite, but instead has four edges, so that it looks rather like a large rectangular sheet of rubber. Next, imagine joining the two long edges of the sheet so it forms a cylinder, then connecting the two ends of the cylinder so that the whole sheet has been transformed into a hollow doughnut. This is exactly the sort of universe that Hawking and Homer were discussing.

If you lived on the surface of this doughnut universe, you could follow the grey arrow and eventually return to your original position.

Alternatively, you could follow the black arrow and, again, you would end up back where you started. The doughnut universe behaves rather like the spacescape of *Asteroids*, Atari's best selling video game of all time. If the player's ship flies eastward, then it leaves the screen on the right and returns on the left, eventually returning to its original position. Similarly, if the ship heads northward, then it leaves the top of the screen and reenters at the bottom, eventually returning once again to where it started.

Of course, we have discussed the theory only in terms of two dimensions, but within the laws of physics it is permissible for a three-dimensional universe to be rolled into a cylinder and formed into a doughnut. For nonmathematicians, it is almost impossible to visualize manipulating three-dimensional space in this manner, but Hawking and Homer understand that the doughnut is a perfectly viable reality for the shape of our universe. As the British scientist J. B. S. Haldane (1892–1964) once said: "My suspicion is that the Universe is not only queerer than we suppose, but queerer than we can suppose."

In other episodes, the writers create a trigger event that galvanizes Homer's brain, which in turn allows him to excel in mathematics. In "НОМЯ" (2001), Homer removes a crayon that has been lodged in his brain and suddenly realizes that he can use calculus to prove that God does not exist. He shows the proof to Ned Flanders, his God-fearing neighbor, who is initially suspicious of Homer's claim to have made God vanish in a puff of logic. Flanders examines the proof and mutters: "We'll just see about that . . .uh-oh. Well, maybe he made a mistake . . .Nope. It's airtight. Can't let this little doozy get out." Unable to find any flaw that will undermine Homer's logic, Flanders sets fire to the proof.

This scene pays homage to one of the most famous episodes in the history of mathematics, when the greatest mathematician of the eighteenth century, Leonhard Euler, pretended to prove the opposite of Homer's conclusion, namely that God does exist. The incident took place while he was at the court of Catherine the Great in St. Petersburg. Catherine and her courtiers were becoming increasingly con-

cerned about the influence of the visiting French philosopher Denis Diderot, who was an outspoken atheist. He was also supposedly terrified of mathematics. Hence, Euler was asked to construct a fake equation that would apparently prove the existence of God and put an end to Diderot's heresies. When he was publicly confronted with Euler's complicated equation, Diderot was left speechless. Diderot became the laughingstock of St. Petersburg after this humiliating encounter, and he soon asked for permission to return to Paris.

Homer's mathematical brain receives another temporary boost in "$pringfield (Or, How I Learned to Stop Worrying and Love Legalized Gambling)" (1993). At the start of that episode, Henry Kissinger is (somewhat inexplicably) touring Homer's workplace, the Springfield Nuclear Power Plant. Unfortunately, the former U.S. secretary of state drops his trademark spectacles into the toilet while visiting one of the power plant's washrooms. Too timid to fish them out, and too embarrassed to tell anyone about his missing glasses, Kissinger then mutters to himself: "No one must know I dropped them in the toilet. Not I, the man who drafted the Paris Peace Accords."

A short while later, Homer visits the same washroom and discovers the glasses in the toilet bowl. Of course, he cannot resist putting them on, whereupon the glasses seem to endow him with the powers of Kissinger's brain. While still in the washroom, Homer even starts regurgitating a mathematical formula:

> "The sum of the square roots of any two sides of
> an isosceles triangle is equal to the square root of
> the remaining side."

At first, this sounds like a straightforward proclamation of the Pythagorean theorem, but in fact it is wrong in several ways. The actual theorem states:

> "The square of the hypotenuse of a right triangle
> is equal to the sum of the squares of the two
> adjacent sides."

The most obvious difference is that Homer's statement concerns isosceles triangles, whereas the Pythagorean theorem relates to right triangles. You may remember from school that an isosceles triangle has two equal sides, whereas a right triangle has no restriction on the lengths of its sides, as long as one corner is a right angle.

There are two more problems in Homer's statement. First, he talks about the "square roots" of lengths, whereas the Pythagorean theorem relies on the "squares" of lengths. Second, the Pythagorean theorem relates the hypotenuse (the longest side) of the right triangle to the other two sides, whereas Homer relates "any two sides" of the isosceles triangle to "the remaining side." "Any two sides" could be the two equal sides or just one of the equal sides and the unequal side.

The diagrams and equations below summarize and highlight the differences between Homer's statement and the Pythagorean theorem. Homer has taken a standard piece of mathematics and given it a twist, thereby creating a modification of the Pythagorean theorem, namely Simpson's conjecture. The difference between a theorem and a conjecture is that the former has been proven to be true, whereas the latter is neither proven nor disproven . . . yet.

SIMPSON'S CONJECTURE	(triangle with sides a, a, b)	(1) $\sqrt{a} + \sqrt{a} = \sqrt{b}$ AND (2) $\sqrt{a} + \sqrt{b} = \sqrt{a}$
PYTHAGOREAN THEOREM	(right triangle with sides c, a, b)	$a^2 + b^2 = c^2$

Simpson's conjecture concerns *all* isosceles triangles, so if we try to prove it then we should need to show that it holds true for an infinity of triangles. However, if instead we try to disprove Simpson's conjecture, then we would need to find just one triangle that defies the

conjecture. As disproving seems easier than proving, let us see if we can find a one counterexample that destroys the conjecture.

Let us consider an isosceles triangle with two sides of length 9 and a base of length 4. Does the sum of the square roots of any two sides of this isosceles triangle equal the square root of the remaining side?

$\sqrt{9} + \sqrt{9} = \sqrt{4}$ implies that $3 + 3 = 2$, which is wrong

$\sqrt{9} + \sqrt{4} = \sqrt{9}$ implies that $3 + 2 = 3$, which is also wrong

In both cases, the square roots simply do not add up, so the conjecture is clearly false.

This is not Homer's finest hour, obviously, yet perhaps we should not judge him too harshly, particularly as he was under the influence of Kissinger's spectacles. Indeed, if anybody is to blame, it must be the writers.

Josh Weinstein, who shared lead writer credit with Bill Oakley on the episode, told me how the scene had developed and why it contained such a nonsensical conjecture: "That joke developed backward, because we needed Mr. Burns, Homer's boss, to think that Homer is smart. We thought, 'So how is he going to think that Homer is smart? Oh, it would be funny if he found a pair of glasses in the toilet. Who would the glasses belong to? Oh, Henry Kissinger!' We like Henry Kissinger (and Nixon-era stuff) and he seemed like somebody who would be friends with Mr. Burns."

The script then needed a line in order for Homer to demonstrate his newly acquired confidence in his own intelligence. At this point, the writing team got to work, and one of the more mathematical writers realized that Homer's situation had strong parallels with one of the final scenes in *The Wizard of Oz* (1939).* As Dorothy follows the yellow brick road to Oz, she is accompanied by the Cowardly Lion, who

* The culprit was probably David Mirkin, an ex-engineer with an interest in mathematics. He was executive producer on this episode and two others in 1993 ("The Last Temptation of Homer" and "Rosebud"), which all contain references to *The Wizard of Oz*.

is searching for courage, the Tin Man, who is searching for a heart, and the Scarecrow, who is searching for a brain. It is said that the Scarecrow represents a typical down-to-earth decent Kansas farmer, who would probably have had tremendous common sense, but would have lacked any formal education. When they eventually find the Wizard, he is unable to give the Scarecrow a brain, but he does reward him with a diploma, at which point the Scarecrow blurts out: "The sum of the square roots of any two sides of an isosceles triangle is equal to the square root of the remaining side."

Thus, Homer was quoting a line originally delivered by the Scarecrow in *The Wizard of Oz*. The Simpson conjecture is really the Scarecrow conjecture. The writers of *The Simpsons* were using the same mathematical pseudo-conjecture, because Homer's discovery of Kissinger's glasses and the Scarecrow receiving his diploma had the same effect on the characters involved, inasmuch as afterward both Homer and the Scarecrow were much more confident about their intellectual ability.

Only a tiny fraction of viewers would have noticed that Homer was recycling the Scarecrow conjecture. These viewers could best be described as occupying the overlap in the Venn diagram that has obsessive fans of *The Wizard of Oz* in one set and mathematicians in the other set. This overlap includes James Yick, Anahita Rafiee, and Charles Beasley, students in the Department of Mathematics and Computer Science at Augusta State University in Georgia, who have scrutinized the original scene from *The Wizard of Oz*. In particular, they have challenged the theory that the Scarecrow was supposed to quote the Pythagorean theorem, and that the actor playing the Scarecrow, Ray Bolger, accidentally made an error that was not spotted until it was too late. Instead, these mathematicians have argued that the scriptwriters of *The Wizard of Oz* deliberately distorted the Pythagorean theorem. They state: "We feel it was an act of deliberate sabotage because of the speed at which the actor states his lines, suggesting a lot of practice, and the three obvious errors in the wording of the lines . . . Were [the writers] trying to make a point about their view of the real value of diplomas? Were they trying to make a state-

ment about the lack of real knowledge in the population of viewers at large, implying that we are all 'scarecrows' as their little inside joke?"

Regardless of its origins and the motivations behind it, the Scarecrow conjecture is undoubtedly false, but it did inspire the trio of mathematicians at Augusta State to investigate the opposite of the Scarecrow conjecture, known as the *crow conjecture*, which states:

"The sum of the square roots of any two sides of
an isosceles triangle is *never* equal to the square
root of the remaining side."

So, is Yick, Rafiee, and Beasley's crow conjecture true? We can test it by checking the two equations. Starting with equation (1), we can restate it and then rearrange it slightly:

$$\sqrt{a} + \sqrt{a} \neq \sqrt{b}$$

$$2\sqrt{a} \neq \sqrt{b}$$

$$4a \neq b$$

$$a \neq \tfrac{1}{4}b$$

This final equation states that it can never be true that the lengths *a* are only one-quarter of the base *b*. Indeed, this must be the case, because *a* must be bigger than ½*b*, otherwise the three sides of the triangle will not touch each other. A quick look at the triangle above should make this obvious.

Having demonstrated that equation (1) is valid, let's check equation (2):

$$\sqrt{a} + \sqrt{b} \neq \sqrt{a}$$

$$\sqrt{b} \neq 0$$

$$b \neq 0$$

In other words, equation (2) states that the base of an isosceles triangle cannot have zero length. This is indeed true, otherwise we would have a triangle with only two sides! These sides would overlap, so arguably we would have a triangle with only one side!

Therefore, we can be sure that it is never possible for the sum of the square roots of any two sides of an isosceles triangle to be equal to the square root of the remaining side. It is not a deeply profound discovery, but the crow conjecture can now be elevated to the status of the crow theorem.

• • •

Simpson's conjecture turned out to be nothing more than a restatement of the Scarecrow conjecture, which in any case turned out to be false. There is, however, some consolation for the Simpson family, as several important—and valid—concepts in mathematics bear their name.

For example, *Simpson's paradox* is arguably one of the most baffling paradoxes in mathematics. It was popularized and investigated by Edward H. Simpson, who developed an interest in statistics while working at Bletchley Park, the secret British code-breaking headquarters during the Second World War.

One of the best illustrations of Simpson's paradox concerns the American Civil Rights Act of 1964, a historic piece of legislation aimed at tackling discrimination. In particular, the paradox emerges if we scrutinize in detail the voting records of the Democrats and Republicans when the act came before the U.S. House of Representatives.

In the northern states, 94 percent of Democrats voted for the act,

compared with only 85 percent of Republicans. Hence, in the north, a higher percentage of Democrats than Republicans voted for the act.

In the southern states, 7 percent of Democrats voted for the act, compared with 0 percent of Republicans. So, also in the south, a higher percentage of Democrats than Republicans voted for the act.

The obvious conclusion is that Democrats showed more support for the Civil Rights Act than Republicans. However, if the numbers are combined for both southern and northern states, then 80 percent of Republicans voted for the act compared with only 61 percent of Democrats.

In other words, I am stating that Democrats outvoted Republicans in the north and south separately in support of the act, but Republicans outvoted Democrats in the north and south combined! This sounds ludicrous, yet these facts are undeniable. This is Simpson's paradox.

In order to make sense of the paradox, instead of dealing in percentages it will help to look at the actual voting numbers. From the northern states, those voting for the act consisted of 145 out of 154 Democrats (94 percent), alongside 138 out of 162 Republicans (85 percent). From the southern states, those for voting for the act consisted of 7 out of 94 Democrats (7 percent), alongside zero out of 10 Republicans (0 percent). As stated already, Democratic support for the act seems to be stronger than Republican support in both the northern and southern states. However, the trend reverses nationally, because 152 out of 248 Democrats (61 percent) voted for the Act, compared with 138 out of 172 Republicans (80 percent).

	Northern Voting Record		Southern Voting Record		National Voting Record	
Democrats	145/154	94%	7/94	7%	152/248	61%
Republicans	138/162	85%	0/10	0%	138/172	80%

So, how do we resolve this example of Simpson's paradox? There are four points about the data that shed light on the mystery. First, if

we are comparing Republican and Democratic voting records, then we have to look at the overall data—the combined national totals—which leads to the conclusion that Republicans were more supportive of the Civil Rights Act than Democrats. That has to be the bottom line.

Second, although we might want to look for a difference in the Republican and Democrat voting records, the really striking difference is between the northern and southern representatives, regardless of political party. Support in the north is at roughly 90 percent, whereas support in the south plummets to just 7 percent. If we focus on one variable (e.g., Democrat v. Republican), while paying less attention to a more important variable (e.g., north v. south), then the latter is often referred to as a *lurking variable.*

Third, percentages can be helpful for making comparisons in some situations, but when we started off looking at only percentages we failed to take into account the actual numbers of votes, and therefore we failed to see the significance of particular results. For example, the 0 percent result for southern Republicans sounds damning, but there were only 10 Republican representatives from the south; if just one southern Republican had voted for the act, then Republican support in the south would have increased from 0 percent to 10 percent and overtaken Democratic support, which was only 7 percent.

Finally, the most important part of the data is the voting record of the southern Democrats. The key point is that there was much less support for the act in the southern states than in the northern states, and the southern states elected predominantly Democrats. This large level of weak support from southern Democrats dragged down the Democratic average, and this was ultimately responsible for reversing the trend when we look at the totality of the data.

Importantly, the voting records for the 1964 Civil Rights Act are not a rare statistical quirk. This sort of reversal in interpreting data, Simpson's paradox, causes confusion in many other situations, ranging from sporting statistics to medical data.

Before finishing this chapter, I should point out that there are further Simpsons in the world of mathematics. For example, the name

Simpson is also mathematically immortalized in *Simpson's rule*, a technique in calculus that can be used to estimate the area under any curve. It was named after the British mathematician Thomas Simpson (1710–61), who at the age of fifteen became a mathematics teacher in Nuneaton, England. Eight years later, according to the historian Niccolò Guicciardini, he made one of those mistakes that could happen to any of us when he "had to flee to Derby in 1733 after he or his assistant had frightened a girl by dressing up as a devil during an astrology session."

And, of course, there is the Carlson-Simpson theorem, which needs no explanation, except to state that it implies the coloring Hales-Jewett theorem and is used in the Furstenberg-Katznelson argument. But I am sure that you do not need me to tell you that.

And finally, there is the unforgettable Bart's theorem.*

* In case you have forgotten it, you can look up Bart's theorem in a paper titled "Periodic Strongly Continuous Semigroups," by Professor Harm Bart, published in *Annali di Matematica Pura ed Applicata* 115, no. 1 (1977): 311–18.

EXAMINATION III

UNIVERSITY SENIOR PAPER

Joke 1 Q: Why do computer scientists get Halloween 2 points
and Christmas mixed up?
A: Because Oct. 31 = Dec. 25.

Joke 2 If the Teletubbies are a product of time and 4 points
money, then:

Teletubbies = Time x Money

$\qquad\qquad$ But, Time = Money

\Rightarrow Teletubbies = Money x Money

\Rightarrow Teletubbies = Money2

$\qquad\qquad$ Money is the root of all evil

$\qquad\qquad\qquad$ \therefore Money = \sqrt{Evil}

$\qquad\qquad\qquad$ \therefore Money2 = Evil

\Rightarrow Teletubbies = Evil

Joke 3 Q: How hard is counting in binary? 2 points
A: It is as easy as 01 10 11.

Joke 4 Q: Why should you not mix alcohol and 2 points
calculus?
A: Because you should not drink and derive.

Joke 5 Student: "What's your favorite thing about 2 points
mathematics?"
Professor: "Knot theory."
Student: "Yeah, me neither."

Joke 6 When the Ark eventually lands after the Flood, 4 points
Noah releases all the animals and makes a
proclamation: "Go forth and multiply."

Several months later, Noah is delighted to see
that all the creatures are breeding, except a pair
of snakes, who remain childless. Noah asks:
"What's the problem?" The snakes have a
simple request of Noah: "Please cut down some
trees and let us live there."

Noah obliges, leaves them alone for a few
weeks and then returns. Sure enough, there are
lots of baby snakes. Noah asks why it was
important to cut down the trees, and the snakes
reply: "We're adders, and we need logs to
multiply."

Joke 7 Q: If $\lim\limits_{x \to 8} \dfrac{1}{x-8} = \infty$ 4 points

then solve the following:

$$\lim\limits_{x \to 5} \dfrac{1}{x-5} = ?$$

A: 5

TOTAL – 20 POINTS

기사리

CHAPTER 11

FREEZE-FRAME MATHEMATICS

· ● · ● · ● · ● · ● · ● ·

The Flintstones, first broadcast in 1960, was a major prime-time success for the ABC network, with 166 episodes aired across six seasons. However, there would not be another major prime-time animated sitcom until 1989, when *The Simpsons* started its run of over five hundred episodes. By proving that an animated sitcom could appeal to both young and old, *The Simpsons* inspired other shows, such as *Family Guy* and *South Park*. Matt Groening and his team of writers also proved that comedies did not necessarily require a laugh track, which paved the way for shows such as Ricky Gervais's *The Office*.

Another pioneering aspect of *The Simpsons*, according to writer Patric Verrone, has been the development of the *freeze-frame gag*: "If it wasn't invented at *The Simpsons*, it's been perfected here. It's a joke that just goes by unnoticed in the normal course of viewing, so you have to freeze the frame to see it. A lot of them are typically book titles or signs. It's harder to put that sort of thing in a live-action show."

Freeze-frame gags—which can last literally for just a single frame, or sometimes for a little longer—were included in *The Simpsons* from the beginning. In "Bart the Genius," the first proper episode of *The Simpsons*, we see a library that contains both *The Iliad* and *The Odyssey*. Blink and you would have missed them. The joke, of course, is that these ancient Greek texts were written by Homer.

Freeze-frame gags were an opportunity to increase the comedic density of the show, but they also enabled the writers to introduce obscure references that rewarded viewers with niche knowledge. In that same episode, one of the students momentarily flashes his Anatoly Karpov lunchbox. Karpov was world chess champion from 1975 to 1985. His other claim to fame is that he holds the record for being the

seller of the most valuable stamp from the Belgian Congo, auctioned off at $80,000 in 2011. If a viewer did not see the gag, then nothing was lost. However, if just one viewer noticed and appreciated the reference, then the writers considered it to be worth the effort.

To a large extent, the freeze-frame gag was a product of technological developments. Roughly 65 percent of American households owned a video cassette recorder by 1989, when *The Simpsons* was launched. This meant that fans could watch episodes several times and pause a scene when they had spotted something curious. At the same time, more than 10 percent of households had a home computer and a few people even had access to the Internet. The following year saw the birth of alt.tv.simpsons, a Usenet newsgroup that allowed fans to share, among other things, their freeze-frame discoveries.

According to Chris Turner, author of *Planet Simpson*, the most extreme version of freeze-frame humor appears in "Homer Badman" (1994), an episode in which a sensationalist investigative show called *Rock Bottom* falsely accuses Homer of lecherous behavior. The host, Godfrey Jones, is forced to make an apology on air and issue a correction, which takes the form of text rapidly scrolling down the screen. The average viewer sees nothing more than a blur, but there were thirty-four freeze-frame gags in four seconds, all perfectly legible for anybody willing to pause the episode and step through the corrections frame by frame.

Crucially, freeze-frame gags provided opportunities for the mathematical writers on *The Simpsons* to throw in some references that would appeal to hard-core number nerds. For example, "Colonel Homer" (1992) features the first appearance of the local movie theater, and eagle-eyed viewers would have noticed that it is called the Springfield Googolplex. In order to appreciate this reference it is necessary to go back to 1938, when the American mathematician Edward Kasner was in conversation with his nephew Milton Sirotta. Kasner casually mentioned that it would be useful to have a label to describe the number 10^{100} (or 10,000,000,000,000,000,000,000,000,000,000,000,000,000,000,000, 000,000,000,000,000,000,000,000,000,000,000,000,000,000,000, 000,000,000). The nine-year-old Milton suggested the word *googol*.

FREEZE-FRAME GAGS
FROM THE SIMPSONS

"HOMER BADMAN" (1994)

Lines on *Rock Bottom* correction list

If you are reading this, you have no life.

Our viewers are not pathetic sexless food tubes.

Quayle is familiar with common bathroom procedures.

The people who are writing this have no life.

"DUMBBELL INDEMNITY" (1998)

Sign outside Stu's Disco

You Must Be at Least This Swarthy to Enter

"LARD OF THE DANCE" (1998)

Name of shop offering "Winter Madness Sale"

Donner's Party Supplies

"BART VS. LISA VS. THE THIRD GRADE" (2002)

Title of Lisa's book

Love in the Time of Coloring Books

"CO-DEPENDENT'S DAY" (2004)

Sign outside First Church of Springfield

We Welcome Other Faiths (Just Kidding)

"BART HAS TWO MOMMIES" (2006)

Sign at Left-Handers Convention

Today's Seminar—Ambidextrous: Lefties in Denial?

In his book *Mathematics and the Imagination*, Kasner recalled how the conversation with his nephew continued: "At the same time that he suggested 'googol' he gave a name for a still larger number: 'Googolplex.' A googolplex is much larger than a googol, but is still finite, as the inventor of the name was quick to point out. It was first suggested that a googolplex should be 1, followed by writing zeros until you get tired."

The uncle rightly felt that the googolplex would then be a somewhat arbitrary and subjective number, so he suggested that the googolplex should be redefined as 10^{googol}. That is 1 followed by a googol zeroes, which is far more zeroes than you could fit on a piece of paper the size of the observable universe, even if you used the smallest font imaginable.

These terms—*googol* and *googolplex*—have become moderately well known today, even among members of the general public, because the term googol was adopted by Larry Page and Sergey Brin as the name of their search engine. However, they preferred a common misspelling, so the company is called Google, not Googol. The name implies that the search engine provides access to vast amounts of information. Google headquarters is, not surprisingly, called the Googleplex.

Simpsons writer Al Jean recalls that the Springfield Googolplex freeze-frame gag was not in the original draft of the script for "Colonel Homer." Instead, he is confident that it was inserted in one of the collaborative rewrites, when the mathematical members of the team tend to exert their influence: "Yeah, I was definitely in the room for that. My recollection is that I didn't pitch Googolplex, but I definitely laughed at it. It was based on theaters that are called octoplexes and multiplexes. I remember when I was in elementary school, the smartass kids were always talking about googols. That was definitely a joke by the rewrite room on that episode."

Mike Reiss, who had worked with Jean on *The Simpsons* since the first season, thinks that the Springfield Googolplex was possibly his freeze-frame gag. When a fellow writer raised a concern that the joke was too obscure, Reiss remembers being very protective: "Someone made some remark about me giving him a joke that nobody was ever going to get, but it stayed in . . . It was harmless; how funny can the name of a multiplex theater be?"

Another mathematical freeze-frame appears in "MoneyBART." In fact, you may already have glimpsed it in the frame presented in Chapter 6. Here is a close-up in order to help identify the freeze-frame reference.

When Lisa is studying to become a first-rate baseball coach, we see her surrounded by books, and one of the spines displays the title "$e^{i\pi} + 1 = 0$." If you have studied mathematics beyond high school, then you may recognize this as *Euler's equation*, sometimes referred to as *Euler's identity*. An explanation of Euler's equation would involve a degree of complexity that is beyond the scope of this chapter, but there is a partial and moderately technical explanation in appendix 2. In the meantime, we will focus on the initial component of the equation, which is a peculiar little number known as *e*.

The number *e* was discovered when mathematicians began to study a fascinating question about the usually tedious subject of bank interest. Imagine a simple investment scenario, in which one invests $1.00 in an extraordinarily convenient and generous bank account that offers 100 percent interest per year. At the end of the year, that $1.00 would have accrued $1.00 interest, giving a total of $2.00.

Now, instead of 100 percent interest after one year, consider a scenario in which the interest is halved, but calculated twice. In other words, the investor receives 50 percent interest after both six and twelve months. Thus, after the first six months, the $1.00 would have accrued $0.50 interest, giving a total of $1.50. During the second six months, interest is gathered on both the $1.00 and the additional $0.50 interest that has already accrued. Therefore the additional in-

terest added after twelve months is 50 percent of $1.50, which equals $0.75, resulting in an overall total of $2.25 at the end of the year. This is known as *compound interest*.

As you can see, the good news is that this half-year compound interest is more profitable than simple annual interest. The bank balance could have been even higher if the compound interest had been calculated more frequently. For instance, if it had been calculated quarterly (25 percent every three months), then the total would have been $1.25 at the end of March, $1.56 at the end of June, $1.95 at the end of September, and $2.44 at the end of the year.

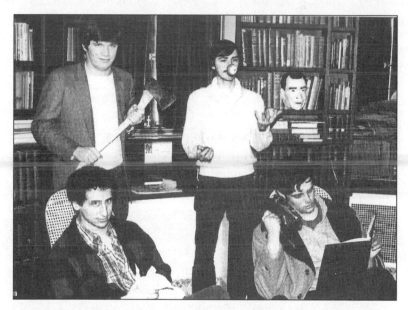

Al Jean (who is holding an iron) was in the room when Mike Reiss (seated, left) suggested Googolplex as the name of Springfield's movie theater. This 1981 photograph shows them while at Harvard in the "Lampoon Castle." Patric Verrone, who is seen here juggling pool balls, is also a successful TV comedy writer, with a list of credits that includes a 2005 episode of *The Simpsons* entitled "Milhouse of Sand and Fog." The fourth member of the group is Ted Phillips, who passed away in 2005. Although he had a talent for writing, he went on to pursue a career in law in South Carolina and was a respected local historian. He is name-checked in the episode "Radio Bart" (1992) and also has a character (Duke Phillips) named after him in *The Critic*, an animated series created by Jean and Reiss.

$$S = P\left(1+\frac{r}{n}\right)^{nc}$$
$$S = Pe^{rc}$$

If n is the number of increments (i.e., the number of times per year that interest is calculated and added), then the following formula can be used to calculate the final sum (F) when the compound interest is also calculated at monthly, weekly, daily, and even hourly intervals:

$$e = \lim_{n\to\infty}\left(1+\frac{1}{n}\right)^n$$

$$F = \$(1 + \tfrac{1}{n})^n$$

here $r = 1$ or $\frac{100}{100}$

Initial sum	Annual interest	Time increment	Number of increments (n)	Incremental interest	Final sum (F)
$1.00	100%	1 year	1	100.00%	$2.00
$1.00	100%	½ year	2	50.00%	$2.25
$1.00	100%	¼ year	4	25.00%	$2.4414...
$1.00	100%	1 month	12	8.33%	$2.6130...
$1.00	100%	1 week	52	1.92%	$2.6925...
$1.00	100%	1 day	365	0.27%	$2.7145...
$1.00	100%	1 hour	8,760	0.01%	$2.7181...

By the time compound interest is calculated on a weekly basis, we are almost $0.70 better off than if we had been earning only simple annual interest. However, after this point, calculating the compound interest even more frequently achieves only one or two more pennies. This leads us to the fascinating question that began to obsess mathematicians: If the compound interest could be calculated not just every hour, not just every second, not just every microsecond, but at every moment, what would be the final sum at the end of the year?

The answer turns out to be $2.718281828459045235360287471352662497757247093699959574966967627724076630353547594571382178525166427.... As you can probably guess, the decimal places continue to infinity, it is an irrational number, and it is the number that we call e.

2.718... was named e because it relates to *exponential growth*, which describes the surprising rate of growth experienced when money gathers interest year after year, or when anything repeatedly grows by a fixed rate again and again. For example, if the investment did increase

e = euler's #

in value by a factor of 2.718... year after year, then $1.00 becomes $2.72 after year one, then $7.39 after year two, then $20.09, then $54.60, then $148.41, then $403.43, then $1,096.63, then $2,980.96, then $8,102.08, and finally $22,026.47, in just ten years.

Such staggering rates of sustained exponential growth are rare within the world of financial investment, but there are concrete examples elsewhere. The most famous illustration of exponential growth has taken place in the world of technology and is known as *Moore's law*, named after Gordon Moore, co-founder of Intel. In 1965, he observed that the number of transistors on a microprocessor chip doubles approximately every two years, and he predicted that this trend would continue. Sure enough, Moore's law has held true decade after decade. The forty years between 1971 and 2011 have resulted in twenty doublings in the number of transistors. In other words, there has been an improvement by a factor of 2^{20}, or roughly one million, in the number of transistors on a chip over four decades. This is why we now have microprocessors with vastly improved performance at hugely reduced costs compared with the 1970s.

By way of analogy, it is sometimes said that if cars had achieved the same rapid improvement as computers, then a Ferrari would cost just $100 today and would manage a million miles per gallon . . . but it would also crash once a week.

Being linked to compound interest and exponential growth is interesting, but *e* has much more to offer the world. Just like π, the number *e* crops up in all sorts of unexpected situations.

For example, *e* is at the heart of the so-called *problem of derangements*, more commonly known as the *hat check problem*. Imagine that you are running the cloakroom at a restaurant, collecting hats from customers and putting them in hat boxes. Unfortunately, you do not make a note of which hat belongs to which person. As the diners return later in the evening, you hand back the hat boxes at random and wave good-bye to the customers before they have a chance to open the boxes. What is the probability that none of the boxes contains the

right hat for the)right person? The answer depends on the number of customers (n), and the probability for zero matches, labeled P(n), can be found according to the following formula*:

$$P(n) = 1 - \frac{1}{1!} + \frac{1}{2!} - \frac{1}{3!} + \frac{1}{4!} + \cdots + \frac{(-1)^n}{n!}$$

So for one guest the probability of zero matches is 0, because the one hat will inevitably reach the right person:

$$P(1) = 1 - \frac{1}{1!} = 0 = 0\%$$

For two guests, the probability of zero matches is 0.5:

$$P(2) = 1 - \frac{1}{1!} + \frac{1}{2!} = 0.5 = 50\%$$

For three customers, the probability of zero matches is 0.333:

$$P(3) = 1 - \frac{1}{1!} + \frac{1}{2!} - \frac{1}{3!} = 0.333 = 33\%$$

For four customers, the probability is roughly 0.375, and for ten customers it is approximately 0.369. As the number of customers tends to infinity, the probability settles down to 0.367879..., which is 1/2.718..., or 1/e.

You can test this for yourself by taking two decks of cards and shuffling each of them separately, so that the two decks are randomized. One deck represents the random way that hats were put in boxes, while the other deck represents the random order in which customers will return to collect their hats. Place the two decks side by side and turn over cards one at a time from the top of each deck. If both cards have the same suit and rank, then this counts as a match. The probability of zero matches after going through both decks will be close to 1/e, which is roughly 0.37, or 37 percent. In other words, if you repeat

* The formula contains the ! symbol, which represents the *factorial* operation. This is best explained by example: 1! = 1, 2! = 2 × 1, 3! = 3 × 2 × 1, and so on.

this entire process one hundred times, then you can expect a very poor social life and roughly thirty-seven pairs of decks with zero matches. The hat check problem might seem trivial, but it is a fundamental question in an area known as *combinatorial mathematics*.

The number *e* also crops up in the study of a type of curve known as a *catenary*, which is the shape formed by a chain hammocked between two points. The term was coined by Thomas Jefferson and is based on the Latin word *catena*, meaning "chain." The shape of a catenary curve is described by the following equation, which has *e* at its heart, twice:

$$y = \frac{a}{2} \left(e^{x/a} + e^{-x/a} \right)$$

The silk in a spider's web forms a series of catenaries between the spokes, which prompted French entomologist Jean-Henri Fabre to write in *La Vie des Araignées* (The Life of the Spider): "Here we have the abracadabric number *e* reappearing, inscribed on a spider's thread. Let us examine, on a misty morning, the meshwork that has been constructed during the night. Owing to their hygrometrical nature, the sticky threads are laden with tiny drops, and, bending under the burden, have become so many catenaries, so many chaplets of limpid gems, graceful chaplets arranged in exquisite order and following the curve of a swing. If the sun pierce the mist, the whole lights up with iridescent fires and becomes a resplendent cluster of diamonds. The number *e* is in its glory."

We can also find *e* popping up in a completely different area of mathematics. Imagine using the randomization button on a calculator to generate random numbers between 0 and 1, and then continuing to add them together until the total exceeds 1. Sometimes it will require two random numbers, usually three, and occasionally four or more numbers to reach a total bigger than 1. However, on average, the number of random numbers required to exceed 1 is 2.71828…, which, of course, is *e*.

There are numerous other examples demonstrating that *e* plays a diverse and fundamental role in several areas of mathematics. This

138 · SIMON SINGH

explains why so many number lovers have a particularly emotional attachment to it.

For example, Donald Knuth, professor emeritus at Stanford University and a godlike figure in the world of computing, is an e enthusiast. After authoring Metafont, his font-creation software, he decided to release updates with version numbers that relate to e. This means that the first version was Metafont 2, then Metafont 2.7, then Metafont 2.71, and so on up to the current Metafont 2.718281. Each new version number is a closer approximation to the true value of e. This is only one of several ways in which Knuth has expressed his quirky approach to his work. Another example is the index of his seminal work *The Art of Computer Programming*, volume 1, in which the entry for "Circular definition" points to "Definition, circular," and vice versa.

Similarly, Google's ubergeek bosses are huge fans of e. When they sold stock in 2004, they announced that they planned to raise $2,718,281,828, which is $1 billion multiplied by e. That same year the company erected the following billboard advertisement:

$$\left\{ \begin{array}{l} \text{first 10-digit prime found} \\ \text{in consecutive digits of } e \end{array} \right\} \text{.com}$$

The only way to find the name of this website was to search through all the digits of e to discover a sequence of ten digits that represented a prime. Anyone with sufficient mathematical ingenuity would have discovered that the first ten-digit prime, which starts at the ninety-ninth digit of e, is 7427466391. Visiting the website www.7427466391.com revealed a virtual signpost that pointed toward another website that was a portal for those who wanted to apply for positions at Google Labs.*

Another way to express admiration for e is to memorize its digits.

* Google is also fascinated by another number. In 2011, its opening bid for a batch of patents was $1,902,160,540, which is $1 billion multiplied by Brun's constant (B_2). This number is the sum of the reciprocals of all the twin primes, i.e., primes that are separated by just one even number.

Therefore, $B_2 = (1/3 + 1/5) + (1/5 + 1/7) + (1/11 + 1/13) + \cdots = 1.902160540\ldots$.

In 2004, Andreas Lietzow from Germany memorized and then recited 316 digits while juggling five balls. However, Lietzow was spectacularly trumped on November 25, 2007, when Bhaskar Karmakar from India, unencumbered by balls, set a new world record by reciting 5,002 digits of *e* in 1 hour 29 minutes and 52 seconds. That same day he also accurately recited 5,002 digits of *e* backward. These are incredible feats of memory, but we can all memorize ten digits of *e* by learning this mnemonic: "I'm forming a mnemonic to remember a function in analysis." The numbers of letters in each word represent the digits of *e*.

And, finally, the writers of *The Simpsons* are passionate about *e*. Not only does it appear as part of a book title in "MoneyBART," it also receives a special mention in "The Fight Before Christmas" (2010). The final segment of the episode is in the style of *Sesame Street*, so it ends with the traditional sponsorship announcement. However, instead of something along the lines of "Today's episode of Sesame Street has been brought to you by the letter *c* and number 9," viewers were treated to "Tonight's *Simpsons* episode was brought to you by the symbol umlaut, and the number *e*, not the letter *e*, but the number whose exponential function is the derivative of itself."

ANOTHER SLICE OF π

· • · • · • · • · • ·

I n "Marge in Chains" (1993), Marge is arrested for shoplifting after she walks out of the Kwik-E-Mart having forgotten to pay for a bottle of bourbon. She is put on trial and is represented by the attorney Lionel Hutz, a man with a dubious reputation. Before Marge's trial begins, Hutz admits that it is likely to be an uphill battle because of his poor relationship with the judge: "Well, he's had it in for me ever since I kinda ran over his dog . . . Well, replace the word *kinda* with the word *repeatedly*, and the word *dog* with *son*."

Hutz's strategy for defending Marge is to discredit Apu Nahasapeemapetilon, proprietor of the Kwik-E-Mart, who witnessed the alleged theft. However, when he calls Apu to the witness box and suggests that his memory might be flawed, Apu's response is to point out that he has a perfect memory: "In fact I can recite pi to forty thousand places. The last digit is 1."

Homer is not impressed, and merely thinks to himself: "Mmm . . . pi(e)."

Apu's extraordinary claim that he has memorized π to forty thousand decimal places only makes sense if mathematicians had determined π to at least that degree of accuracy. So, when the episode was broadcast in 1993, what was the state of play with respect to calculating π?

We saw in chapter 2 how mathematicians, from the ancient Greeks onward, used the polygon approach to establish increasingly precise values for π, which eventually gave them a result accurate to thirty-four decimal places. By 1630, the Austrian astronomer Christoph Grienberger was using polygons to measure π to thirty-eight decimal places. From a scientific perspective, there is literally no point in iden-

tifying any more digits, because this is sufficient for completing the most titanic astronomical calculation conceivable with the most refined accuracy imaginable. This statement is not hyperbole. If astronomers had established the exact diameter of the known universe, then knowing π to thirty-eight decimal places would be sufficient to calculate the universe's circumference accurate to within the width of a hydrogen atom.

Nevertheless, the struggle to measure π to more and more decimal places continued. The challenge took on an Everest quality. The number π was an infinite peak in the mathematical landscape, and mathematicians tried to scale it. There was, however, a change in strategy. Instead of using the slow polygon approach, mathematicians discovered several formulas for determining the value of π more quickly. For example, in the eighteenth century Leonhard Euler discovered this elegant formula:

$$\frac{\pi^4}{90} = \frac{1}{1^4} + \frac{1}{2^4} + \frac{1}{3^4} + \frac{1}{4^4} + \frac{1}{5^4} + \frac{1}{6^4} + \cdots$$

It is remarkable that π can be deduced from such a straightforward pattern of numbers. This equation is known as an *infinite series*, because it consists of an infinite number of terms, and the more terms included in a calculation, the more accurate the result. Below are the results of calculating π using one, two, three, four, and five terms of Euler's series:

$$\frac{\pi^4}{90} = \frac{1}{1^4} = 1.0000, \qquad\qquad \pi = 3.080$$

$$\frac{\pi^4}{90} = \frac{1}{1^4} + \frac{1}{2^4} = 1.0625, \qquad\qquad \pi = 3.127$$

$$\frac{\pi^4}{90} = \frac{1}{1^4} + \frac{1}{2^4} + \frac{1}{3^4} = 1.0748, \qquad\qquad \pi = 3.136$$

$$\frac{\pi^4}{90} = \frac{1}{1^4} + \frac{1}{2^4} + \frac{1}{3^4} + \frac{1}{4^4} = 1.0788, \qquad \pi = 3.139$$

$$\frac{\pi^4}{90} = \frac{1}{1^4} + \frac{1}{2^4} + \frac{1}{3^4} + \frac{1}{4^4} + \frac{1}{5^4} = 1.0804, \qquad \pi = 3.140$$

The approximations approach from below the true value of π, with each result becoming slightly more accurate as each extra term is introduced. After five terms, the estimate is 3.140, which is already accurate to two decimal places. Then, after one hundred terms, π can be determined accurately to six decimal places: 3.141592.

Euler's infinite formula is a reasonably efficient method for calculating π, but subsequent generations of mathematicians invented other infinite series that approached the true value of π even more rapidly. John Machin, who was professor of astronomy at London's Gresham College in the early eighteenth century, developed one of the fastest, albeit less elegant, infinite series.[*] He shattered all previous records by measuring π to one hundred decimal places.

Others exploited Machin's infinite series with even greater verve, including an English amateur mathematician named William Shanks, who devoted most of his life to calculating π. In 1874, he claimed to have calculated 707 digits of π.

In honor of his heroic achievement, the science museum in Paris known as the Palais de la Découverte decorated its Pi Room with an inscription of all 707 digits. Unfortunately, in the 1940s it was discovered that Shanks had made an error while calculating the 527th decimal place, which impacted on every subsequent digit. The Palais de la Découverte called in the decorators and Shanks's reputation took a knock. Nevertheless, 526 decimal places was still a world record at the time.

[*] Machin's formula for evaluating the value of π relied on the following observations: $\frac{1}{4}\pi = 4 \cot^{-1}(5) - \cot^{-1}(239)$. Here, cot represents the cotangent function. This is not an infinite series, but it can be converted into a very efficient one via a so-called Taylor series expansion.

After the Second World War, mechanized and electronic calculators took over from the pencil and paper used by Shanks and previous generations of mathematicians. The power of technology is illustrated by the fact that Shanks spent a lifetime calculating 707 digits of π, 181 of which were wrong, while in 1958 the Paris Data Processing Center performed the same calculation without error on an IBM 704 in forty seconds. Although π's digits were now set to tumble at an accelerating rate, the level of excitement among mathematicians was tempered by the realization that even computers could not tackle an infinite task.

This fact was a plot point in the 1967 *Star Trek* episode "Wolf in the Fold." In order to exorcise an evil energy force that has occupied the USS *Enterprise*'s computer, Spock issues the following command: "Computer—this is a Class A compulsory directive. Compute to the last digit the value of π." The computer is so distraught by this request that it cries out "No" over and over again. Despite its distress, the computer must obey the directive, and the resulting computational impossibility somehow purges the circuits of the evil force.

Spock's genius in "Wolf in the Fold" more than makes up for some appalling innumeracy displayed by Captain James T. Kirk in another episode earlier that same year. In "Court Martial," one of Kirk's crewmen has gone missing on board the *Enterprise*, and nobody is sure if he is alive or dead. Kirk, who would be held responsible for the crewman's fate, decides to use the computer to search for the missing man's heartbeat. He explains his plan: "Gentlemen, this computer has an auditory sensor. It can, in effect, hear sounds. By installing a booster, we can increase that capability on the order of *one to the fourth power*." Of course, 1^4 is still 1.

Shortly after the French computer scientists calculated 707 digits in less than a minute, the same team used a Ferranti Pegasus to calculate 10,021 digits of π. Then, in 1961, the IBM Data Processing Center in New York computed π to 100,265 digits. Inevitably, bigger computers led to more digits, and the Japanese mathematician Yasumasa Kanada calculated π to two million decimal places in 1981. The eccentric Chudnovsky brothers (Gregory and David) built their own

DIY supercomputer in their Manhattan apartment and broke the billion-digit barrier in 1989, but they were overtaken by Kanada, who cracked fifty billion digits in 1997 and then one trillion digits in 2002. At present, Shigeru Kondo and Alexander Yee are top of the π chart.

This duo reached five trillion digits in 2010, and then doubled the record to ten trillion digits in 2011.

• • •

Thus, returning to the courtroom, Apu could easily have had access to the first forty thousand decimal places of π, because mathematicians had calculated beyond this level of accuracy by the early 1960s. However, is it also possible that he could have memorized forty thousand decimal places?

As mentioned previously, in the context of *e*, the best approach for remembering a handful of digits is to rely on a phrase such that each word contains the relevant number of letters. For example, "May I have a large container of coffee" gives 3.1415926. "How I wish I could recollect pi easily today!" gives one more digit. The great British scientist Sir James Jeans, in between pondering deep questions about astrophysics and cosmology, invented a phrase that offers seventeen digits of π: "How I need a drink, alcoholic of course, after all those lectures involving quantum mechanics."

Several memory experts have extended this technique. They can recount π by telling themselves long, elaborate stories, with the number of letters in each word reminding them of the next digit of π. This technique enabled Canadian Fred Graham to break the 1,000-digit barrier in 1973. By 1978, American David Sanker cracked 10,000 digits, and in 1980, an Indian-born British mnemonist named Creighton Carvello recited π to 20,013 digits.

A few years later, British taxi driver Tom Morton also tried to memorize 20,000 digits, but he stumbled at 12,000 digits, because there was a printing error on one of the cue cards that he was relying on during his preparation. In 1981, the Indian memory expert Rajan Mahadevan broke the 30,000-digit barrier (31,811 digits to be pre-

ANOTHER SLICE OF π · 145

cise), and Japanese mnemonist Hideaki Tomoyori set a new world record of exactly 40,000 digits in 1987. Today, the record holder is Chao Lu from China, who memorized 67,890 digits in 2005.

However, it was Tomoyori's 40,000-digit record that was in place when the script for "Marge in Chains" was being finalized in 1993. Hence, Apu's claim to have memorized π to 40,000 digits was a direct reference and tribute to Tomoyori, who was the world's most famous and successful π memory expert at the time.

This episode was written by Bill Oakley and Josh Weinstein. According to Weinstein, the overall plot of "Marge in Chains" had already been outlined by the time it was assigned to Oakley and himself: "We were the junior writers, so we were assigned scripts that other people didn't want to do. Scripts revolving around Marge are very hard to write. By contrast, Homer is instantly funny, and so is Krusty. But Marge is really hard work, so her storylines were often pawned off on the new guys, like us."

Weinstein and Oakley took the basic storyline for "Marge in Chains," developed the plot details, wrote the core jokes, and handed in their draft script. Importantly, when we met, Weinstein was anxious to point out that this version of the script contained absolutely no mention of π.

He explained that the scene with Apu in the witness box began with the attorney Lionel Hutz asking the same question that still appears in the transmitted episode: "So, Mr. Nahasapeemapetilan, if that is your real name, have you ever forgotten anything?"

However, instead of claiming that he could recite π to forty thousand places, Apu revealed that he had been famous across India for his incredible memory. In fact, in the original script, Apu stated on oath that he had been known as Mr Memory and had appeared in over four hundred documentary films about his mental ability.

It is perhaps not surprising that the original script for "Marge in Chains" had no mention of π or forty thousand digits, as neither Oakley nor Weinstein have mathematical backgrounds. So, when did the mathematical references appear in the script?

As usual, the first draft script was dissected and discussed by the

rest of the writing team in order to refine the story and inject additional humor wherever possible. At this point, Weinstein and Oakley's colleague Al Jean saw an opportunity to add some mathematics to the episode. Thanks to his lifelong interest in mathematics, Jean was aware that the world record for memorizing π was forty thousand decimal places, so he suggested altering the script so that Apu makes a claim that matches the memorization record. And, to give the claim some credibility, Jean suggested that Apu should cite the forty-thousandth decimal place.

Everyone agreed that this was a good idea, but nobody happened to know the forty-thousandth decimal place of π. Worse still, it was 1993, so the World Wide Web was only sparsely populated, Google did not exist, and searching Wikipedia was not yet an option. The writers decided they needed some expert advice, so they contacted a brilliant mathematician named David Bailey, who at the time was working at the NASA Ames Research Center.* Bailey responded by printing out all forty thousand decimal places of π and mailing them to the studio. Here are the digits from the 39,990th through to the 40,000th decimal place, and you can see that Apu is correct when he says that the last digit in his memorized sequence is 1:

$$\downarrow \text{ 40,000th decimal place}$$
$$...52473837651...$$

The fact that Bailey made his contribution as a mathematician based at NASA was referenced three years later in "22 Short Films About Springfield" (1996). When Barney Gumble, Springfield's favorite drunk, stumbles into Moe's Tavern, he finds that Moe has some

* Bailey helped to invent the *spigot algorithm* for finding the digits of π. A spigot is a type of tap, and a spigot algorithm generates answers in a taplike fashion, which means that π is calculated drip by drip, digit by digit. The spigot algorithm can be tuned to generate any particular digit with perfect accuracy, so you might then think that it would be easy for Bailey to tune his algorithm to deliver the forty-thousandth digit. Unfortunately, Bailey's algorithm only works in hexadecimal (base 16), not decimal (base 10).

bad news for him: "Remember when I said I'd have to send away to NASA to calculate your bar tab? . . . The results came back today. You owe me seventy billion dollars."

Apu's line about π in "Marge in Chains" also influenced another episode, namely "Much Apu About Nothing" (1996). In this episode, Apu reveals some of his backstory, and his past has to be compatible with someone who would be interested in memorizing π to 40,000 decimal places. Hence, when he recalls his journey from India to America, Apu tells Marge: "I came here shortly after my graduation from Caltech. Calcutta Technical Institute. As the top student in my graduating class of seven million."

Although the Calcutta Technical Institute is fictional, there is a technical institute near Calcutta named the Bengal Institute of Technology, which perhaps could claim to be the inspiration for Apu's alma mater. It has the acronym BIT, which is highly appropriate for a college that specializes in computer science and information technology. We also learn that Apu went to America to study at the Springfield Heights Institute of Technology, which has a rather less fortunate acronym. Under the supervision of Professor Frink, Apu spent nine years completing his PhD in computer science by supposedly developing the world's first tic-tac-toe program, which could only be beaten by the best human players.

David S. Cohen, who wrote "Much Apu About Nothing," decided that Apu should be a computer scientist rather than a mathematician, because Cohen himself had been a graduate student in computer science at the University of California, Berkeley, and had shared classes with several Indian students. In particular, Apu's backstory is based on the life of one of Cohen's closest friends at Berkeley, Ashu Rege, who went on to work for NVIDIA, a pioneering computer graphics company.

• • •

Pi has made one more notable appearance on *The Simpsons*. In the concluding scenes of "Lisa's Sax" (1997), we learn that Homer bought Lisa a saxophone in order to nurture her nascent genius. However,

before investing in a musical instrument, Homer and Marge considered sending Lisa to Miss Tillingham's School for Snotty Girls and Mama's Boys. In a flashback, we see Homer and Marge visiting the school, where they encounter two child prodigies in the playground, who have invented their own lyrics to a hand-clapping song:

> *Cross my heart and hope to die,*
> *Here's the digits that make π,*
> *3.14159265358979323846....*

Al Jean was the writer responsible for deftly crowbarring this mathematical reference into the episode. At first hearing, it seems like an uncontroversial recitation of the world's most famous irrational number, but on further consideration I began to wonder why π was being expressed in a base-10 decimal form.

Base 10 is our standard number system, with the first decimal place representing tenths $(1/10^1)$, then each subsequent decimal place representing hundredths $(1/10^2)$, thousandths $(1/10^3)$, and so on. Our number system developed in this manner because the human hands between them have ten digits.

However, if you take a close look at the hands of the characters in *The Simpsons*, you will notice that they have only three fingers and a thumb on each hand, so eight digits in total. Therefore, counting in Springfield should rely on the number 8, which should lead to an entirely different system of counting (known as base 8), which in turn should result in a different way of expressing π (3.1103755242...).

The mathematics of base 8 are not important, particularly as *The Simpsons*, like us, rely on base 10. Nevertheless, there are two outstanding questions that must be addressed. First, why do the residents of Springfield only have eight digits on their hands? And, second, why does the universe of *The Simpsons* rely on base 10, when the characters have only eight digits?

The mutation that results in only eight digits in *The Simpsons* dates back to the early days of animation on the big screen. Felix the Cat, who debuted in 1919, had only four digits on each hand, and Mickey

Mouse shared this trait when he made his first appearance in 1928. When asked why his anthropomorphized rodent had missing digits, Walt Disney replied: "Artistically five digits are too many for a mouse. His hand would look like a bunch of bananas." Disney also added that simplified hands meant less work for the animators: "Financially, not having an extra finger in each of 45,000 drawings that make up a six-and-one-half-minute short has saved the Studio millions."

For these reasons, eight digits became standard around the world for both animal and human animated characters. The only exception is in Japan, where only four digits on a hand can have sinister connotations; the number 4 is associated with death, and the Yakuza, the infamous Japanese Mafia, sometimes remove the little finger either as a punishment or a test of loyalty. This meant that the British cartoon *Bob the Builder*, when it was sold to Japan in 2000, had to be altered in order to give the characters the required number of fingers.

While the Japanese are uncomfortable with the idea of four digits per hand, this is accepted as a perfectly natural state of affairs by all the characters in *The Simpsons*. Indeed, anything else is considered abnormal. This becomes apparent in "I Married Marge" (1991), an episode which includes a scene that takes place on the day Bart is born. We hear Marge asking Homer if he thinks their new son is beautiful, and Homer replies: "Hey, as long as he's got eight fingers and eight toes, he's fine by me."

Also, in "Lady Bouvier's Lover" (1994), Marge's mother and Homer's father start dating, much to the consternation of Homer: "If he marries your mother, Marge, we'll be brother and sister! And then our kids, they'll be horrible freaks with pink skin, no overbites, and five fingers on each hand."

However, despite their finger deficit, we know that the residents of Springfield count in base 10, not base 8, because they express π as 3.141.... So, how and why did a community with only eight digits per person end up counting in base 10?

One possibility is that Homer and Marge's ancient yellow ancestors counted on more than just their digits. They could have counted on their eight fingers and two nostrils. This might sound odd, but several

societies have developed counting systems based on more than just fingers. For example, the men of the Yupno tribe in Papua New Guinea assign the numbers 1 to 33 to various parts of the body, starting with fingers, then moving on to nostrils and nipples. The counting concludes with 31 for the left testicle, 32 for the right one, and 33 for "the man thing." European scholars, such as the Venerable Bede, have also experimented with counting systems based on parts of the body. This eighth-century English theologian developed a system that enabled him to count up to 9,999 by using gestures and every bit of the human anatomy. According to Alex Bellos, author of *Alex's Adventures in Numberland*, Bede's system was "one part arithmetic, one part jazz hands."

Although counting on fingers, thumbs, and nostrils could explain the decimalization of *The Simpsons*, there is another theory to consider. Is it conceivable that numbers in the cartoon universe were not invented by humans but instead by a higher power? As a rationalist, I tend to spurn supernatural explanations, but we cannot ignore the fact that God appears in several episodes of *The Simpsons*, and in each case He has ten digits. Indeed, He is the only character in *The Simpsons* possessing ten digits.

CHAPTER 13

HOMER³

• • • • • • • • • • •

The first "Treehouse of Horror" episode appeared in the second season of *The Simpsons*, and since then they have become an annual Halloween tradition. These special episodes usually consist of three short stories that are allowed to break the conventions of life in Springfield, with storylines that can include anything from aliens to zombies.

David S. Cohen, one of the writers most dedicated to getting mathematics into *The Simpsons*, wrote the final part of "Treehouse of Horror VI" (1995), a segment titled "Homer³." This is, without doubt, the most intense and elegant integration of mathematics into *The Simpsons* since the series began a quarter of a century ago.

The storyline begins quite innocently with Patty and Selma, Homer's sisters-in-law, paying a surprise visit to the Simpsons. Keen to avoid them, Homer hides behind a bookcase, where he encounters a mysterious portal that seems to lead into another universe. As the dulcet tones of Patty and Selma get louder, Homer hears that they want everyone to help clean and organize their collection of seashells. In desperation, he dives through the portal, leaving behind his two-dimensional Springfield environment and entering an incredible three-dimensional world. Homer is utterly perplexed by his new extra dimensionality and notices something shocking: "What's going on here? I'm so bulgy. My stomach sticks way out in front."

Instead of being drawn in the classic flat-animation style of *The Simpsons*, scenes set in this higher dimension have a sophisticated three-dimensional appearance. In fact, these scenes were generated using cutting-edge computer animation techniques, and the cost of generating them, even though they lasted less than five minutes, was

far beyond the budget of an entire normal episode. Fortunately, a company named Pacific Data Images (PDI) volunteered its services, because it realized that *The Simpsons* would provide a global platform for showcasing its technology. Indeed, PDI signed a deal with Dream-Works later that year which led directly to the production of *Antz* and *Shrek*, thereby kick-starting a revolution in film animation.

When Homer approaches a signpost indicating the *x*, *y*, and *z* axes in his new three-dimensional universe, he alludes to the fact that he is standing within the most sophisticated animated scene ever to have appeared on television: "Man, this place looks expensive. I feel like I'm wasting a fortune just standing here. Well, better make the most of it."

Homer makes another pertinent comment when he first encounters his new environment: "That's weird. It's like something out of that twilighty show about that zone." This is a nod to the fact that "Homer[3]" is a tribute to a 1962 episode of *The Twilight Zone* titled "Little Girl Lost."

$$P = NP$$

$$e^{\pi i} = -1$$

A three-dimensional Homer Simpson after traveling through the portal in "Homer[3]." Two mathematical equations are floating behind him in the distance.

In "Little Girl Lost," the parents of a young girl named Tina become distraught when they enter her bedroom and cannot find her. Even more terrifying, they can still hear her voice echoing around them. Tina is invisible yet still audible. She is no longer in the room, but she seems just a breath away. Desperate for help, the parents call upon a family friend named Bill, who is a physicist. Having pinned down the location of a portal by chalking some coordinates on the bedroom wall, Bill declares that Tina has slipped into the fourth dimension. The parents struggle to understand the concept of a fourth dimension, because they (like all humans) have trained their brains to cope with our familiar three-dimensional world.

Although Homer leaps from two to three dimensions, not from three to four dimensions, exactly the same sequence of events takes place in "Homer³." Marge cannot fathom what has happened to Homer, because she can hear him but not see him, and she also receives advice from a scientist, Professor John Nerdelbaum Frink, Jr.

Despite his comically eccentric personality, it is important to not underestimate Professor's Frink's genius. Indeed, his scientific credentials are made clear in "Frinkenstein," a story from "Treehouse of Horror XIV" (2003), when he receives a Nobel Prize from none other than Dudley R. Herschbach, who won his own Nobel Prize in 1986 and who voices his own character.*

Just like the physicist in *The Twilight Zone*, Frink draws a chalk outline around the portal, watched by Ned Flanders, Chief Wiggum, Reverend Lovejoy, and Dr. Hibbert, who have all come to offer support. Frink then begins to explain the mystery: "Well, it should be obvious to even the most dimwitted individual, who holds an advanced degree in hyperbolic topology, that Homer Simpson has stumbled into . . . *the third dimension*."

Frink's statement suggests that the characters in *The Simpsons* are trapped in a two-dimensional world, and therefore they struggle to

* The awarding of the Nobel Prize is witnessed by Frink's resurrected father, who is voiced by the legendary comic actor Jerry Lewis. This resulted in a voice circle. Lewis based his voice for Frink Sr. on Hank Azaria's voice for Frink Jr., which in turn was based on Lewis's lead character in *The Nutty Professor*.

imagine the third dimension. The animated reality of Springfield is slightly more complicated than this, because we regularly see Homer and his family crossing behind and in front of each other, which ought to be impossible in a strictly two-dimensional universe. Nevertheless, for the purposes of this "Treehouse of Horror" segment, let us assume that Frink is correct in implying the existence of only two dimensions in *The Simpsons*, and let us see how he explains the concept of higher dimensions as he draws a diagram on the blackboard:

PROFESSOR FRINK: Here is an ordinary square.
CHIEF WIGGUM: Whoa, whoa! Slow down, egghead!
PROFESSOR FRINK: But suppose we extend the square beyond the two dimensions of our universe along the hypothetical z-axis . . . There.
EVERYONE: [gasps]
PROFESSOR FRINK: This forms a three-dimensional object known as a *cube*, or a *Frinkahedron* in honor of its discoverer.

Frink's explanation illustrates the relationship between two and three dimensions. In fact, his approach can be used to explain the relationship between all dimensions.

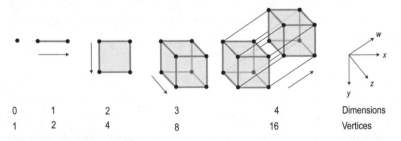

| 0 | 1 | 2 | 3 | 4 | Dimensions |
| 1 | 2 | 4 | 8 | 16 | Vertices |

If we start with zero dimensions, we have a zero-dimensional point. This point can be pulled in, say, the x direction to trace a path that forms a one-dimensional line. Next, the one-dimensional line can be pulled in the perpendicular y direction to form a two-dimensional square. This is where Professor Frink's explanation picks up, because

the two-dimensional square can be pulled in the z direction, which is perpendicular to its face, to form a three-dimensional cube (or Frinka-hedron). Finally, it is mathematically, if not physically, possible to go one step further by dragging the cube into another perpendicular direction (labeled the w dimension) to form a four-dimensional cube. Cubes in four (or more) dimensions are known as *hypercubes*.

The diagram of a four-dimensional hypercube is a mere sketch, the equivalent of a stick figure drawing being used to capture the essence of Michelangelo's statue of David. Nevertheless, the stick-figure hypercube suggests an emerging pattern that helps explain the geometry of shapes in four and even higher dimensions. Let us consider the number of endpoints or corners (known as *vertices*) that each object possesses as we move from dimension to dimension. The number of vertices follows a simple pattern: 1, 2, 4, 8, 16, In other words, if d is the number of dimensions, then the number of vertices equals 2^d. Hence, a ten-dimensional hypercube would have 2^{10} or 1,024 vertices.

Despite Professor Frink's deep understanding of higher dimensions, the bad news is that he is unable to save Homer, who is left to wander across his new universe. This leads to a bizarre series of events that ends with a visit to an erotic cake store. During this adventure, Homer encounters several fragments of mathematics which materialize in the three-dimensional landscape.

For example, soon after Homer travels through the portal, an apparently random series of numbers and letters floats in the far distance: 46 72 69 6E 6B 20 72 75 6C 65 73 21. The letters, in fact, are actually *hexadecimal* (or base 16) digits. Hexadecimal numbers are expressed using the usual digits 0 to 9, plus six others, namely A = 10, B = 11, C = 12, D = 13, E = 14, and F = 15. Together, each pair of hexadecimal digits represents a character in ASCII (American Standard Code for Information Interchange), which is a protocol for converting letters and punctuation into numbers, largely for the benefit of computers. According to the ASCII protocol, 46 represents "F," 72 represents "r," and so on. Translated, the entire sequence reads as a bold proclamation in praise of geeks: "Frink rules!"

A few moments later, a second mathematical tidbit appears in the three-dimensional landscape, courtesy of writer David S. Cohen:

$$1,782^{12} + 1,841^{12} = 1,922^{12}$$

This is yet another false solution to Fermat's last theorem, just like the one created by Cohen for "The Wizard of Evergreen Terrace," which was discussed in chapter 3. He had written a computer program (shown in appendix 3) to select numbers such that the two sides of the equation are almost equal. If we match the sum of the first two squares to the sum of the third square, then the results are accurate for the first nine digits, as shown in bold:

1,025,397,835,622,633,634,807,550,462,948,226,174,976 ($1,782^{12}$)

+ **1,515,812,422**,991,955,541,481,119,495,194,202,351,681 ($1,841^{12}$)

= **2,541,210,258**,614,589,176,288,669,958,142,428,526,657

2,541,210,259,314,801,410,819,278,649,643,651,567,616 ($1,922^{12}$)

This means that the discrepancy in the equation is just 0.00000003 percent, but that is more than enough to make it a false solution. Indeed, there is a quick way to spot that $1,782^{12} + 1,841^{12} = 1,922^{12}$ is a false solution, without having to do any lengthy calculations. The trick is to notice that we have an even number (1,782) raised to the twelfth power added to an odd number (1,841) raised to the twelfth power supposedly equaling an even number (1,922) raised to the twelfth power. The oddness and evenness are important because an odd number raised to any power will always give an odd result, whereas an even number raised to any power will always give an even result. Since an odd number added to an even number always gives an odd result, the left side of the equation is doomed to be odd, whereas the right side of the equation must be even. Therefore, it should be obvious that this is a false solution:

$$\text{even}^{12} + \text{odd}^{12} \neq \text{even}^{12}$$

Blink and you will miss five other nods to nerdiness that flash past Homer in his three-dimensional universe. The first is a rather ordinary looking teapot. Why is this nerdy? When pioneering graphics researcher Martin Newell at the University of Utah wanted to render a computer-generated object in 1975, he chose this household item; it was relatively simple, yet also offered challenges, such as a handle and curves. Ever since, the so-called Utah teapot has become an industry standard for demonstrating computer-graphic software. This particular style of teapot has also made cameo appearances in a tea party scene in *Toy Story*, in Boo's bedroom in *Monsters, Inc.*, and in several other films.

The second nod is a flyby by the numbers 7, 3, and 4, a coded reference to Pacific Data Images, who produced the computer graphics. These digits on a telephone dialing pad are associated with the letters *P*, *D*, and *I*.

Third, we glimpse a cosmological equation ($\rho_{m0} > 3H_0^2/8\pi G$) that describes the density of Homer's universe. Provided by one of Cohen's oldest friends, the astronomer David Schiminovich, the equation implies a high density, which means that the resulting gravitational attraction will ultimately force Homer's universe to collapse. Indeed, this is exactly what happens toward the end of the segment.

Just before Homer's universe disappears, Cohen dangles a particularly intriguing mathematical morsel for the discerning viewer. In the scene shown on page 152, a slightly unusual arrangement of Euler's equation is visible over Homer's left shoulder. This equation also appears in "MoneyBART."

Finally, in the same image, the relationship P = NP can be seen over Homer's right shoulder. Although the majority of viewers would not have noticed these three letters, let alone given them a second thought, P = NP represents a statement about one of the most important unsolved problems in theoretical computer science.

P = NP is a statement concerning two types of mathematical problems. P stands for *polynomial* and NP for *nondeterministic polynomial*. In crude terms, P-type problems are easy to solve, while NP-type problems are difficult to solve, but easy to check.

For example, multiplication is easy and so is classified as a P-type problem. Even as the numbers being multiplied get bigger, the time required to calculate the result grows in a relatively modest fashion.

By contrast, *factoring* is an NP-type problem. Factoring a number simply means identifying its divisors, which is trivial for small numbers, but rapidly becomes impractical for large numbers. For example, if asked to factor 21, you would immediately respond 21 = 3 × 7. However, factoring 428,783 is much harder. Indeed, you might need an hour or so with your calculator to discover that 428,783 = 521 × 823. Crucially, though, if someone handed you the numbers 521 and 823 on a slip of paper, you could check within a few seconds that these are the correct divisors. Factoring is thus a classic NP-type problem: hard to solve for large numbers, yet easy to check.

Or . . . is it possible that factoring is not as difficult as we currently think?

The fundamental question for mathematicians and computer scientists is whether factoring is genuinely hard to accomplish, or whether we are missing a trick that would make it simple. The same applies to a host of other supposedly NP-type problems—are they all genuinely hard, or are they merely hard because we are not smart enough to figure out the way to solve them easily?

This question is of more than mere academic interest, because some important technologies rely on NP-type problems being intractable. For example, there are widely used encryption algorithms that depend on the assumption that it is hard to factor big numbers. However, if factoring is not inherently difficult, and someone discovers the trick that makes factoring simple, then it would undermine these encryption systems. In turn, this would jeopardize the security of everything from personal online purchases to high-level international political and military communications.

The problem is often summarized as "P = NP or P ≠ NP?", which asks the question: Will apparently difficult problems (NP) one day be shown to be just as easy as simple problems (P), or not?

Finding the solution to the mystery of P = NP or P ≠ NP? is on the mathematicians' most wanted list, and there is even a prize on its

head. The Clay Mathematics Institute, established in Cambridge, Massachusetts, by the philanthropist Landon Clay, listed this puzzle as one of its seven Millennium Prize Problems in 2000, offering a $1 million reward for a definitive answer to the question P = NP or P ≠ NP?

David S. Cohen, who explored P-type and NP-type problems while studying for his master's degree in computer science at the University of California, Berkeley, has a hunch that NP-type problems are indeed much easier than we currently think, which is why P = NP appears behind Homer in his 3-D universe.

However, Cohen holds a minority view. When William Gasarch, a computer scientist at the University of Maryland, polled one hundred researchers in 2002, only 9 percent thought that P = NP, while 61 percent favored P ≠ NP. He repeated the poll in 2010, and this time 81 percent favored P ≠ NP.

Of course, truth in mathematics is not decided by a popularity contest, but if the majority turn out to be right, then Cohen's positioning of P = NP in the landscape of "Homer³" will look somewhat incongruous. This, however, should not prove to be an issue in the short term, as half of the mathematicians polled did not think that the problem would be resolved during this century.

Finally, there is one more mathematical reference in "Homer³" that deserves a mention. More accurately, the reference does not actually appear in the "Homer³" segment, but rather in the credit sequence for the whole "Treehouse of Horror VI" episode. By tradition, the credits in the Halloween episodes of *The Simpsons* have always been quirky. For example, Matt Groening is credited variously as Bat Groening, Rat Groening, Matt "Mr. Spooky" Groening, and Morbid Matt Groening.

This tradition was inspired by a comic book titled *Tales from the Crypt*, which regularly contained mutant credits for its writers and artists. Its publisher, EC Comics, became notorious after the Senate Subcommittee on Juvenile Delinquency ran comic book hearings in 1954 that concluded that *Tales from the Crypt* and its other titles were partly responsible for corrupting the nation's youth. This resulted in

the removal of zombies, werewolves, and their ilk from all comics, and in turn these constraints forced the discontinuation of *Tales from the Crypt* in 1955. Nevertheless, *Tales from the Crypt* still has many fans, most of whom were not even born when it went to an early grave. Al Jean is one these fans, and it was his suggestion to pay homage to the comic by mimicking the idea of mutant credits in "Treehouse of Horror" episodes.

All of which explains why the credits for "Treehouse of Horror VI" include Brad "the Impaler" Bird, Lycanthropic Lee Harting, and Wotsa Matta U. Groening. And, if you look very carefully, you will spot a charming reference to the Pythagorean theorem and the writer of "Homer[3]":

$$DAVID^2 + S.^2 = COHEN^2$$

Examination IV

MASTERS DEGREE

Joke 1 Q: What's a polar bear? 2 points
A: A rectangular bear after a coordinate
transformation.

Joke 2 Q: What goes "Pieces of seven! Pieces of 2 points
seven!"?
A: A parroty error.

Joke 3 Russell to Whitehead: "My Gödel is killing me!" 3 points

Joke 4 Q: What's brown, furry, runs to the sea, and is 2 points
equivalent to the axiom of choice?
A: Zorn's lemming.

Joke 5 Q: What's yellow and equivalent to the axiom 2 points
of choice?
A: Zorn's lemon.

Joke 6 Q: Why is it that the more accuracy you 3 points
demand from an interpolation function,
the more expensive it becomes to compute?
A: That's the law of spline demand.

Joke 7 Two mathematicians, Isaac and Gottfried, are in 6 points
a pub. Isaac bemoans the lack of mathematical
knowledge among the general public, but
Gottfried is more optimistic. To prove his point,
Gottfried waits until Isaac goes to the bathroom
and calls over the barmaid. He explains that he
is going to ask her a question when Isaac
returns, and the barmaid simply has to reply:
"One third x cubed."

 She replies: "Won thud ex-what?"

 Gottfried repeats the statement, but more
slowly this time: "One . . . third . . . x . . .
cubed."

 The barmaid seems to get it, more or less,
and walks away muttering over and over again:
"Won thud ex-cubed."

 Isaac returns, he downs another drink with
Gottfried, the argument continues and eventu-
ally Gottfried asks over the barmaid to prove his
point: "Isaac, let's try an experiment. Miss, do
you mind if I ask you a simple calculus question?
What is the integral of x^2?"

 The barmaid stops, scratches her head, and
hesitantly regurgitates: "Won . . . thud . . .
ex-cubed." Gottfried smiles smugly, but just
before the barmaid walks away she stares at
the two mathematicians and says: ". . . plus a
constant!"

TOTAL – 20 POINTS

FUTU

From left to right, the cast of *Futurama* includes Zapp Brannigan (a twenty-five-star general and captain of the starship *Nimbus*), Mom (the Machiavellian owner of MomCorp), Professor Hubert J. Farnsworth (the 160-year-old founder of Planet Express), Leela (captain of the Planet Express ship), Bender (a debauched robot),

Philip J. Fry (a twentieth- and thirty-first-century delivery boy), Zoidberg (the Planet Express staff doctor, hailing from Decapod 10), Kif Kroker (a member of the Nimbus crew, who is in love with Amy), and Amy Wong (a member of the Planet Express crew, who is in love with Kif).

CHAPTER 14

THE BIRTH OF *FUTURAMA*

· ● · ● · ● · ● · ● ·

While *The Simpsons* was reaching new mathematical heights with the transmission of "Homer³" in October 1995, Matt Groening was beginning to focus his mind on another project. His first animated TV sitcom had become such a massive global success that the Fox network asked him to pitch a sister series.

So, in 1996, Groening teamed up with David S. Cohen to develop an animated sci-fi series. Cohen was Groening's natural ally, because he had a lifelong fascination and love for science fiction which dated back to watching repeats of the original *Star Trek* series. Cohen had also developed a great respect for the eminent figures in science-fiction literature, such as Arthur C. Clarke and Stanislaw Lem. Hence, for Cohen, taking science fiction seriously was an important starting point for the sitcom: "The decision Matt Groening and I made early on was not to go too silly. We didn't necessarily want to make fun of science fiction, so much as to make funny science fiction."

Cohen also had the necessary nerdy knowledge required to deal with the inevitable technological issues that arise in sci-fi adventures, such as how to travel intergalactic distances in a reasonable time. This is a perennial problem in science fiction, because neither spaceships nor indeed anything can travel faster than the speed of light, and light takes more than two million years to travel to the nearest spiral galaxy. Cohen came up with two solutions that would enable characters to travel intergalactic distances in a reasonable amount of time. One of his solutions was to introduce a plot point stating that scientists had succeeded in increasing the speed of light in 2208. His other, even cheekier, solution was to propose an engine that achieved superluminal velocities by accelerating the universe around it, not the spaceship to which it was attached.

Together, Groening and Cohen began working on a series of story-lines based around the adventures of a character named Philip J. Fry, a New York City pizza delivery boy who was cryogenically frozen in the first few hours of 2000. Revived one thousand years later in New New York, Fry eagerly looks forward to embarking on a new life in the thirty-first century, optimistic that his new career will be more rewarding than his old one. Alas, he is frustrated to learn that he is to receive a career implant chip that will condemn him to his same old job as a delivery boy. The only difference is that, instead of delivering pizzas around New York, he will be an interplanetary delivery boy with a company called Planet Express.

Groening and Cohen then began to invent the other members of the Planet Express team. Most notably, Fry's colleagues would include Leela, a one-eyed mutant who would repeatedly break Fry's heart, and Bender, a robot whose hobbies included stealing, gambling, cheating, drinking, and worse. Other characters on the drawing board were Professor Hubert J. Farnsworth (the 160-year-old founder of Planet Express Inc.), Dr. John A. Zoidberg (the company's lobster-like alien doctor), Hermes Conrad (ex-Olympic limbo champion and the company's accountant), and Amy Wong (intern).

In many ways, the plan was for this animated series to be just like any classic workplace-based sitcom, such as the American series *Taxi* or the British series *The IT Crowd*. The only difference was that almost any storyline was possible, because the Planet Express crew could encounter all manner of strange aliens on weird planets with peculiar problems while gallivanting around the universe delivering packages.

Despite initial interest from Fox, Groening soon realized that network executives were not impressed with his quirky cast of misfit characters and their cosmic adventures. When Fox then tried to interfere, Groening resisted. The pressure increased, and Groening dug in his heels even further. Eventually, after what Groening described as "by far the worst experience of my grown-up life," he prevailed and the new series was commissioned on the same terms as *The Simpsons*, with the writers in control.

After being officially green-lit, the series was given the title *Futurama*, after the name of an exhibition at the 1939 New York World's Fair that took visitors on a journey into "the world of tomorrow." Next, Groening and Cohen began recruiting a new team of writers, because it had been tacitly agreed that *Futurama* would not poach staff from *The Simpsons*. Not surprisingly, several of the *Futurama* recruits had backgrounds in subjects such as computing, mathematics, and science. One of the new writers, Bill Odenkirk, had completed a PhD in organic chemistry at the University of Chicago. Indeed, he was a co-inventor of 2,2'-Bis(2-indenyl) biphenyl, which can be used as a catalyst to make plastics.

During this recruitment phase, writers of animated shows became eligible to join a union. Since there was already a union member named David S. Cohen, and unionized writers are not allowed to share the same name, the *Futurama* writer changed his name to David X. Cohen. The *X* is not an abbreviation, but instead it neatly encapsulates some of Cohen's main interests, such as science fiction and mathematics—Cohen is both an *X*-Phile (lover of *The X-Files*) and an *x*-phile (lover of algebra).

The first episode of *Futurama* was broadcast on March 28, 1999. Although everyone expected that this new science fiction series would contain plenty of science fact, the more erudite viewers were soon impressed by the sheer quantity and a quality of nerdy references.

For example, the third episode, "I, Roommate" (1999), reveals how Fry decides to move in with Bender, the foul-mouthed, bad-tempered robot. Hanging on the wall of their new apartment is a framed cross-stitch message:

This is a reference to a computer programming language known as BASIC (Beginner's All-purpose Symbolic Instruction Code), in which each instruction is given a number, and the instructions are followed in numerical order. The GOTO instruction is commonplace in BASIC, and in this case the instruction 30 GOTO 10 means go back to line 10. Hence, the cross-stitch conveys the idiom "Home sweet home." If we take the cross-stitch to its logical extreme, then it actually reads, "Home sweet home sweet home sweet home . . ."

Because it is merely part of the background to the scene, this joke about BASIC obeys the first rule of the *Futurama* writing room: Obscure references are fine as long as they do not get in the way of the plot. A similarly obscure joke appears in "Mars University" (1999), when we briefly see a blackboard covered in esoteric equations relating to a branch of particle physics known as *supersymmetric string theory*, except in *Futurama* it is called *superdupersymmetric string theory*. The main joke involves a diagram labeled *Witten's Dog*, which is a sly reference to both Ed Witten and Schrödinger's cat.

Ed Witten, one of the fathers of superstring theory, is generally considered the world's greatest living theoretical physicist and arguably the smartest scientist never to have won a Nobel Prize. By way of compensation, Witten can at least claim the accolade of being immortalized in *Futurama*. Schrödinger's cat is a famous *thought experiment*, one that is conducted in our imaginations rather than in the laboratory. Erwin Schrödinger, who won the Nobel Prize in Physics in 1933, asked what would happen inside a wooden box containing a cat, some radioactive material, and a poisoning mechanism that can be triggered by an unpredictable radioactive decay. After one minute, is the cat dead or alive? Has there been a radioactive decay that has triggered the poisoning mechanism? Back in the nineteenth century, physicists would have said that the cat is either dead or alive, but we do not know which. However, in the early decades of the twentieth century, the newly developed quantum view of the universe offered different interpretations. In particular, the Copenhagen interpretation suggested the bizarre notion that the cat was in

a so-called *superposition of states*, which means it is both dead and alive . . . until the box is opened, at which point the situation is resolved.

Schrödinger and his cat make a guest appearance in another episode, which is titled "Law and Oracle" (2011). Traffic cops chase after a speeding Schrödinger, who eventually crashes. When he emerges from the wreckage, he is questioned about the box in his car. The cops are URL (pronounced Earl) and Fry, who has temporarily left his job at Planet Express.

URL: What's in the box, Schrödinger?

SCHRÖDINGER: Um . . . A cat, some poison, *und* a cesium atom.

FRY: The cat! Is it alive or dead? Alive or dead?!

URL: Answer him, fool.

SCHRÖDINGER: It's a superposition of both states until you open it and collapse the wave function.

FRY: Says you.
 [Fry opens the box and a cat jumps out of it, attacking him. URL takes a close look at the box.]

URL: There's also a lotta drugs in there.

Of course, this is a book about mathematics, not physics, so it is time to focus on the dozens of scenes in *Futurama* involving everything from convoluted geometry to incredible infinities. One such scene appears in "The Honking" (2000), which tells the story of Bender returning to his late uncle Vladimir's haunted castle in order to attend the reading of Vladimir's will. As the robot sits with his friends in the library, the digits 0101100101 appear on the wall, written in blood. Bender is more confused than spooked, but when he sees the digits reflected in the mirror—1010011010—he is immediately terrified.

Although no explanation is given in the dialogue, binary-savvy viewers would have appreciated the horrific significance of this scene.

The number that appears on the wall, 0101100101, when translated from binary into decimal is equivalent to 357. This number has no unpleasant connotations, but its reflection is spine-chilling. We can convert the reflection, 1010011010, from binary to decimal as follows:

Binary number	1	0	1	0	0	1	1	0	1	0
	×	×	×	×	×	×	×	×	×	×
Place value	2^9	2^8	2^7	2^6	2^5	2^4	2^3	2^2	2^1	2^0

$$\text{Total} = 512 + 0 + 128 + 0 + 0 + 16 + 8 + 0 + 2 + 0$$
$$= 666$$

666, of course, will forever be associated with the Devil, because it is the Number of the Beast. Therefore, perhaps 1010011010 should be considered the Number of the Binary Beast.

Mathematicians, who generally do not have a reputation for diabolical numerology and demonic worship, have a surprising fondness for 666. They have even singled out a particular prime number that includes this series of digits: 1,000,000,000,000,066,600,000,000, 000,001. It is labeled Belphegor's prime, in honor of one of the seven princes of hell. As well as containing 666 at its heart, this infamous prime also has thirteen unlucky zeroes on either side of the Number of the Beast.

The reversed hidden message in "The Honking" is a nod to *The Shining*, a classic horror film from 1980. In one of the film's most famous scenes, a child named Danny enters his mother's bedroom and scrawls REDЯUM on the door in lipstick. She awakes to find him standing next to her bed with a knife in his hand, and then glimpses the writing reflected in her dressing table mirror, which now reads MURDƎЯ.

666 written in reversed binary is a neat mathematical code, one of many coded messages that appear in *Futurama*. All these messages demonstrate various principles of *cryptography*, the formal name for

the branch of applied mathematics that deals with code making and code breaking.

For example, several episodes contain billboards, notes, or graffiti that display messages written in alien scripts. The simplest alien script appears in "Lethal Inspection" (2010), when we see a note that reads:

⊙✦✦⊠ ✦Ꮐ⅄⊠ψ ✦ψⓛ✦

ⓠ✦ℋ⅄ ⊠ⓔ✦⊙ ⟨ⓔꝫⓐ ⓔℋ⊠

ꝫ⊙✦ψ⊙⅄✦⊠ ✦ꝫⓠψ⊙ⓛ

✦✦ ♡ψ⟨ ⅄ⓔ♡ ⊠ⓔℋℋψⓐ

Cryptographers call this a *substitution cipher*, because every letter of the English alphabet has been replaced by a different character, in this case an alien symbol. This type of cipher was first cracked by the ninth-century Arab mathematician Abu al-Kindi, who realized that every letter has a personality. Moreover, the personality of a particular letter is adopted by whichever symbol replaces that letter in the coded message. By spotting these traits, it is possible to decipher the message.

For example, frequency is an important part of a letter's personality. *e, t,* and *a* are the three most frequent letters in English, while the most common symbols in the alien message are ψ and ✦, which both appear six times. Hence, ψ and ✦ probably represent *e, t,* or *a,* but which is which? A helpful clue appears in the first word, ⊙✦✦⊠, which has a repeated ✦. There are few words that fit the pattern *aa* or *tt*, but there are lots of words of the form *ee*, such as *been, seen, teen, deer, feed,* and *fees.* Hence, it is fair to assume that ✦ = e. With a

bit more detective work, it would be possible to unravel this particular message: *Need extra cash? Melt down your old unwanted humans. We pay top dollar.* And with one or two more messages the entire alien script could be deciphered from A (↓) to Z (⊕).

A	B	C	D	E	F	G	H	I	J	K	L	M	N	O	P	Q	R	S	T	U	V	W	X	Y	Z
↓	ʂ	�ϟ	𝕏	⟁	⊑	⟨	↳	⊙	⋈	�	𝕈	回	⊙	℘	✓	✳	⊛	𝕏	人	3	⊡	✝	Ǥ	Ξ	⊕

Not surprisingly, mathematically adept Futurama fans found this alien code trivial to crack, so Jeff Westbrook (who has written for both *Futurama* and *The Simpsons*) developed a more complex alien code.

Westbrook's efforts resulted in reinventing the *text autokey cipher*, which is akin to a cipher first devised by Girolamo Cardano (1501–76), one of the greatest Italian Renaissance mathematicians. The cipher operates by first assigning numbers to the letters of the alphabet: A = 0, B = 1, C = 2, D = 3, E = 4, …, Z = 25. After this preliminary step, encryption requires just two more steps. First, each letter is replaced with the numerical total of all the letters in all the words up to and including the letter itself. Hence, BENDER OK is transformed as follows:

Letter	B	E	N	D	E	R	O	K
Number	1	4	13	3	4	17	14	10
Total	1	5	18	21	25	42	56	66

The second and final encryption step involves replacing each total number with the corresponding symbol from this list:

There are only 26 symbols, which are associated with the numbers 0 to 25, so what symbol represents R, O, and K, which have just been

assigned totals of 42, 56, and 66, respectively? The rule* is that numbers bigger than 25 are reduced by 26 again and again until they are in the range 0 to 25. Hence, to find the symbol for R, we subtract 26 from 42, which leaves us with 16, which is associated with ⋏. By applying the same rule to the remaining two letters, BENDER OK is encrypted as Ƨ∨╱⊤⊣⋌⋏⋉∨.

However, if it was preceded by some other words, then BENDER OK would be encrypted differently, as the running total would be affected. This made Westbrook's autokey cipher fiendishly difficult to crack. He used it to encode various messages across several episodes, and they proved to be a serious challenge to those *Futurama* fans who made a hobby out of cracking the codes that appeared in the series. Indeed, it took a year before anybody cracked the exact details of the autokey cipher and decoded the various messages.

• • •

Although one might expect some challenging codes to appear in the *Futurama* episode "The Duh-Vinci Code" (2010), its most interesting mathematical aspect relates to a completely different area of mathematics. The plot involves the Planet Express team analyzing the fine detail of Leonardo da Vinci's painting *The Last Supper*, whereupon they notice something odd about James the Lesser, one of the apostles sitting at the left end of the table. A high-powered X-ray reveals that da Vinci originally painted James as a wooden robot. In order to find out whether or not James was an early automaton, the crew heads to Future-Roma, where they discover St. James's tomb. Importantly, they also stumble upon a crypt with an appropriately cryptic engraving that reads:

$$\mathrm{II}^{XI} - (\mathrm{XXIII} \cdot \mathrm{LXXXIX})$$

* This rule belongs to a branch of mathematics known as modular arithmetic. As well as being very useful in the context of cryptography, modular arithmetic also plays a vital role in several other areas of mathematical research, including the proof of Fermat's last theorem.

At first sight, the Roman numerals look rather like a date. On closer inspection, however, we can see that the engraving includes parentheses, a subtraction sign, and a dot that represents a multiplication sign. We even have the highly unusual arrangement of one Roman numeral raised to the power of another Roman numeral (II^{XI}). If we convert all these Roman numerals to more familiar digits, we can begin to make sense of the inscription:

$$II^{XI} - (XXIII \cdot LXXXIX)$$

$$2^{11} - (23 \times 89)$$

Now, $2^{11} = 2{,}048$ and $23 \times 89 = 2{,}047$, so the result of this subtraction is simply 1. This is not particularly noteworthy, but if we complete the equation and rearrange it slightly, then it might begin to look familiar:

$$2^{11} - (23 \times 89) = 1$$

Smallest $2^p - 1$ not prime

$$2^{11} - 1 = (23 \times 89)$$

$$2^{11} - 1 = 2{,}047$$

$2^p - 1$ not prime

We can now see that the number 2,047 fits the general form $2^p - 1$. p is 11 in this particular case, but p can be any prime number. The number recipe $2^p - 1$ was discussed in chapter 8, where it was pointed out that it uses one prime number as an ingredient in order to sometimes generate a second prime number, in which case the resulting prime is dubbed a Mersenne prime. However, $2^{11} - 1$ is interesting, because the result, 2,047, is clearly *not* prime, but rather it is the product of 23 and 89. Indeed, 2,047 is notable as the smallest number of the type $2^p - 1$ that is not prime.

This reference fulfills two of the key criteria required to qualify as a classic freeze-frame gag. First, the cryptic inscription has no bearing whatsoever on the plot, but is merely an instance of the writers having fun with numbers. And, second, it is impossible to jot down the Roman

numerals, translate them into decimals, and then recognize their significance within the few moments that the inscription is in view.

Another freeze-frame gag appears in "Put Your Head on My Shoulders" (2000). When Bender sets up a computer dating agency, we see a sign pointing out that his service is both "discreet and discrete." *Discreet* implies that Bender will respect his clients' privacy, as we might expect from such agencies. *Discrete* is a more surprising adjective for a dating agency, because it is used in mathematical circles to describe an area of research that deals with data that does not vary smoothly or continuously. Pancake flipping is one area of discrete mathematics, because it is possible to consider one flip or two flips, but not one and a half or any other type of fractional flip. This freeze-frame gag was possibly inspired by an old joke about discrete mathematics:

> Q: What do you call a mathematician who has lots of romantic
> liaisons, but who doesn't like to talk about it?
> A: A discrete data.

Other *Futurama* freeze-frame gags relate to signs, such as the one at Studio $1^2 2^1 3^3$ in "Rebirth" (2010). If we work out the result, then $1^2 2^1 3^3 = 1 \times 2 \times 27 = 54$, so this is a reference to Studio 54, the famous 1970s New York nightclub. Similarly, we glimpse a sign that reads "Historic $\sqrt{66}$" (instead of "Historic Route 66") in "Parasites Lost" (2001), and there is the irrationally named πth Avenue in "Future Stock" (2002).

Although it is tempting to look at all these mathematical quips and consider them superficial, in many instances the writers have thought long and hard about the underlying ideas. Madison Cube Garden, which appears in several episodes of *Futurama*, is a case in point. When David X. Cohen invented the concept of a thirtieth-century incarnation of New York's Madison Square Garden, the next step was to think about how it would be drawn in the Futurama landscape. The obvious design would have been a cubic stadium,

with a base, four walls, and a flat glass roof. However, Ken Keeler and his fellow writer J. Stewart Burns decided to investigate the geometry of cubes to see if there was a more interesting option for the orientation and design of Madison Cube Garden. In the end, they took this question so seriously that they spent a couple of hours studying the geometry of cubes while the rest of the writing team took a break.

Without much thought as to where it would lead, Burns and Keeler began to wonder what cross sections might be possible if they could take a slice through a cube. For example, a horizontal slice, which splits the cube into two equal parts, results in a square cross section. By contrast, a slice that starts at a top edge and runs to the diagonally opposite edge forms a rectangular cross section. Alternatively, lopping off a corner creates a triangular cross section. Depending on the angle of the slice, the cross section might be an equilateral, isosceles, or scalene triangle.

Still driven by mere curiosity, Burns and Keeler wondered if a more exotic cross-sectional shape might be possible. The duo set aside their sketchpads and set to work building paper cubes, only to chop them up again. After much debate and crumpled paper, Burns and Keeler had a revelation. They eventually realized that it was possible to create a hexagonal cross section by taking a single slice through a cube at a particular angle. It sounds implausible, but imagine drawing a line between the midpoints of two adjacent edges, as shown by a dashed line on the cube below. Next, draw a dotted line across the opposite corner of the opposite face. Finally, take a slice from the dashed line through to the dotted line and the result will be a regular hexagonal

cross section. The cross section has six sides, because the slice passes through all six faces of the cube.

There is another way to obtain this cross section. Imagine suspending a cube from a piece of cotton attached to one of its corners. Then make a slice horizontally, exactly halfway down the dangling polyhedron. If the cube could somehow remain intact after the slice . . . and if it could be gently lowered onto a surface . . . and if its lowest corner could be embedded in that surface, then you would have an almost perfect model of Madison Cube Garden. To complete your model, the region above the cross section becomes a transparent roof, while the region below provides an appropriate arrangement for raked seating.

In the years since Cohen named the stadium and the Burns-Keeler partnership created its unique geometric architecture, Madison Cube Garden has been home to Ultimate Robot Fighting League matches,

giant ape fights, and the 3004 Olympic Games. In fact, Madison Cube Garden has appeared in ten episodes, making it probably the best known piece of mathematics in *Futurama*, but not the most intriguing.

That prize goes to the number 1,729.

CHAPTER 15

1,729 AND A
ROMANTIC INCIDENT

• • • • • • • • • • • • • •

F uturama's Zapp Brannigan is a twenty-five-star general and cap-
tain of the starship *Nimbus*. Although he has many adoring fans,
who view him as a courageous military hero, the reality is that most
of his victories are against lesser opponents, such as the pacifists of the
Gandhi Nebula and the Retiree People of the Assisted Living Nebula.
Brannigan is essentially a buffoon whose vanity and arrogance annoy
his crew. Indeed, his long-suffering assistant Lieutenant Kif Kroker
struggles to hide his disdain for his incompetent leader.

Kif is an alien from the planet Amphibios 9, and his appearances
in *Futurama* often revolve around his dysfunctional relationship with
Brannigan or his ongoing romantic relationship with Planet Express's
intern, Amy Wong. Whenever Kif and Amy are in the same space
neighborhood, they make the most of being able to spend time to-
gether. In "Kif Gets Knocked Up a Notch" (2003), Amy visits Kif on
board the *Nimbus*, where he takes her to the holo-shed, which is used
to simulate realities by projecting three-dimensional holographic ob-
jects and creatures. She squeals with delight when a familiar animal
appears in the holo-shed.

> AMY: Spirit! Kif, that's the pony I always wanted, but my
> parents said I had too many ponies already.
> KIF: Yes, I programmed it in for you. Four million lines of
> BASIC!

We have already encountered a joke that relies on a knowledge of the BASIC computer programming language, in the episode titled "I, Roommate." Although references to computer science are a tradition within *Futurama*, there was one non-nerdy writer who did not appreciate this particular line of dialogue. During a script meeting, he argued that the reference to "four million lines of BASIC!" was too obscure and should be removed. As soon as this criticism was raised, it was robustly quashed by Eric Kaplan, a writer who had studied the philosophy of science. As Patric Verrone, who was at the meeting, recalls: "There was a very famous remark made by Eric Kaplan. Somebody said 'Four million lines of BASIC, who's going to get that?' And Kaplan just said, 'Fuck 'em,' to coin a phrase. And so that became the mantra. If viewers don't get it, they'll get the next joke."

In the same episode, there is an even more obscure mathematical reference, which can be seen on the side of the *Nimbus*. Keen-eyed, obsessive fans will have spotted that the *Nimbus* displays the registry number BP-1729. It would be easy to dismiss this as an arbitrary number, but the *Futurama* writers never miss an opportunity to celebrate mathematics, so it is safer to assume every number that appears on screen is significant.

Indeed, 1,729 must be significant because it crops up in different situations in various episodes. For example, in "Xmas Story" (1999), there is an appearance by Mom, the Machiavellian owner of Mom-Corp and Mom's Friendly Robot Company. As Mom owns the factory that built Bender, she considers herself to be Bender's mother, so she sends him a card that reveals his serial number:

> MERRY XMAS
> SON #1729

Moreover, in "The Farnsworth Parabox" (2003), the Planet Express crew becomes embroiled in an adventure involving parallel universes, with each universe conveniently contained in a box and labeled

with a number. While checking several boxes in order to find his own universe, Fry jumps into a box and finds himself in Universe 1,729.

So, what makes 1,729 so special? Perhaps it keeps cropping up in *Futurama* because it points to a special part of the number *e*. If we pinpoint the 1,729th decimal place of *e*, then we discover that it marks the start of the first consecutive occurrence of all ten digits in this famously irrational number:

1,729th decimal place

↓

$$e = 2.71828\ldots 5889\underline{7071942586397}87727547109\ldots$$

Some might consider this a trivial observation, so perhaps 1,729 features in *Futurama* because it is a *harshad number*, a category of number invented by the respected Indian recreational mathematician and schoolteacher D. R. Kaprekar (1905–86). *Harshad* means "giver of joy" in the ancient Indian language Sanskrit, and the reason these numbers generate a sense of bliss is that they are multiples of the sum of their digits. So, by adding up the digits of 1,729, we get $1 + 7 + 2 + 9 = 19$, and indeed 19 divides into 1,729 with no remainder.

Moreover, 1,729 is a particularly special type of harshad number, because it is the product of the sum of its digits and the reverse of this sum: $19 \times 91 = 1,729$. This makes it a remarkable number, but not unique, because there are three other numbers that share this property: 1, 81, and 1,458. Since the writing team is not obsessed with 1 or 81 or 1,458, there must be another reason why the series repeatedly features 1,729 in its scripts.

In fact, the writers chose 1,729 as *Nimbus*'s registry number, Bender's serial number, and the label for a parallel universe because it was mentioned in one of the most famous conversations in the history of mathematics. It took place in late 1918 or early 1919 between two of the greatest mathematicians of the twentieth century, Godfrey Harold Hardy and Srinivasa Ramanujan. It is hard to imagine two men from such different backgrounds with so much in common.

G. H. Hardy (1877–1947), whose parents were both teachers, grew

up in a middle-class home in Surrey, England. At the age of two he was writing numbers that reached into the millions, and a little later he calculated the divisors of hymn numbers in order to amuse himself during church services. He won a scholarship to the prestigious Winchester College and then attended Trinity College, Cambridge, where he joined an elite secret society known as the Cambridge Apostles. By the time he was thirty, he was one of the few British mathematicians considered world class. Indeed, at the start of the twentieth century, it was felt that the French and Germans, among others, had leapfrogged the British in terms of their mathematical rigor and ambition, but Hardy's research and leadership was credited with revitalizing his nation's reputation. All of this would have been sufficient to earn him a place in the pantheon of great mathematicians, but he made an even greater contribution by recognizing and nurturing the talent of a brilliant youngster named Srinivasa Ramanujan, whom he believed to be the most naturally gifted mathematician of the modern era.

Ramanujan was born in 1887 in the South Indian state of Tamil Nadu. At the age of two he survived a bout of smallpox, but his three younger siblings were less fortunate, each one dying in infancy. His impoverished parents devoted themselves to their only child and enrolled him in the local school. As each year passed, his teachers increasingly noticed that Ramanujan was developing a tremendous aptitude for mathematics, so much so that they were unable to keep up with him. Much of his inspiration and education came as a result of stumbling upon a library book, *A Synopsis of Elementary Results in Pure Mathematics*, by G. S. Carr, which contained thousands of theorems and their proofs. He investigated these theorems and the techniques used to prove them, but he had to perform the bulk of his calculations with a chalk and slate, using his roughened elbows as erasers, as he was unable to afford paper.

The only downside to his obsession with mathematics was that it led him to neglect the rest of his schooling. Hence, when it came to examinations, he performed poorly in these other subjects, which meant that Indian colleges refused to offer him the scholarship he needed to be able to afford to continue with his studies. Instead, he

found a job as a clerk and supplemented his meager income by tutoring mathematics students. The additional money was desperately needed after he got married in 1909. Ramanujan was twenty-one and his new bride, Janakiammal, was just ten years old.

During this period, Ramanujan began to develop new mathematical ideas in his spare time. He felt that they were innovative and important, but he had nobody to whom he could turn for advice and support. Desperate to explore mathematics in more depth and to have his work recognized, Ramanujan began to write to mathematicians in England in the hope that someone would mentor him or at least give him feedback on his newly discovered theorems.

One batch of letters eventually reached M. J. M. Hill at University College, London. He was mildly impressed, but admonished the young Indian for using outdated methods and making trivial mistakes. He wrote, in a schoolmasterly tone, that Ramanujan's work needed to be "very clearly written, and should be free from errors; and he should not use symbols which he does not explain." It was an unforgiving report card, but at least Hill responded. By contrast, both H. F. Baker and E. W. Hobson at the University of Cambridge returned Ramanujan's papers without comments.

Then, in 1913, Ramanujan wrote to G. H. Hardy: "I have had no university education but I have undergone the ordinary school course. After leaving school I have been employing the spare time at my disposal to work at mathematics. I have not trodden through the conventional regular course which is followed in a university course, but I am striking out a new path for myself."

When a second letter followed, Hardy found that Ramanujan had sent him a total of 120 theorems to consider. The young Indian savant would later say that many of these theorems were whispered to him in his sleep by Namagiri, an avatar of the Hindu goddess Lakshmi: "While asleep, I had an unusual experience.. There was a red screen formed by flowing blood, as it were. I was observing it. Suddenly a hand began to write on the screen. I became all attention. That hand wrote a number of elliptic integrals. They stuck to my mind. As soon as I woke up, I committed them to writing."

Upon receiving Ramanujan's papers, Hardy's reaction veered between "fraud" and so brilliant that it was "scarcely possible to believe." In the end, he concluded that the theorems "must be true, because, if they were not true, no one would have the imagination to invent them." Hardy dubbed Ramanujan "a mathematician of the highest quality, a man of altogether exceptional originality and power," and he began to make arrangements for the young Indian, still only twenty-six, to visit Cambridge. Hardy took great pride in being the man who had rescued such raw talent, and would later call it "the one romantic incident in my life."

The two mathematicians finally met in April 1914, and their resulting partnership gave rise to discoveries in several areas of mathematics. For example, they made major contributions toward understanding a mathematical operation known as *partition*. As the name implies, partitioning concerns dividing up a number of objects into separate groups The key question is, for a given number of objects, how many different ways can they be partitioned? The boxes below show that there is one way to partition one object, but there are five ways to partition four objects:

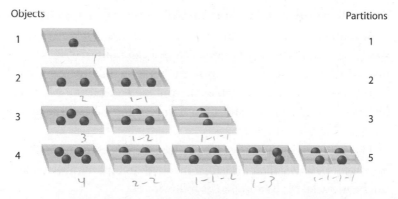

Objects

Partitions

1 1

2 2

3 3

4 5

It is easy to find the number of partitions for a small quantity of objects, but it becomes trickier and trickier with more and more objects. This is because the number of possible partitions balloons in a rapid and erratic fashion. 10 objects can be partitioned in just 42 ways, but 100 objects can be partitioned in 190,569,292 ways. And

1,000 objects can be partitioned in an astonishing 24,061,467,864, 032,622,473,692,149,727,991 ways.

One of Hardy and Ramanujan's breakthroughs was to invent a formula that can be used to predict the number of partitions for very large numbers. The formula requires a great deal of effort to compute, so they also invented a rough-and-ready formula that gave a good estimate of the number of partitions for any given number of objects. Ramanujan also made an interesting observation that continues to provide food for thought today: If the number of objects ends with 4 or 9, then the number of partitions is always divisible by 5. To illustrate Ramanujan's claim, 4, 9, 14, 19, 24, and 29 objects generate 5, 30, 135, 490, 1,575, and 4,565 partitions, respectively.

Ramanujan's achievements were numerous, complex, and brilliant, and his genius was recognized in 1918 when he was elected one of the youngest fellows in the history of the Royal Society. Sadly, while his move to Cambridge enabled his mind to embark on incredible adventures, the harsh English winters and the change in diet took their toll on Ramanujan's health. Toward the end of 1918, he left Cambridge and was admitted to a private nursing home, Colinette House in Putney, London. It was against this background that the conversation linking Ramanujan to *Futurama* took place.

According to Hardy: "I remember once going to see him when he was lying ill at Putney. I had ridden in taxi cab number 1729 and remarked that the number seemed to me rather a dull one, and that I hoped it was not an unfavorable omen. 'No,' he replied, 'it is a very interesting number; it is the smallest number expressible as the sum of two cubes in two different ways.'"

The two men were clearly not comfortable engaging in small talk or gossip. As usual, their exchange revolved around numbers, and it can be unpacked and expressed as follows:

$$1,729 = 1^3 + 12^3$$

$$= 9^3 + 10^3$$

In other words, if we had 1,729 small cubelets, we could arrange them as two cubes with dimensions $1 \times 1 \times 1$ and $12 \times 12 \times 12$, or we could arrange them as two cubes with dimensions $9 \times 9 \times 9$ and $10 \times 10 \times 10$. It is rare that numbers can be split into two cubes, and even rarer that they can be split into two cubes in two different ways . . . and 1,729 is the smallest number that exhibits this property. In honor of Ramanujan's comment about Hardy's taxicab, 1,729 is known in mathematical circles as a *taxicab number*.

Prompted by Ramanujan's off-the-cuff remark, mathematicians have asked a related question: What is the smallest number that is the sum of two cubes in *three* different ways? The answer is 87,539,319, because

$$87{,}539{,}319 = 167^3 + 436^3$$

$$= 228^3 + 423^3$$

$$= 255^3 + 414^3$$

This number, which is also labeled a taxicab number, crops up in a special extended *Futurama* episode titled "Bender's Big Score" (2007). When Fry hails a cab, the number on the roof is 87,539,319. It is, of course, very appropriate that the taxicab number (in the normal sense) is a taxicab number (in the mathematical sense).

Thus, by repeatedly referencing 1,729 and including 87,539,319, the *Futurama* writers are paying tribute to Ramanujan, whose story is largely unknown outside the world of mathematics. It is an inspiring story of a natural genius plucked from obscurity by a Cambridge don, yet it ends tragically. Suffering from various ailments, including vitamin deficiencies and probably hepatic amoebiasis, Ramanujan returned to India in 1919 in the hope that a warmer climate and a more familiar diet might restore his health. After barely a year in India, he died on April 26, 1920, at the age of thirty-two.

Nevertheless, Ramanujan's ideas remain at the heart of modern mathematics, and always will. This is partly because the language of mathematics is universal and partly because mathematical proofs are

absolute. Unlike ideas in the arts and humanities, mathematical theorems do not go in and out of fashion. As Hardy himself pointed out: "Archimedes will be remembered when Aeschylus is forgotten, because languages die and mathematical ideas do not. 'Immortality' may be a silly word, but probably a mathematician has the best chance of whatever it may mean."

• • •

These *Futurama* references to taxicab numbers can all be traced back to one writer, Ken Keeler, who ranks as one of the most mathematically gifted writers on either *The Simpsons* or *Futurama*. According to Keeler, his fascination with mathematics was largely inspired by his father, Martin Keeler, a medical doctor whose favorite hobby was playing games with numbers. Whenever the family went to a restaurant and received the bill at the end of the meal, he would check it for prime numbers, and his children were expected to join in. On one particular occasion, Ken recalls asking his father if there was a quick way to add up square numbers. For example, what is the sum of the first five square numbers, or the first ten square numbers, or the first n square numbers? Dr. Keeler thought about it for a short while and then correctly responded with the correct formula: $n^3/3 + n^2/2 + n/6$. Keeler's formula can be checked with an example, such as $n = 5$:

Sum of the first five square numbers: $1 + 4 + 9 + 16 + 25 = 55$

Dr. Keeler's formula: $\dfrac{5^3}{3} + \dfrac{5^2}{2} + \dfrac{5}{6} = 55$

This is not a seriously challenging problem for a mathematician, but Dr. Keeler was not a mathematician. Moreover, he solved the problem using a radical and highly intuitive approach. A brief and moderately technical explanation in Ken Keeler's own words appears in appendix 4.

His father's playful approach to mathematics was partly responsible for Ken Keeler's decision to study applied mathematics at college and then pursue a doctorate in the subject. However, after completing

his PhD, he was torn between a career in research and trying his hand at comedy writing, his other great passion. Although he landed a job as a researcher at AT&T Bell Labs in New Jersey, he had already sent his résumé to the producers of *Late Night with David Letterman*. That proved to be the turning point. He was invited to join the writing team, left his research job, and never looked back. Keeler then had stints writing for *Wings* and *The Critic*, before becoming part of the *Futurama* team, working alongside half a dozen other mathematically inclined writers. Nowhere else in Hollywood would Keeler's love of the number 1,729 have been so fully appreciated.

One of Keeler's other mathematical contributions to *Futurama* is the Loew's \aleph_0-Plex, which first appeared in "Raging Bender" (2000). Loews built a reputation in the twentieth century for operating some of the world's biggest multiplex movie theaters, but the \aleph_0 prefix implies a major scaling up of their operations in the thirty-first century. \aleph_0 (pronounced *aleph-null*) is a mathematical symbol that represents infinity, so the name of the movie theater implies that it has an infinite number of screens. According to Keeler, when the Loew's \aleph_0-Plex made its debut on *Futurama*, the draft script included a comment that this movie theater with infinitely many screens "still wouldn't be big enough to show *Rocky* and all its sequels at once."

Although the symbol \aleph_0 will be unfamiliar to most readers, there is another symbol for infinity, ∞, that we come across in high school. Hence, you might ask what is the difference between ∞ and \aleph_0. In short, ∞ is a broad-brush symbol for the concept of infinity, whereas \aleph_0 applies to a particular type of infinity!

The concept of a "particular type of infinity" might sound impossible, particularly as the earlier story of Hilbert's Hotel demonstrated two clear conclusions:

(1) infinity + 1 = infinity

(2) infinity + infinity = infinity

It would be easy to jump to the conclusion that there is nothing bigger than infinity, and that all infinities have the same bigness, so to

speak. However, there are actually different sizes of infinity, and this can be demonstrated using a fairly simple argument.

We begin by focusing on the set of decimal numbers that sits between 0 and 1. This includes simple decimals such as 0.5 and also numbers that have many more decimal places, such as 0.736829474638.... There are clearly an infinite number of these decimals, because for any given decimal (e.g., 0.9), there is a bigger one (0.99), and then a bigger one (0.999), and so on. Next, we can consider how the infinity of decimals between 0 and 1 compares with the infinity of counting numbers, 1, 2, 3,.... Is one type of infinity bigger than the other, or are they the same size?

To find out which, if either, infinity is larger, let us imagine what would happen if we tried to match all the counting numbers against all the decimal numbers between 0 and 1. The first step would be to somehow make a list of all the counting numbers and a separate list of all the decimal numbers between 0 and 1. For this particular argument, the list of counting numbers should be in numerical order, while the list of decimals numbers can be in any order. The lists are then written down side by side, with a one-to-one matching.

Counting numbers	Decimal numbers
1	0.70052...
2	0.15432...
3	0.51348...
4	0.82845...
5	0.15221...
⋮	⋮

Hypothetically, if we can match the counting numbers and the decimal numbers in this way, then there must be the same number of each, and the two infinities would therefore be equal. However, establishing a one-to-one correspondence turns out to be impossible.

This becomes clear in the final stage of our infinity investigation, which involves creating a number by taking the first digit of the first

decimal number (7), the second digit of the second decimal number (5), and so on. This generates the sequence 7–5–3–4–1…. Then, by adding 1 to every digit (0 → 1, 1 → 2, …, 9 → 0), we generate a new sequence, 8–6–4–5–2…. Finally, this sequence can be used to construct a decimal number, 0.86452….

This number, 0.86452…, is interesting because it cannot possibly exist in the supposedly complete list of decimal numbers between 0 and 1. That seems like a bold claim, but it can be verified. The new number cannot be the first number on the list, because we know that the first digit won't match. Similarly, it cannot be the second number, because we know that the second digit won't match, and so on. More generally, it cannot be the nth number, because the nth digit won't match.

Slight variations of this argument can be repeated to show that there are lots of other numbers that are missing from the list of decimals. In other words, when we try to match up the two infinities, the list of decimals between 0 and 1 is doomed to be incomplete, presumably because the infinity of decimal numbers is greater than the infinity of counting numbers.

This argument is a simplified version of *Cantor's diagonal argument*, a watertight proof published in 1892 by Georg Cantor. Having confirmed that some infinites are bigger than others, Cantor was confident that the infinity that describes counting numbers was the smallest type of infinity, so he labeled it \aleph_0, with \aleph (aleph) being the first letter of the Hebrew alphabet. He suspected that the set of decimals between 0 and 1 illustrated the next and bigger type of infinity, so he labeled it \aleph_1 (aleph-one). Larger types of infinity, for they also exist, are logically named \aleph_2, \aleph_3, \aleph_4, ….

Thus, although *Futurama*'s Loew's \aleph_0-Plex movie theater has an infinite number of screens, we now know that it is only the smallest type of infinity. Had it been an \aleph_1-Plex movie theater, it would have had even more screens.

Futurama does make one more reference to Cantor's categorization of infinities. Mathematicians describe \aleph_0 as countably infinite, because it describes the scale of infinity associated with the counting

numbers, whereas larger infinities are dubbed *uncountably infinite*. As noted by David X. Cohen, the latter term receives a casual mention in an episode titled "Möbius Dick" (2011): "We go briefly into this weird four-dimensional universe and there are many, many copies of Bender floating around all doing a conga line and then he comes back to reality and says, 'That was the greatest uncountably infinite bunch of guys I ever met.'"

CHAPTER 16

A ONE-SIDED STORY

• • • • • • • • • • •

n "Möbius Dick", the Planet Express ship is traveling through the galaxy and inadvertently enters the Bermuda Tetrahedron, a spaceship graveyard containing dozens of famous lost vessels. The Planet Express crew decide to investigate the region, whereupon they are attacked by a fearsome four-dimensional space whale, which Leela nicknames Möbius Dick.

The space whale's name is both a play on Herman Melville's novel *Moby-Dick* and a reference to a bizarre mathematical object known as a *Möbius strip* or *Möbius band*. The Möbius strip was discovered independently by the nineteenth-century German mathematicians August Möbius and Johann Listing. Using their simple recipe, you can build one for yourself. You will require:

(a) a strip of paper,

(b) sticky tape.

First, take the strip and twist one end through half a turn, as shown below. Then tape the two ends together to create the Möbius strip. That is all. A Möbius strip is essentially just a loop with a twist.

Join

Half turn

So far, the Möbius strip does not seem very special, but a simple experiment reveals its remarkable property. Take a felt-tip pen and draw a line around the strip without taking the pen off the paper, without crossing any edges, and continuing until you get back to where you started. You will notice two things: It takes two circuits to get back to where you started, and you will have drawn along every section of the strip. This is very surprising, because we assume that a piece of paper has two sides and you can only draw on both of them if your pen is allowed to leave the paper or go around an edge. So what happened in the case of the Möbius strip?

Sheets of paper have two sides (a top side and a bottom side), and loops of paper also typically have two sides (an inner side and an outer side), but the Möbius strip has the unusual property of only having one side. The two sides on the initial strip of paper were transformed into one side when the half twist was introduced prior to joining the ends together. This unusual property of a Möbius strip has provided the basis for my third all-time favorite mathematical joke:

> Q: Why did the chicken cross the Möbius strip?
> A: To get to the other . . . er . . . !

Although we do not actually see a Möbius strip in the episode "Möbius Dick," the good news is that there are plans to feature one of these odd bits of mathematical tomfoolery in an upcoming *Futurama* plot. When I visited David X. Cohen at the *Futurama* offices in the fall of 2012, he told me about an episode in the upcoming season titled "2-D Blacktop," * which will star Professor Farnsworth. Cohen explained that the storyline involves the elderly proprietor of Planet Express turning into a speed freak who soups up his spaceship in order to race it on a Möbius drag strip. The interesting feature of such a track—as demonstrated by the felt-tip experiment—is that Farnsworth will need to complete two laps in order to get back to where he started.

* The episode's title is a twist on *Two-Lane Blacktop*, a cult 1971 movie about two street racers.

Cohen revealed a few plot details: "Leela gets mad at the Professor and they end up racing on the Möbius drag strip. Leela is leading, but the Professor has this big racing move called the dimensional drift. He spins the wheel while pulling the emergency brake, which causes him to drift through one dimension higher than where he is. So, he skids out of the third dimension, then passes briefly through the fourth dimension, so he can reappear back in the third dimension further along the track."

Unfortunately, shifting up and down through dimensions also leaves Professor Farnsworth traveling in the opposite direction to Leela. Their vehicles collide head-on, thereby crushing them both down into the second dimension! The next scene then takes place against a dimensionally challenged landscape.

In many ways, "2-D Blacktop" is the antidote to "Homer³." That episode from *The Simpsons* explored the consequences of being lifted into a higher dimension, drawing upon a *Twilight Zone* episode for its inspiration. By contrast, "2-D Blacktop" explores what it means to be squashed down to a lower dimension, and it too is inspired by a classic piece of science fiction.

"2-D Blacktop" is an homage to a Victorian sci-fi novella titled *Flatland*, by Edwin A. Abbott. Subtitled *A Romance of Many Dimensions*, the story begins in a two-dimensional world known as Flatland. This universe is composed of a single surface populated with various shapes, such as line segments (women), triangles (working-class men), and squares (middle-class men). Essentially, the greater the number of sides, the higher the status, so women have the lowest status, polygons make up the upper echelons of society, and circles are high priests. As a theologian who had studied mathematics at the University of Cambridge, Abbott was keen that readers appreciated his *Flatland* as both a social satire and an adventure in geometry.

The central character and narrator is a Square, who has a dream in which he visits Lineland, a one-dimensional universe, where a population of points are confined to traveling along a single line. The Square talks to the points and tries to explain the concept of a second dimension and the resulting variety of shapes that occupy Flatland, but the

points remain confused. They cannot even appreciate the true nature of the Square, because his shape is inconceivable from their one-dimensional point of view. They see the Square as a line, because that is the cross section that a square makes as it passes through Lineland.

After waking up and realizing that he is back in his Flatland, the Square's adventures continue when he is visited by a Sphere, an object from the exotic third dimension. Of course, this time it is the Square who is baffled, because he can only perceive the Sphere as a Circle, which is the cross section that the Sphere makes as it passes through Flatland. However, everything begins to make sense when the Sphere drags the Square up into Spaceland. As the Square looks down upon his fellow Flatlanders from the third dimension, he can even speculate about the possibilities of a fourth, a fifth, and even higher dimensions.

When he returns to Flatland, the Square tries to spread the gospel of the third dimension, but nobody wants to listen. Worse still, the authorities clamp down on such blasphemy. In fact, the leaders of Flatland already know of the existence of the Sphere, so they arrest the Square in order to keep the third dimension a secret. The story ends tragically with the Square locked up in prison for telling the truth.

So how does the forthcoming *Futurama* episode pay tribute to *Flatland*? When Professor Farnsworth and Leela collide in "2-D Blacktop," the head-on impact transforms them into flat versions of themselves, sliding around in a flat landscape, which is populated by flat animals, flat plants, and flat clouds.

The animation adheres strictly to the rules of a two-dimensional world, which means that no object can pass over another object, only around it. However, while I watched a rough cut two-dimensional sequence from "2-D Blacktop" with editor Paul Calder, he spotted the fluffy edges of one cloud overlapping slightly with the fluffy edges of another cloud. Overlaps are forbidden in a two-dimensional world, so this will require fixing before the episode is aired.

As they attempt to understand the implications of their new world, Leela and the Professor gradually realize that their digestive canals vanished when they were squashed from three dimensions down to two. This is a necessary part of the transformation process, because a

digestive canal in two dimensions is a recipe for disaster. To appreciate the problem, imagine the Professor as a flat cut-out figure facing to the right. Then draw a line from his mouth to his posterior, representing his gastrointestinal canal. Finally cut along this line and slightly separate the two parts of the Professor's body; the canal is a tunnel in three dimensions, but is simply a gap in two dimensions. Now you can see the problem. With a digestive system in place, the Professor's body would drift apart in two dimensions. Obviously the same would be true for Leela.

However, without digestive tracts, the Professor and Leela are unable to eat. The other creatures in this two-dimensional world survive by somehow absorbing nutrients, as opposed to eating and excreting food, but the Professor and Leela have not mastered this trick.

In short, for the Professor and Leela, digestive tracts are a case of "can't live with them, can't live without them." Hence, they have to escape their two-dimensional world before they starve to death, and fortunately the writers come to their rescue. Cohen explained: "The Professor and Leela have this realization. They can use the dimensional drift to get out of the second dimension and into the third dimension. We actually have this amazing sequence, because they fly through this huge fractal landscape that represents the area between two dimensions and three dimensions. The scene contains some pretty amazing computer graphics."

The *fractal* landscape is particularly appropriate, because fractals actually exhibit a *fractional dimensionality*. The fractal landscape appears on the journey between the two-dimensional and three-dimensional worlds, which is exactly where one might expect to find a fractional dimension.

If you want to know more about fractals, please refer to appendix 5, where there is a very brief overview of this topic, focusing particularly on how an object can possibly be fractionally dimensional.

• • •

The Möbius strip in "2-D Blacktop" resonates with a mathematical concept that appears in "The Route of All Evil" (2002). This episode

has a subplot that involves Bender turning himself into a home brewery. He gets the idea after he and his Planet Express colleagues visit a 7^{11} convenience store to buy some alcohol. The store stocks Bender's usual tipple, Olde Fortran malt liquor, named in honor of FORTRAN (FORmula TRANslation), a computer-programming language developed in the 1950s. The shelves are also stacked with St. Pauli's Exclusion Principle Girl beer, which combines the name of an existing beer (St. Pauli Girl) with one of the foundations of quantum physics (the Pauli exclusion principle). Most interesting of all is a third brew called Klein's, which comes in a strange flask. Aficionados of weird geometry will recognize that this is a *Klein bottle*, which is closely related to the Möbius strip.

The beer is called Klein's in honor of Felix Klein, one of the greatest German mathematicians of the nineteenth century. His destiny may have been dictated the moment he was born, because each element of his date of birth, April 25, 1849, is the square of a prime number:

$$
\begin{array}{ccc}
\text{April} & 25 & 1849 \\
4 & 25 & 1{,}849 \\
2^2 & 5^2 & 43^2
\end{array}
$$

Klein's research ranged across several areas, but he is most famous for the so called Klein bottle. As with the Möbius strip, it will be easier to understand the shape and structure of a Klein bottle if you construct your own. You will require:

(a) a sheet of rubber,

(b) some sticky tape,

(c) a fourth dimension.

If, like me, you do not have access to a fourth dimension, then you can imagine how we might theoretically build a pseudo–Klein bottle in three dimensions. First, imagine rolling the rubber sheet into a cylinder and taping it along its length as shown below in the first diagram. Then mark the two ends of the cylinder with arrows going in opposite directions. Next, and this is the tricky step, you must introduce a twist in the cylinder so that you can connect the two ends with both arrows heading in the same direction.

This is where the fourth dimension would come in very useful, but instead you will have to make do with a minor fudge. As shown in the middle two diagrams, bend the cylinder back on itself, and then imagine pushing one end of the cylinder through the wall of the self-same cylinder and up the inside. Finally, after this self-intersection step, roll the penetrating end of the cylinder downward, as in the fourth diagram, in order to connect the two ends of the cylinder. Crucially, when this connection is made, the arrows on each end of the cylinder will be pointing in the same direction.

Both this Klein bottle and the Klein beer bottle in *Futurama* are self-intersecting, because they both exist in three dimensions. By contrast, a Klein bottle in four dimensions would avoid the necessity for self-intersection. In order to explain how an extra dimension can help avoid self-intersection, let us consider a similar situation involving fewer dimensions.

Imagine a figure eight shape made with a pen on a piece of paper. Inevitably, the ink line intersects itself at the center of the eight, in the same way that that the cylinder intersects itself at the center of the Klein bottle. The inky intersection occurs because the line is trapped within a two-dimensional surface. The problem does not arise, however, if a third dimension is added and the figure eight is created with a piece of rope. One section of the rope can rise up into this third dimension as it overlays another section, so there is no need for the rope to intersect itself. Similarly, if the rubber sheet cylinder could rise up into the fourth dimension, then it would be possible to create a Klein bottle without a self-intersection.

Another way to think about why the Klein bottle intersects itself in three dimensions, but not in four, is to consider how we might view a windmill in three dimensions compared with two dimensions. In three dimensions, we can see that the blades sweep around in front of the vertical tower. However, the situation is different if we look at a shadow of the windmill projected onto the grass. In this two-dimensional representation, the blades appear to sweep through the tower over and over again. The blades intersect the tower in the two-dimensional projection, but not in the three-dimensional world.

The architecture of a Klein bottle is obviously different from that of an ordinary bottle, which in turn leads to a remarkable property. This becomes apparent if we imagine traveling over the surface of the Klein bottle on the opposite page. In particular, imagine following the path of the black arrow, which is positioned on the outer surface of the Klein bottle.

The arrow moves upward, then loops around the outside of the neck and dives down to the intersection point, where the arrow's head becomes grey. This indicates that the arrow is now entering the inside

of the bottle. As the arrow moves forward, it soon passes its starting position, except that now it is inside the bottle. If the arrow continues its journey up toward the neck and down again to the base, it then returns to the outer surface and eventually arrives back at its original position. Because the arrow is able to journey smoothly between the inner and outer surfaces of the Klein bottle, this indicates that the two surfaces are actually both part of the same surface.

Of course, without a well defined inside and outside, the Klein bottle fails one of the main criteria required for a fully functioning bottle. After all, how can you put beer *in* a Klein bottle, when *in* is the same as *out*?

In fact, Klein never called his creation a bottle. It was originally called a *Kleinsche Fläche*, meaning a "Klein surface," which is appropriate as it consists of a single surface. However, English-speaking mathematicians probably misheard this as *Kleinsche Flasche*, which translates into English as "Klein bottle," and the name stuck.

Finally, returning to a point raised earlier, the Klein bottle and the Möbius strip are closely related to each other. The most obvious connection is that both the strip and the bottle share the curious property of having only one surface. A second, and less obvious, connection is that a Klein bottle sliced into two halves creates a pair of Möbius strips.

Unfortunately, you cannot perform this party trick, because it is only possible to slice a Klein bottle if you have access to a fourth dimension. However, you can slice a Möbius strip. Indeed, I would encourage you to cut a Möbius strip along its length in order to find out what happens.

Finally, if you have become hooked on slicing strips, here is one more suggestion for your new hobby of geometry surgery. First, create a strip with a full 360-degree twist (as opposed to the half twist in a Möbius strip). What happens when this strip is cut along its length? It takes a twisted mind to predict the outcome of this twisted dissection.

CHAPTER 17

THE FUTURAMA THEOREM

• • • • • • • • • • •

D ue to his sometimes geriatric-delinquent antics, it is easy to forget that *Futurama*'s Professor Hubert J. Farnsworth is a mathematical genius. In fact, in the feature-length *The Beast with a Billion Backs* (2008), we learn that Farnsworth has been awarded a Fields Medal, the highest accolade in mathematics. It is sometimes dubbed the Nobel Prize of Mathematics, but the title of Fields Medallist is arguably even more prestigious than Nobel laureate, because the medals are only awarded every four years.

The Professor regularly discusses his mathematical ideas in a lecture course "The Mathematics of Quantum Neutrino Fields," which takes place at Mars University, where he is a tenured professor. A tenured position is essentially a job for life, which means that the Professor has to avoid the hazard of tenure-induced mental stagnation. This is a well-known phenomenon in academic circles, and the problem was highlighted by the American philosopher Daniel C. Dennett in his book *Consciousness Explained*: "The juvenile sea squirt wanders through the sea searching for a suitable rock or hunk of coral to cling to and make its home for life. For this task, it has a rudimentary nervous system. When it finds its spot and takes root, it doesn't need its brain anymore so it eats it! (It's rather like getting tenure.)"

Rather than stagnating, Farnsworth has used his tenured position to dabble in other areas of research. So, as well as being a mathematician, he is also an inventor. Indeed, it is no coincidence that Groening and Cohen named the Professor after Philo T. Farnsworth (1906–71), a prolific American inventor who held over one hundred U.S. patents ranging from TV technology to a mini nuclear fusion device.

One of the Professor's oddest inventions is the Cool-O-Meter, which

204 · SIMON SINGH

accurately assesses the level of cool possessed by a person, with the measurement given in units of *megafonzies*. One fonzie is the quantity of cool associated with Arthur Fonzarelli, the lead character in the 1970s sitcom *Happy Days*. By choosing a nomenclature based on an iconic figure, Farnsworth was echoing the *millihelen*, which is a tongue-in-cheek unit of beauty based on the famous reference to Helen of Troy in Christopher Marlowe's *Doctor Faustus*: "Was this the face that launch'd a thousand ships / And burnt the topless towers of Ilium?" Therefore the millihelen is technically defined as "a unit of measure of pulchritude, corresponding to the amount of beauty required to launch one ship."

From a mathematical point of view, the Professor's most interesting invention is the Mind-switcher, which appears in "The Prisoner of Benda" (2010). As the name suggests, the machine takes two sentient beings and swaps their minds, allowing them to inhabit each other's bodies. The mathematics is not in the mind-switching per se, but rather is required to help unravel the mess caused by such mental juggling. Before discussing the nature of this mental arithmetic, let us explore the episode in detail and understand exactly how the Mind-switcher works.

"The Prisoner of Benda" begins with an opening caption that reads, "What happens in Cygnus X-1 stays in Cygnus X-1," echoing the well-known maxim "What happens in Vegas stays in Vegas." In the case of Cygnus X-1, this is literally true, because it is the name of a black hole in the constellation Cygnus, and whatever happens in a black hole is forever condemned to remain in the black hole. The writers probably picked Cygnus X-1 because it is considered a glamorous black hole, thanks to being the subject of a famous wager. The mathematician and cosmologist Stephen Hawking had initially doubted that the object in question was indeed a black hole, so he placed a bet with his colleague Kip Thorne. When careful observations proved that he was wrong, Hawking had to buy Thorne a one-year subscription to *Penthouse* magazine.

The episode's title is a pun based on the Victorian novel *The Prisoner of Zenda*, by Anthony Hope, in which King Rudolf of Ruritania

(a fictional country) is drugged and kidnapped by his evil brother prior to his coronation. In order to save the crown from falling into the wrong hands, Rudolf's English cousin exploits his resemblance to the king and adopts his identity. In short, the plot of *The Prisoner of Zenda* revolves around someone taking on a new identity, which is also the central theme of "The Prisoner of Benda."

The identity swapping starts when Professor Farnsworth uses his Mind-switcher to switch minds with Amy, so that he can experience the joy of being young again from within Amy's body. Amy is also eager to switch, because she can now gorge herself with food, knowing that the Professor's skinny body can easily afford to gain some weight.

The plot becomes more complicated when Bender and Amy switch minds. Of course, prior to this switch, Amy's body has the Professor's mind, so the result of the switch is that Bender's body contains the Professor's mind and Amy's body contains Bender's mind. This enables Bender to commit a robbery by seducing the guards, with the bonus that he cannot be correctly identified. Meanwhile, the Professor runs off to join the Circus Roboticus. The situation gets even messier after an orgy of further mind-switching. Here is a complete sequence of switches that occur during the episode. Each pair of names refers to the bodies involved in the mind-switch, not necessarily the minds inside those particular bodies at the time of the switch.

1	Professor Farnsworth	↔ Amy
2	Amy	↔ Bender
3	Professor Farnsworth	↔ Leela
4	Amy	↔ Wash Bucket*
5	Fry	↔ Zoidberg
6	Leela	↔ Hermes
7	Wash Bucket	↔ Emperor Nikolai†

* Wash Bucket is a robotic mop bucket who has appeared in four episodes.
† Emperor Nikolai is the robot emperor of Robo-Hungary.

Although there are only seven switches in total, the consequences of this mental juggling are very confusing. One way to keep track of what is happening is by drawing a *Seeley diagram*, invented by Dr. Alex Seeley, a *Futurama* fan living in London. A quick glance at this diagram reveals that the seven mind-switches eventually result in the Professor's body containing Leela's mind, Leela's body containing Hermes's mind, and so on.

As the episode draws to a close, everyone grows bored with the novelty and wants to return to his, her, or its original body. Alas, there is a major problem caused by a glitch in the Mind-switcher: Once two

This Seeley diagram tracks the various mind-switches. Circles represent minds, squares represent bodies, and the letters inside them represent the various individuals. Initially, the nine mind-body pairings match, because every body begins with the correct mind. The minds then move to different bodies after each switch. For example, after the first switch, the Professor's body [P] is matched with Amy's mind (A), and vice versa. The bodies always remain on the same horizontal line, while the minds move up and down as they are switched.

bodies have swapped minds, the Mind-switcher cannot perform a second swap between this pair of bodies. Hence, it is not at all clear that the various minds can return to their own bodies.

This Mind-switcher glitch was introduced by the writers to make the plot more interesting. However, someone then had to find a way to overcome this barrier to reach a happy ending, and the responsibility fell to Ken Keeler, the lead writer for this episode. He realized that one way to break the deadlock would be to introduce fresh people into the scenario, characters who could provide indirect paths by which the minds of the Professor and everyone else could return to their correct bodies. However, rather than tackling the particular scenario from "The Prisoner of Benda," Keeler tried to address the more general problem: How many fresh people need to be introduced into a group of any size to unravel any conceivable mind-switching muddle?

When he began to explore the problem, Keeler had no real hunch as to what the answer might be. Would the number of fresh people depend on the size of the group being untangled? If so, perhaps the number of fresh people would be directly proportional to the size of the group, or perhaps the number of fresh people would grow exponentially in relation to the group size. Or maybe there was a magic number of fresh people that could fix any muddled group?

Finding the answer turned out to be a significant challenge, even for someone with a PhD in applied mathematics. It reminded Keeler of some of the tougher problems that he had encountered at university. After an extended period of concentration and head-scratching, Keeler completed a cast-iron proof that delivered an undeniable result. The answer turned out to be surprisingly neat. Keeler concluded that introducing just two fresh people would be enough to untangle mind-switching chaos of any magnitude, as long as those two people were deployed in the correct manner. Keeler's proof, which is somewhat technical, has come to be known as the *Futurama theorem* or *Keeler's theorem*.

This proof is presented in "The Prisoner of Benda" by "Sweet" Clyde Dixon and Ethan "Bubblegum" Tate, two basketball players from the Globetrotter Homeworld, who are also famous for their

This grainy picture was taken by Patric Verrone on December 9, 2009, on the day of the table-read for "The Prisoner of Benda." Ken Keeler is sketching out his proof of the Futurama theorem while standing on a couch in the *Futurama* office.

mathematical and scientific talents. Indeed, Bubblegum Tate is Senior Lecturer in Physics at Globetrotter University and the Downtown Professor of Applied Physics at Mars University. These characters appear in several episodes of *Futurama*, and they regularly demonstrate their mathematical knowledge. For instance, in "Bender's Big Score," Bubblegum Tate gives Sweet Clyde some advice about solving a time-travel equation: "Use variation of parameter and expand the Wronskian."*

As "The Prisoner of Benda" reaches its climax, Sweet Clyde declares: "Q to the E to the D! . . . Basically, no matter how permuted-up your minds are, they can be restored using, at most, two extra players." Sweet Clyde scribbles down an outline of the proof on a fluorescent green chalkboard.

The best way to understand the proof, which is couched in technical notation, is to focus on how it is applied in order to help the characters in "The Prisoner of Benda" sort out their predicament. The proof essentially describes a clever unmuddling strategy, which begins

* The Wronskian is used in the study of differential equations and is named after the nineteenth-century French-Polish mathematician Józef Maria Hoene-Wroński.

The Futurama theorem, as written down by Sweet Clyde at the conclusion of "The Prisoner of Benda." Bubblegum Tate looks at the details of the proof, while Bender (containing the Professor's mind) watches in admiration. A transcription of the proof as it appears on the board is available in appendix 6.

with the realization that individuals with switched minds can be placed into well-defined sets; in the case of "The Prisoner of Benda," there are two sets. Careful examination of the mind-switching Seeley diagram on page 206 reveals that the first set consists of Fry and Zoidberg. This is apparent from the lowest two lines of the diagram, which reveal that Fry's mind ends up in Zoidberg's body, while Zoidberg's mind ends up in Fry's body. This is considered a set because we can see that there is a mind for every body, and the only problem is that the minds and bodies are jumbled.

The other set consists of all the other characters. The Seeley diagram shows that the Professor's mind is in Bender's body, Bender's mind is in the Emperor's body, the Emperor's mind is in Wash Bucket's body, Wash Bucket's mind is in Amy's body, Amy's mind is in Hermes's body, Hermes's mind is in Leela's body, and, finally, Leela's mind is in the Professor's body, which closes the set. Again, this is

considered a set because there is a mind for every body, but the minds and bodies are jumbled.

Having identified the sets, Keeler added two fresh people to the mix, Bubblegum Tate and Sweet Clyde, who then unmuddle the two sets one at a time. To see this in action, let us start with the smaller set and unmuddle it.

The Seeley diagram below tracks exactly what happens in the episode. We can see that the unmuddling phase begins with Sweet Clyde mind-switching with Fry (who has Zoidberg's mind), then Bubblegum Tate mind-switches with Zoidberg (who has Fry's mind). With two more mind-switches, Fry's mind is returned to his own body and Zoidberg's mind is returned to his own body.

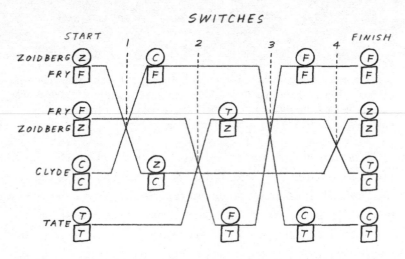

Sweet Clyde and Bubblegum Tate are still mixed up, and the obvious next step would be to put their minds back in their correct bodies by performing one more mind-switch—this would be allowed, because they have not yet switched with each other. However, that would be a premature switch. The mathketball geniuses were introduced as fresh people to unmuddle sets, and their work is not yet complete. So they must remain mixed up until they have dealt with the second set.

The Seeley diagram below tracks the nine mind-switches that occur as the second set is unmuddled. There is no need to go through the Seeley diagram switch by switch, but the overall pattern shows how the addition of Sweet Clyde and Bubblegum Tate creates the wiggle room required to resolve the situation. They are involved in every single mind-switch, which explains why the lowest quarter of the diagram looks so much busier than the region above it. Sweet Clyde and Bubblegum Tate act as temporary vessels for minds looking for the right home. As soon as they receive a mind, they switch it so that the mind ends up in the appropriate body. Whichever mind they then receive, they immediately pass it on to the appropriate body in the next switch, and so on.

Although Keeler did an excellent job of solving the mind-switching riddle and developing the Futurama theorem, it is important to point out that he either missed a trick, or ignored it in order to make

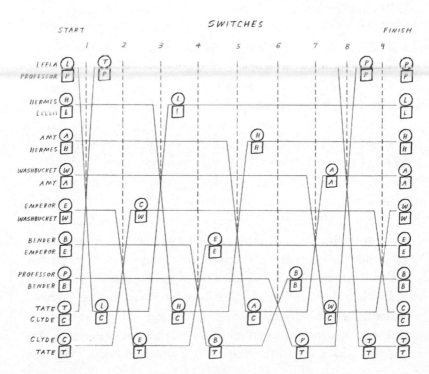

the finale of "The Prisoner of Benda" more interesting. The trick in question is a potential shortcut. Remember, to unmuddle any situation, it is necessary to introduce two new characters. However, in the scenario that we have been examining, one of the sets being unmuddled consists of just two characters (Fry's mind in Zoidberg's body and Zoidberg's mind in Fry's body). Hence, they could have acted as two fresh people in relation to the larger set. This is possible because Fry and Zoidberg had not previously switched with anyone in the larger set.

The two-stage unmuddling process that appeared in the episode required four switches followed by nine switches, giving thirteen switches in total. By contrast, if the shortcut had been used, then every mind could have been returned to every body in a total of only nine switches.

The use of an existing set to provide the two fresh people required to unmuddle another set was first explored by James Grime, a mathematician based in Cambridge, England. Hence, some people refer to this trick as *Grime's corollary*, a mathematical statement that emerges from the Futurama theorem.

Keeler's work has also inspired a research paper on the topic of mind-switching to be published in the *American Mathematical Monthly*. Authored by Ron Evans, Lihua Huang, and Tuan Nguyen from the University of California, San Diego, the paper is titled "Keeler's Theorem and Products of Distinct Transpositions," and looks at how to unmuddle any mind-switching situation in the most efficient manner.

By contrast, Keeler has decided not to publish his own research on mind-switching. He modestly describes it as a fairly standard piece of mathematics, and is generally reluctant to discuss the proof. He told me that his most detailed description of the Futurama theorem appeared in a fake script that he distributed to his colleagues: "When a writer hands in his draft of a script, the first step of the rewrite process is that the writers get copies and take a half hour or so to read it. As a practical joke, I started the script with a wholly facetious three-page

THE FUTURAMA THEOREM · 213

scene of Sweet Clyde explaining his theorem to the Professor in technical detail. Several of the writers waded through the whole thing, eyes doubtless glazing, before discovering the real script started on page four."

Keeler's mischievous hoax script reinforces the point that the actual script for "The Prisoner of Benda" is based on some genuinely interesting and innovative mathematics. In many ways, this episode is the pinnacle of all the mathematical references that have ever appeared in both *The Simpsons* and *Futurama*. Mike Reiss and Al Jean began by introducing mathematical freeze-frame gags into the first season of *The Simpsons*, and two decades later Ken Keeler created an entirely new theorem in order to help the Planet Express crew. Indeed, Keeler can claim the honor of being the first writer in the history of television to have created a new mathematical theorem purely for the benefit of a sitcom.

EXAMINATION V

PHD

Joke 1 Q: What's purple and commutes? 1 point
A: An abelian grape.

Joke 2 Q: What's lavender and commutes? 1 point
A: An abelian semigrape.

Joke 3 Q: What's nutritious and commutes? 1 point
A: An abelian soup.

Joke 4 Q: What's purple, commutes, and is worshipped 1 point
by a limited number of people?
A: A finitely venerated abelian grape.

Joke 5 Q: What's purple, dangerous, and commutes? 1 point
A: An abelian grape with a machine gun.

Joke 6 Q: What's big, grey, and proves the uncountabil- 2 points
ity of the decimal numbers?
A: Cantor's diagonal elephant.

Joke 7 Q: What's the world's longest song? 2 points
A: "\aleph_0 Bottles of Beer on the Wall."

Joke 8 Q: What does the "B." in Benoit B. Mandelbrot 4 points
stand for?
A: Benoit B. Mandelbrot.

Joke 9 Q: What do you call a young eigensheep? 1 point
 A: A lamb, duh!

Joke 10 One day, ye director of ye royal chain mail factory 4 points
 was asked to submit a sample in order to try to
 win a very large order for chain mail tunics and
 leggings.

 Though the tunic sample was accepted, he was
 told that the leggings were too long. He submitted
 a new sample, and this time the leggings were
 better, but too short. He submitted yet another
 sample, and this time the leggings were better
 still, but too long again.

 Ye director called ye mathematician and asked
 for her advice. He tailored another pair of chain
 mail leggings according to her instructions, and
 this time the samples were deemed to be perfect.

 Ye director asked ye mathematician how she
 calculated the measurements, and she replied: "I
 just used the wire-trousers hem test of uniform
 convergence."

Joke 11 An infinite number of mathematicians walk into a 2 points
 bar. The bartender says, "What can I get you?"
 The first mathematician says, "I'll have one-half of
 a beer." The second mathematician says, "I'll have
 one-quarter of a beer." The third mathematician
 says, "I'll have one eighth of a beer." The fourth
 mathematician says, "I'll have one-sixteenth . . ."
 The bartender interrupts them, pours out a single
 beer and replies, "Know your limits."

TOTAL – 20 POINTS

EΠLOGUE

· • · • · • · • · • · • · • ·

Futurama has garnered many honors over the years, including six Emmy Awards. That partly explains why the *Guinness Book of World Records* has recognized it as the Current Most Critically Acclaimed Animated Series.

Similarly, *The Simpsons* is the winner of more than two dozen Emmys and has become the longest-running scripted television series in history. According to *Time* magazine's review of the twentieth century, *The Simpsons* was rated as the best TV series and Bart Simpson was considered to be one of the world's hundred most important people. He was the only fictional character to appear on the list. Bart and his family also made history in 2009, when they became the first TV characters to have their own U.S. Postal Service stamps while still on-air. Matt Groening proudly proclaimed: "This is the biggest and most adhesive honor *The Simpsons* has ever received."

However, alongside this public and much deserved recognition, there has also been a quiet appreciation and respect from the nerd community. For us, the greatest achievements of *The Simpsons* and *Futurama* have been their celebrations of and flirtations with mathematics. Both series have enriched the geekosystem.

It would be easy for non-nerds to dismiss the mathematical shenanigans that appear on *The Simpsons* and *Futurama* as superficial and frivolous, but that would be an insult to the wit and dedication of the two most mathematically gifted writing teams in the history of television. They have never shied away from championing everything from Fermat's last theorem to their very own Futurama theorem.

As a society, we rightly adore our great musicians and novelists, yet

we seldom hear any mention of the humble mathematician. It is clear that mathematics is not considered part of our culture. Instead, mathematics is generally feared and mathematicians are often mocked. Despite this, the writers of *The Simpsons* and *Futurama* have been smuggling complex mathematical ideas onto prime-time television for almost a quarter of a century.

As my final day with the writers in Los Angeles approached, I had come to the conclusion that they were proud of their mathematical legacy. At the same time, among some of them, there was a sense of sadness that they had not been able to continue with their mathematical careers. Opportunities in Hollywood had obliged them to set aside any dreams of proving great theorems.

When I raised the possibility of regrets, David X. Cohen expressed reservations about this move away from research and towards television: "This dredges up painful self-doubts that we writers are racked with, especially we writers who bailed out on our science and mathematics careers. For me, the ultimate use of an education is to discover something new. In my mind, the most noble way to leave your mark on the world is to expand man's understanding of the world. Was I going to achieve that? Quite possibly not, so it may be the case that I made a wise decision."

Although he has neither invented a radical new computing technology nor cracked the mystery of whether $P = NP$ or $P \neq NP$, Cohen still feels that he might have made an indirect contribution to research: "I really would have preferred to live my whole life as a researcher, but I do think that *The Simpsons* and *Futurama* make mathematics and science fun, and perhaps that could influence a new generation of people; so, somebody else down the line might achieve what I didn't achieve. I can certainly console myself and sleep at night with thoughts like that."

As for Ken Keeler, he looks back at his time spent as a mathematician as part of his progression toward becoming a comedy writer: "Everything that happens to us has some effect on us, and I do suppose that the time I spent in grad school made me a better writer. I

certainly don't regret it. For example, I chose Bender's serial number to be 1,729, a historically significant number in mathematics, and I think that reference alone completely justifies my doctorate.

"I don't know if my thesis advisor sees it that way though."

APPENDIX 1

THE SABERMETRICS APPROACH IN SOCCER

• • • • • • • • • •

B illy Beane began to think about a sabermetric approach for soccer soon after the Oakland A's owners showed an interest in buying a Major League Soccer team. Since then, Beane has been linked with English soccer teams including Liverpool, Arsenal, and Tottenham Hotspur.

However, prior to Beane's involvement, others were already taking a mathematical look at soccer. In particular, there has been rigorous research into the impact of players being red-carded. This is a question that would interest Lisa Simpson, who was shown a red card by her own father while playing soccer in "Marge Gamer" (2007).

Three Dutch professors, G. Ridder, J. S. Cramer, and P. Hopstaken, authored a paper titled "Down to Ten: Estimating the Effect of a Red Card in Soccer," which was published in the *Journal of the American Statistical Association* in 1994. In the paper, the authors "propose a model for the effect of the red card that allows for initial differences in the strengths of the teams and for variation in the scoring intensity during the match. More specifically, we propose a time-inhomogeneous Poisson model with a match-specific effect for the score of either side. We estimate the differential effect of the red card by a conditional maximum likelihood (CML) estimator that is independent of the match-specific effects."

The authors argued that a defender who commits a deliberate foul on a goal-bound attacker outside the penalty box will make a positive contribution to his team by not conceding a goal, but he will also make a negative contribution as he will be sent off and unable to play

in the rest of the game. If the incident takes place in the last minute of a game, then the positive contribution outweighs the negative, as the player is sent off just as the game is about to end. On the other hand, if the incident takes place in the first minute, then the negative contribution outweighs the positive contribution, because the team is down to ten men for nearly the entire game. The overall impacts in extreme situations are common sense, but what about when an opportunity to prevent a goal with a deliberate foul presents itself in the middle of the game? Is it worth it?

Professor Ridder and his colleagues used a mathematical approach to determine the crossover time, which is the point in the game when being sent off begins to be worthwhile if it means not conceding a goal.

If we assume that the teams are well matched, and if the attacker is almost certain to score, then it is worth committing the foul any time after the sixteenth minute of a ninety-minute game. If there is a 60 percent chance of scoring, then a defender should wait until the forty-eighth minute before demolishing the attacker. And, if there is only a 30 percent chance of scoring, then the defender should wait until the seventy-first minute before doing the dirty deed. It is not exactly the most honorable way to apply mathematics to sport, but it is a useful result.

APPENDIX 2

MAKING SENSE OF
EULER'S EQUATION

.

$$e^{i\pi} + 1 = 0$$

Euler's equation is remarkable because it unifies five of the funda-
mental ingredients of mathematics, namely 0, 1, π, e, and i. This
brief explanation attempts to shed light on what it means to raise e to an
imaginary power, thereby helping to show why the equation holds true.
It assumes a working knowledge of some moderately advanced topics,
such as trigonometric functions, radians, and imaginary numbers.

Let us start with the *Taylor series*, which allows us to represent any
function as an infinite sum of terms. If you want to know more about
how a Taylor series is constructed, then you will need to do some home-
work, but for our purposes the function e^x can be represented as follows:

$$e^x = 1 + \frac{x}{1!} + \frac{x^2}{2!} + \frac{x^3}{3!} + \frac{x^4}{4!} + \frac{x^5}{5!} + \cdots$$

Here x can represent any value, so we can substitute x with ix,
where $i^2 = -1$. Hence, we get the following series:

$$e^{ix} = 1 + \frac{ix}{1!} - \frac{x^2}{2!} - \frac{ix^3}{3!} + \frac{x^4}{4!} + \frac{ix^5}{5!} + \cdots$$

Next, we group terms according to whether or not they contain i:

$$e^{ix} = \left(1 - \frac{x^2}{2!} + \frac{x^4}{4!} - \cdots\right) + i\left(\frac{x}{1!} - \frac{x^3}{3!} + \frac{x^5}{5!} - \cdots\right)$$

Taking an apparently irrelevant detour, it is also possible to find a pair of Taylor series to represent the sine and cosine functions, which leads to the following results:

$$\sin x = \frac{x}{1!} - \frac{x^3}{3!} + \frac{x^5}{5!} - \frac{x^7}{7!} + \cdots$$

$$\cos x = 1 - \frac{x^2}{2!} + \frac{x^4}{4!} - \frac{x^6}{6!} + \cdots$$

Hence, we can write e^{ix} in terms of $\sin x$ and $\cos x$:

$$e^{ix} = \cos x + i \sin x$$

Euler's identity involves the term $e^{i\pi}$, and we are now ready to calculate this by substituting x for π:

$$e^{i\pi} = \cos \pi + i \sin \pi$$

In this context, π is an angular measurement in radians, such that $360° = 2\pi$ radians. Hence, $\cos \pi = -1$ and $\sin \pi = 0$. This means that

$$e^{i\pi} = -1$$

Therefore,

$$e^{i\pi} + 1 = 0$$

According to Professor Keith Devlin, a British mathematician at Stanford University and author of the blog *Devlin's Angle*: "Like a Shakespearean sonnet that captures the very essence of love, or a painting that brings out the beauty of the human form that is far more than just skin deep, Euler's equation reaches down into the very depths of existence."

FERMAT'S LAST THEOREM PROGRAM

• • • • • • • • • •

```c
/*

Fermat Near-Miss Finder

Written by David X. Cohen
May 11, 1995.

This program generated the equation:

1782^12 + 1841^12 = 1922^12

For "The Simpsons" episode "Treehouse Of Horror VI".
Production code: 3F04
Original Airdate: October 30, 1995
*/

#include <stdio.h>
#include <math.h>

main()
{
    double x, y, i, z, az, d, upmin, downmin;

    upmin = .00001;
    downmin = -upmin;

    for(x = 51.0; x <= 2554.0; x ++)
      {
        printf("[%.1f]", x);

        for(y = x + 1.0; y <= 2555.0; y ++)
```

```
    {
    for(i = 7.0; i <= 77.0; i ++)
      {
       z = pow(x, i) + pow(y, i);
       if(z == HUGE_VAL) {
            printf("[*]");
            break; }

       z = pow(z, (1.0/i));

       az = floor(z + .5);
       d = z - az;

       if(az == y) break;

       if((d < 0.0) && (d >= downmin))
            {
               downmin = d;
               printf("\n%.1f, %.1f, %.1f, = %13.10f\n", x, y, i, z);
            }
       else if((d >= 0.0) && (d <= upmin))
            {
               upmin = d;
               printf("\n%.1f, %.1f, %.1f, = %13.10f\n", x, y, i, z);
            }
       if(z < (y + 1.0)) break;
      }
    }
   }

  return(1);
}
```

DR. KEELER'S RECIPE FOR
THE SUM OF SQUARES

* • * • * • * • * • *

I n an interview with Dr. Sarah Greenwald of Appalachian State University, Ken Keeler recounted the following episode concerning his father, Martin Keeler, who had an intuitive approach to mathematics:

> The main influence was my father, who was a doctor . . . He only got through first-year calculus, but I remember I once asked him what the sum of the first n squares was and he was able to derive the formula in a few minutes: $n^3/3 + n^2/2 + n/6$.
>
> What still surprises me is that he didn't do it by a geometrical argument (like the way you usually derive the sum of the first n integers) or an inductive argument. He assumed the formula was a cubic polynomial with unknown coefficients, then found the coefficients by solving the system of four linear equations generated by computing the first four sums of squares. (And he solved them by hand, without determinants.) When I asked him how he knew the formula would be a cubic polynomial, he said: "What else would it be?"

APPENDIX 5

FRACTALS AND FRACTIONAL DIMENSIONS

· ● · ● · ● · ● · ● · ● ·

We normally think of fractals as patterns that consist of self-similar patterns at every scale. In other words, the overall pattern associated with an object persists as we zoom in and out. As the father of fractals Benoit Mandelbrot pointed out, these self-similar patterns are found in nature: "A cauliflower shows how an object can be made of many parts, each of which is like a whole, but smaller. Many plants are like that. A cloud is made of billows upon billows upon billows that look like clouds. As you come closer to a cloud you don't get something smooth but irregularities at a smaller scale."

Fractals are also recognizable because they exhibit fractional dimensions. To get a sense of what it means to have fractional dimensionality, we will examine a particular fractal object, namely the *Sierpinski triangle*, which is constructed according to the following recipe.

First, take a normal triangle and cut out a central triangle, which results in the first of the four triangle shapes shown on the next page in the first diagram. This shape has three subtriangles, and each one of these then has a central triangle removed, which results in the second of the four triangle shapes. Central triangles are removed again, resulting in the third skeletal triangle shape. If this process is repeated an infinite number of times, the ultimate result is the fourth triangle shape, which is a Sierpinski triangle.

One way to think about dimensionality is to consider how objects change in area when their lengths change. For example, doubling the lengths of the sides on a normal two-dimensional triangle leads to a

quadrupling of its area. Indeed, doubling the lengths of any normal two-dimensional shape leads to a quadrupling of its area. However, if we double the lengths of the Sierpinski triangle above to create the larger Sierpinski triangle below, it does not lead to a quadrupling of its area.

Increasing its lengths by a factor of 2 causes the Sierpinski triangle area to increase by a factor of only 3 (not 4), because the larger triangle can be built from only three versions of the original small grey triangle. This surprisingly low growth rate in area is a clue that the Sierpinski triangle is not quite two-dimensional. Without going into the mathematical detail, the Sierpinski triangle has 1.585 dimensions (or log 3/log 2 dimensions, to be exact).

A dimensionality of 1.585 sounds like nonsense, but it makes sense in relation to the construction process that creates a Sierpinski triangle. The process starts with a solid two-dimensional triangle with lots of obvious area, but removing central triangles over and over again—an infinite number of times—means that the final Sierpinski triangle has something in common with a network of one-dimensional fibers, or even a collection of zero-dimensional points.

KEELER'S THEOREM

• • • • • • • • • • •

"**S**weet" Clyde Dixon's proof of Keeler's theorem (also known as the Futurama theorem) appears on the fluorescent green chalkboard in "The Prisoner of Benda," as shown on page 209. Here is a transcription of that proof:

First, let π be some k-cycle on $[n] = \{1, ..., n\}$: WLOG write:

$$\pi = \begin{pmatrix} 1 & 2 & \cdots & k & k+1 & \cdots & n \\ 2 & 3 & \cdots & 1 & k+1 & \cdots & n \end{pmatrix}$$

Let $\langle a, b \rangle$ represent the transposition that switches the contents of a and b.

By hypothesis, π is generated by DISTINCT switches on $[n]$. Introduce two "new bodies" $\{x, y\}$ and write:

$$\pi^* = \begin{pmatrix} 1 & 2 & \cdots & k & k+1 & \cdots & n & x & y \\ 2 & 3 & \cdots & 1 & k+1 & \cdots & n & x & y \end{pmatrix}$$

For any $i = 1, \ldots, k$, let σ be the (L-to-R) series of switches

$$\sigma = (\langle x,1 \rangle \langle x,2 \rangle \cdots \langle x,i \rangle)\,(\langle y,i+1 \rangle \langle y,i+2 \rangle \cdots \langle y,k \rangle)\,(\langle x,i+1 \rangle)$$
$$(\langle y,1 \rangle)$$

Note that each switch exchanges an element of $[n]$ with one of $\{x, y\}$, so they are all distinct from the switches within $[n]$ that generated π, and also from $\langle x, y \rangle$. By routine verification,

$$\pi^* \sigma = \begin{pmatrix} 1 & 2 & \cdots & n & x & y \\ 1 & 2 & \cdots & n & x & y \end{pmatrix}$$

i.e., σ reverts the *k*-cycle and leaves *x* and *y* switched (without performing $\langle x, y \rangle$).

NOW let π be an ARBITRARY permutation on [*n*]: it consists of disjoint (nontrivial) cycles, and each can be inverted as above in sequence, after which *x* and *y* can be switched if necessary via $\langle x, y \rangle$, as was desired.

ACKNOWLEDGMENTS

• ° • ° • ° • ° • ° • ° •

I could not have written this book without the support of the many writers on *The Simpsons* and *Futurama* who gave up their time to be interviewed, and who often went above and beyond the call of duty to help me. Particular thanks go to J. Stewart Burns, Al Jean, Ken Keeler, Tim Long, Mike Reiss, Matt Selman, Patric Verrone, Josh Weinstein, and Jeff Westbrook. Above all, David X. Cohen has been incredibly friendly, patient, and generous with his time ever since I first e-mailed him back in 2005. I should also add that Ken, Mike, Al, and David all provided personal pictures for the book, as did Mike Bannan. Thanks also to Fox and Matt Groening for giving me permission to use images from *The Simpsons* and *Futurama*.

Thanks to Roni Brunn, who sent me information about Math Club, and to Amy Jo Perry, who helped arrange interviews and made me feel very welcome during my trip to Los Angeles. I am also grateful to Professor Sarah Greenwald and Professor Andrew Nestler for sparing time to be interviewed. I would encourage readers to visit their websites to find out even more about the mathematics of *The Simpsons* and *Futurama*.

This is my first book as a dad, so thanks go to my son, three-year-old Hari Singh, who has spent much of the last year bashing on my keyboard and dribbling on my manuscript when I was not looking. He has been the best possible distraction.

When I have been locked away in my office, Mrs. Singh (alta Anita Anand) has done a great job of keeping Hari entertained with cakemaking, picture-painting, butterfly-hatching, dragon-slaying, and hide-and-seek. When she has been locked in her office writing her book, we have either let Hari run free in the streets or relied on various people to keep an eye on him. Thanks to Granny Singh, Grandad Singh, Granny Anand, Natalie, Isaac, and Mahalia.

As ever, Patrick Walsh, Jake Smith-Bosanquet, and their colleagues at Conville & Walsh Literary Agency have been a constant source of support and advice. It has been great to work with a new British editor, Natalie Hunt, and it has been doubly brilliant to work once again with George Gibson, who had faith in me as a new writer when he published my first book, about Fermat's last theorem.

In my research I have drawn on various web resources created and run by dedicated fans of *The Simpsons* and *Futurama*. Details of these websites appear in the online resources section. Thanks also go to Dawn Dzedzy and Mike Webb for baseball advice, Adam Rutherford and James Grime for various suggestions, Alex Seeley for other suggestions, John Woodruff for even more suggestions, and Laura Stooke for transcribing my interviews. I would also like to thank Suzanne Pera, who has organized all my paperwork and admin for the past ten years and more, and who retires this year. She has been a complete superstar and has stopped my life from falling apart. I am not sure how I will cope in 2014.

In 2013, I gave a talk about *The Simpsons and Their Mathematical Secrets* at Imperial College, London. In fact, I spoke in the lecture theatre where I received the majority of my undergraduate physics lectures. At the end of my talk, Tom Rivlin and Robin Saunders, who belong to the Imperial College Science Fiction, Fantasy, and Gothic Horror Society, asked why the book did not include the Banach-Tarski paradox, which is mentioned in the *Futurama* episode "Benderama". This was an unfortunate omission, so I will take this opportunity to mention that the Banach-Tarski paradox proves that a sphere can, in some mathematical sense, be decomposed and reassembled into two identical spheres of the same size. All of this is relevant to the "Benderama" plot, which is based around Professor Frink's invention of the Banach-Tarski Dupla-Shrinker, which can create two copies of any object. I would like to thank Tom and Robin for their alertness.

Finally, I had planned to write this book back in 2005, but I was distracted by bogus claims made by many alternative therapists, ranging from homeopaths to chiropractors. So, instead of writing about *The Simpsons* and *Futurama*, I co-authored a book called *Trick*

or Treatment? Alternative Medicine on Trial with Professor Edzard Ernst.

Then, after writing an article for the *Guardian* about chiropractic, I was sued for libel by the British Chiropractic Association. This, alongside the libel cases of Dr. Peter Wilmshurst, Dr. Ben Goldacre, and many others, helped trigger the Libel Reform Campaign in Britain. Fighting my case took two miserable years, but during this time I realized that I have some very loyal friends and I made lots of new friends, too.

The very first libel reform rally was organized by David Allen Green, with my solicitor Robert Dougans standing by my side. Three hundred bloggers, skeptics, and scientists were crammed into the Penderel's Oak pub in Holborn, London, where they heard speeches by Tracey Brown, Nick Cohen, Brian Cox, Chris French, Dave Gorman, and Evan Harris. There were also messages of support from Richard Wiseman, Tim Minchin, Dara Ó Briain, Phil Plait, Sile Lane, and many others. Many of these people would go on to lobby politicians and speak at other libel reform rallies.

That was just the start. I received support from the James Randi Educational Foundation in the United States, *Cosmos* magazine in Australia, Skeptics in the Pub groups around the world, the Hay Festival of Literature and the Arts, QEDcon, Sense About Science, the Science Media Centre, Index on Censorship, English PEN, and many other groups and individuals. I suddenly became part of a much bigger family, who all supported science, rationalism, and free speech. This family included Dr. Robin Ince, who hosted a fund-raising gig and who was always willing to help whenever required. He is a slightly grumpy national treasure.

On February 10, 2010, at a time when the Libel Reform Campaign desperately needed more support, I promised that my next book would mention those who went out of their way that month to persuade others to sign a libel-reform petition. In the end, over sixty thousand people signed the petition, which made politicians aware that the public was clamoring for a fairer free speech law. As promised, I would like to thank: Eric Agle, Therese Ahlstam, João

P. Ary, Leonardo Assumpção, Matthew Bakos, Dilip G. Banhatti, David V. Barrett, James Barwell, Ritchie Beacham-Paterson, Susan Bewley, Russell Blackford, Rosie, Florian, and Hans Breuer, Matt Burke, Bob Bury, Cobey Cobb, Crispin Cooper, Simon Cotton, Rebecca Crawford, Andi Lee Davis, Malcolm Dodd, Tim Doyle, John Emsley, Tony Flinn, Teresa Gott, Sheila Greaves, Sherin Jackson, Elliot Jokl, Bronwyn Klimach, John Lambert, Daniel Lynch, Toby Macfarlaine, Duncan Macmillan, Alastair Macrae, Curtis Palasiuk, Anil Pattni, Mikko Petteri Salminen, Colette Phillips, Steve Robson, Dennis Rydgren, Mark Salter, Joan Scanlon, Adrian Shaughnessy, David Spratt, Jon Starbuck, Sarah Such, Ryan Tanna, James Thomas, Stephen Tordoff, Edward Turner, Ayesha W., Lee Warren, Martin Weaver, Mark Wilcox, Peter S. Wilson, Bill Wroath, and Roger van Zwanenberg.

There is now a plaque in the Penderel's Oak that reads: "After a four year campaign, involving thousands of people and hundreds of organisations, the old laws were overturned. The new Defamation Act became law on 25th April 2013."

ONLINE RESOURCES

• • • • • • • • • •

Professors Andrew Nestler and Sarah Greenwald have provided excellent online sources for those wishing to explore the mathematics of *The Simpsons* and *Futurama*, including material aimed at teachers.

The Simpsons and Mathematics
www.simpsonsmath.com
http://homepage.smc.edu/nestler_andrew/SimpsonsMath.htm

The Simpsons Activity Sheets
http://mathsci2.appstate.edu/~sjg/simpsonsmath/worksheets.html

Futurama and Mathematics
http://www.futuramamath.com
http://mathsci2.appstate.edu/~sjg/futurama

There are various other sites that offer general information about *The Simpsons* and *Futurama*. Some of the sites contain sections discussing mathematical references.

The Simpsons
http://www.thesimpsons.com/
http://simpsons.wikia.com/wiki/Simpsons_Wiki
http://www.snpp.com/

Futurama
http://theinfosphere.org/Main_Page
http://futurama.wikia.com/wiki/Futurama_Wiki
http://www.gotfuturama.com/

PICTURE CREDITS

* ● * ● * ● * ● * ● * ● *

INDEX

Notes: Page numbers in *italics* refer to illustrations.
* denotes TV character or fictional character.

INDEX · 255

NOTE ON THE AUTHOR

* • · • · • · • · • · • · • ·

SIMON SINGH received his PhD in particle physics from the University of Cambridge. A former BBC producer, he directed a BAFTA Award–winning documentary about Fermat's last theorem and wrote a bestselling book on the same subject, entitled *Fermat's Last Theorem*. His best seller *The Code Book* was the basis for the Channel Four series *The Science of Secrecy*. His third book, *Big Bang*, was also a best seller, and *Trick or Treatment: Alternative Medicine on Trial*, written with Edzard Ernst, did not sell very well at all, but it did cause quite a fuss. Singh lives in London.